GW00758544

The Cornish Review Anthology
1949-52

The Cornish Review Anthology
1949-52

Selected and edited
by Martin Val Baker

WESTCLIFFE
BOOKS

First published in 2009 by Westcliffe Books,
an imprint of Redcliffe Press Ltd.,
81g Pembroke Road, Bristol BS8 3EA

www.redcliffepress.co.uk
info@redcliffepress.co.uk

This selection © Martin Val Baker and Westcliffe Books

The material in this book was originally commissioned by
Denys Val Baker for publication in *The Cornish Review* and the present
publishers do not know what arrangements were made about copyright. We
shall be pleased to provide complimentary copies to any living contributors
whose work is reproduced in this anthology, or to family members.

The publishers wish to acknowledge the following permissions:

Enitharmon Press for Frances Bellerby's 'Artist in Cornwall' and 'Hospital Car';
Diana Calvert for Arthur Caddick's 'The Lighthouse' and 'Funeral Lines for The
Cornish Review'; David Higham Associates Ltd for Charles Causley's 'Song of
the Dying Gunner AA1' and 'Serenade to a Cornish Fox' from *Collected Poems
1951-1997*, pub. Macmillan; Special Collections, University of Exeter for Jack
Clemo's 'Alien Grain', 'Impregnation', 'Initiated' and 'The Shadow'; Michael
and Margaret Snow, Literary Estate of W S Graham for 'The Voyage of Alfred
Wallis' and 'Hymn'.

ISBN 978-1-904537-36-6

British Library Cataloguing-in-Publication Data
A catalogue record for this book is available from the British Library

All rights reserved. Except for the purpose of review, no part of this book may
be reproduced, stored in a retrieval system, or transmitted, in any form or by
any means, electronic, mechanical, photocopying, recording or otherwise,
without the prior permission of the publishers.

Cover design by Mark Cavanagh
Typeset by Harper Phototypesetters Ltd., Northampton and printed by
MPG Books Ltd, Bodmin, Cornwall

CONTENTS

MARTIN VAL BAKER

INTRODUCTION

The *Cornish Review* was a quarterly literary magazine that ran for two separate incarnations – firstly from 1949 to 1952 (ten issues) and then in a revival in 1966, this time lasting until 1974 before it succumbed to an economic shortfall brought on by the withdrawal of an Arts Council grant. Here we offer an anthology of the first series featuring articles, poems and reviews typical of the magazine's contents in those vibrant days of the forties and fifties.

The editor of the *Review* was a young Welsh writer Denys Val Baker (1917-1984) who moved permanently to Cornwall after the breakdown of his first marriage in 1948. He had had a couple of spells in the county previously, living for some months in Dora Russell's cottage Carn Voel at Porthcurno in 1945 and later working as a publicist for local repertory theatre companies in Camborne and Falmouth. During these days he would no doubt have met up with many of the members of the thriving arts community who settled in West Cornwall after the war and were to be the basis of the contributors to the first issues.

In fact despite his relatively young age Val Baker had nearly a decade's experience in the study and production of small reviews during his previous life in London. Around 1940 he had first published the magazine *Opus* which seems to have had fourteen issues before being renamed *Voices* in 1943. He wrote a critique of literary reviews at the behest of the writers' organisation P.E.N. This was called *Little Reviews 1914–43* and led to his being commissioned by Allen and Unwin to edit a *Little Reviews Anthology*, a publication which appeared yearly from 1943 to 1949.

It was in 1949, by now living with his second wife Jess in a tiny cottage at the base of the romantic Trencrom Hill just outside St Ives, that Denys Val Baker launched the first issue of the *Cornish Review*. Convinced that Cornwall needed a magazine to feature the

wealth of artistic talent that now populated the county, Val Baker began to contact writers and makers with a view to finding supporters for his new literary venture. Although there was a strong body of native talent in Cornwall already these had been greatly bolstered by a large number of post-war refugees from the cities keen to work in a pleasant environment and to follow their calling. The eventual list of contributors was pretty impressive and many of these went on to make national reputations for themselves.

Buoyed by a terrific initial enthusiasm Val Baker ordered a rather optimistic first print run of 3,000 only to find that Cornwall was not ready yet for a publication of this nature. For some years unopened boxes of the first issue followed the family around their various homes in Cornwall until eventually the editor was obliged to scrap them. However the sales did eventually settle down around the thousand mark and the first series lasted for ten issues until the impoverished Val Baker was forced to abandon his rather expensive hobby. Fourteen years later when his fortunes had improved somewhat Val Baker was able to relaunch *The Cornish Review* from his new home, The Old Sawmills near Fowey, this time producing twenty-six issues before the publication's final demise in 1974 after the withdrawal of an Arts Council grant.

In his 1962 autobiography *The Sea's In The Kitchen* Denys Val Baker devotes a chapter to the first series of the *Review,* and perhaps we should leave him to tell the whole story...

DENYS VAL BAKER

THE LIFE AND DEATH OF THE *CORNISH REVIEW*

'The bones of this land are not speechless,' warns the poet, Frances
Bellerby, of Cornwall. 'He who seeks to mirror this place should
first learn their language.'

It was because I found so many people at work endeavouring in
their various creative ways to 'mirror this place' that, after settling in
Cornwall, I began to think seriously in terms of a publication
which might serve their needs. The pottery of Bernard Leach, the
paintings of Ben Nicholson, the sculpture of Sven Berlin, the
printing of Guido Morris, the poetry of W. S. Graham, the autobi-
ography of Jack R. Clemo, the scholarship of R. Morton Nance,
Grand Bard of the Cornish Gorsedd, the dialect stories of George
Manning Sanders, the memories of A. L. Rowse, the travels of Anne
Treneer, the sketches of Lady Vyvyan, the perceptive essays of R.
Glyn Grylls surely all these activities constituted a culture, a creative
life, of which Cornwall might well be proud? Certainly I myself
found it a fascinating aspect of Cornwall, the way in which artists
of all kinds seemed to be (sometimes quite mysteriously) drawn
down to this western tip of England's most westerly county. The
hold which Cornwall exerts on the creative artist is difficult to
illustrate. The easiest example is perhaps the sculptor; for here
indeed is a sculptor's country. As Sven Berlin has said, Cornwall has
a most peculiar influence on the unconscious mind of man. In his
own case he was made to feel that he was so rooted in the Cornish
landscape that to go and work in a city or some other area would
so alter his vision that it might be impossible to work for a
conceivable time. Peter Lanyon, a Cornish-born painter, once said
about the north Cornish coast:

> Here, in a small stretch of headland, cove and Atlantic adventure, the
> most distant histories are near the surface as if the final convulsions

of rock upheaval and cold incision, setting in a violent sandwich of strata, had directed the hide and seek of Celtic pattern.

Writers, as I can testify from my own experience, are equally inspired by the Cornish setting and atmosphere: it is difficult to travel about in Cornwall without being made acutely aware of the vast mystery of life, without being tantalized by haunting vistas of the past, and even hints of the supernatural.

Perhaps, on reflection, it was as well I lived on Trencrom Hill when I began to think about publishing a magazine. Somehow in such surroundings I was inspired to think only of the creative functions of such a magazine, all the interesting articles it could publish, the fascinating paintings it might reproduce, all the reviews and essays and stories and poems and other items which could reflect creative life in Cornwall. Up in the Penwith hills, or alternatively talking to eager painters at work in their studios, I was undoubtedly encouraged to look on the rosy side of such a venture. A more realistic Gallup poll among the average residents of Camborne, Falmouth, Truro, and a few other Cornish centres might have thrown a necessary cold douche on my optimism. That there was a real need for such a magazine I believed then, and indeed believe now; but of course to go blithely ahead on my own, using my own capital and just hoping for the best was asking for the trouble that I eventually got. I ought to have been warned by the knowledge that a whole half century had elapsed since the last ill fated attempt to run such a magazine. And doubly warned by the significant fact that, although edited by no less a figure than 'Q', Sir Arthur Quiller Couch himself, that magazine came to an untimely end after only a few issues.

Far from taking warning, I was simply mystified that no one had had the enterprise to start such a magazine during all those fifty years. Well, I was going to change all that. I was going to bring out the *Cornish Review* whose declared aim was, simply, 'to fulfil an obvious need to provide a platform for discussing and analysing cultural activities in Cornwall, along with an outlet for new poetry and fiction by writers of Cornish descent or living in Cornwall'.

What's more I would make it a 'proper job', no half measures, but a magazine which any bookstall would be proud to display, whether in Penzance or St Austell, or the West End of London. A prospectus was drawn up and printed, and for night after night we would sit by the oil lamp in our cottage folding up these leaflets and inserting them in envelopes addressed to a whole variety of Cornwall lovers, both at home and farther afield (addresses culled from a variety of sources, one of the most helpful being the London Cornish Association). The magazine was to be published quarterly, price 2s 6d or 10s 8d, annually post free, and the contents of the first issue would total 96 pages, including 12 pages of photographs. We mailed out some 500 prospectuses and within a week or two had accumulated 200 annual subscriptions.

This was good on its own small scale: remarkably good – but of course not enough. Subscriptions are an important basis of any publishing venture, but in addition one simply must have a wide range of retail sales. Many new publications employ agencies to do this work for them, but of course this applies to a national sales coverage. The *Cornish Review* sales would be achieved almost entirely through bookshops in and around Cornwall, and if anyone was going to contact those bookshops it obviously, if only for economic reasons, had better be me. So I got an early dummy prepared by the printer, whipped up all my enthusiasm, climbed into the very old Austin Seven we ran at the time, and one memorable morning set off to sell the *Cornish Review,* ahead of publication day, to the shops which I naively assumed would receive it with open arms.

I suppose it can only have been a kind of sublime enthusiasm that carried me through what, in retrospect, I see as one of the most dismal journeys ever made by a misguided idealist. In the first place it hardly even occurred to me that anyone in Cornwall would not welcome a purely Cornish publication – least of all local booksellers. If only for its novelty value I imagined that the *Cornish Review* would be greeted warmly, given a sort of extra push as being a local, and so on. Indeed, in more luxurious moments, I often dreamed of whole windows filled with compelling displays of

Cornwall's new and exciting magazine of the arts. Well, leave us our dreams.

Perhaps here I should explain that from the patriotic viewpoint, Cornwall is more of a continent than a county: that is, it is not so important that you are in Cornwall, what matters drastically, irrevocably is *what part* of Cornwall you come from. Thus, initially, on the first day of my personal sales campaign I was given a false kind of confidence, in that my first calls were essentially local ones. Living midway between St Ives and Penzance I naturally visited these towns first. In St Ives it was assumed to be a St Ives venture, and in Penzance a Penzance one, consequently the booksellers were at least a little interested. It is true that one of the largest bookshops in the West Country, noted for its specialization in Cornish books, required twenty minutes' earnest consideration before tentatively ordering six copies of this dubious new magazine, 'O.S., of course ...' (the book trade's favourite initials, a formula by which they only need to pay for copies they actually sell, even if they have them for months). Still, the orders quickly mounted up to several hundreds, and the next day I set off 'on the road' in the highest of spirits. These were somewhat dampened by a mistaken stop at Hayle and an exhausting search there for bookshops which simply did not exist. Never mind, I reassembled my enthusiasm and advanced on Camborne and Redruth, Cornwall's largest urban area. Really I ought to have been warned by my experience of helping to start the Studio Theatre there some years previously. But then theatres are expensive and have to be supported regularly every week: the *Cornish Review* was merely coming out four times a year, and at only 2s. 6d, a time, surely...

Well, I won't differentiate between Camborne and Redruth, but the total orders from this area of more than 20,000 people amounted to 24 copies. In Falmouth and Truro it was better, but in Newquay, Cornwall's most commercially successful holiday resort, supposedly with an eye for new business I hit an all time low, no orders at all. This record was equalled by Bodmin and Liskeard and Bude, and though I doggedly penetrated down the tortuous cliff hills of Port Isaac and Boscastle and, over on the south coast,

Polperro and Fowey, the orders formed the thinnest and most anaemic of trickles. When I finally returned to the welcome remoteness of Trencrom after nearly a week of exploring Cornwall in all its facets I had indeed gained a greater understanding of the county's almost unbelievable insularity but I had only obtained orders for the *Cornish Review* which, added to subscriptions, still fell short of 1,000. Since the cost of producing 1,000 copies of a 96-page review, including two dozen blocks, was going to be in the region of £200 and the income from selling 1,000, even allowing for full price in the case of 200 subscribers' copies, would hardly exceed £100, even the most elementary businessman would have scrapped the whole project. I suppose the trouble is I am just not an elementary business man, but I must admit even I hesitated. I never expected to make any real profit out of the *Cornish Review,* and indeed I was secretly quite prepared to lose a certain amount of my own money. After all, I told myself, I didn't smoke, many smokers I knew spent as much as £150 a year on cigarettes, surely I could look on it in those terms? (All wrong of course, but it helps to keep up morale.) But supposing the losses were much heavier than I expected, what would happen then?

Fortunately I am so constituted that I can never look that far ahead. A few days up among the Penwith hills restored my Celtic buoyancy. Wasn't there a crying need for such a magazine? Hadn't I already assembled a pile of excellent material, with the promise of many more manuscripts from authors, many of them very well known? What about that fascinating series 'My World' by leading craftsmen? The portraits of Cornish towns? The interviews with painters? The poetry anthologies? The reviews of art exhibitions? The account of the revival of the Cornish language? The history of the Cornish Gorsedd? The studies of Richard Trevithick and John Opie and 'Q' and Charles Lee and other famous figures of Cornish life! Much of this material was already on my desk. And then there were all those subscribers, who had rallied round so readily (not to mention those well meaning friends in all spheres who, though unable to help financially, were constantly and even extravagantly urging me on). It was perhaps a sobering thought that even at this

time similar magazines which had fostered art and literature in other Celtic countries, the *Welsh Review* and *Wales* in Wales, and the *Bell* in Eire were in process of folding up (what's more, I knew this only too well). Surely then all the portents and omens were against going on with the *Cornish Review?* Of course they were. And how many times do we meekly obey those omens? Far fewer than we realize. Maybe it is something inherent in our human nature.

So I parcelled up the editorial contents of the first issue and posted them off to the printer and thus set into motion the processes which, in the spring of 1949, offered to the world the first number of the *Cornish Review.* It was beautifully printed by Underhills of Plymouth, with an attractive green and white cover with the titling lettered by Misome Peile of St Ives printed over an outline of the county of Cornwall. Among the varied contents were an outline of 'Cornish Culture' by R. Morton Nance, and of 'Cornish Drama' by P. A. Lanyon Orgill, with some pertinent 'Reflections on the Cornish' by Lady Mander (R. Glyn Grylls of the old Cornish family of that name); a story by Lady Vyvyan, a study of 'Q' by E. W. Martin, poems by Jack Clemo, A. L. Rowse, Ronald Duncan, Frances Bellerby, Gladys Hunkin, and reproductions of paintings by Ben Nicholson, John Armstrong, John Park, Barbara Hepworth, Tom Early, Sven Berlin, W. Barns-Graham and Alfred Wallis. At the rear of the magazine we printed reviews of books by authors in Cornwall, and of plays put on in the county, as well as comments on current art exhibitions: there were also, as I felt in a regional magazine they would be appreciated, very full biographical notes on contributors.

My experience with booksellers had made me a little wary as to the general reception of the *Review,* but fortunately here I was unduly cautious. It is a fact that I have had many years experience of editing a wide number of magazines so that, looking back now, I think it is fair to say that our first issue was a good one and, as the *Times Literary Supplement* commented, 'fully deserves the local support for which it appeals'. Still it was greatly heartening to receive so many congratulations, most of which are perhaps best summarized in a letter which Howard Spring wrote, from his

lovely white house at Falmouth, and which we reproduced in our second issue:

> It is fitting that this region should have a place for uttering its own voice, for it is a region of character and idiosyncrasy. Its people, and climate, and their interaction, have produced something easily distinguished from anything that will be found elsewhere; and this is true despite the levelling consequences of our day. So long as it remains true there will be a reason for a magazine like this, which seeks to make known what is peculiarly Cornish in writing, painting, sculpture and all that belongs to a native culture. The expression that is given to this need not spring out of the heart of the Cornish-born. Many who paint in Cornwall, and write in Cornwall, are not Cornish-born. Nevertheless, Cornwall speaks through them; and the thing in this magazine must be that the voice of Cornwall shall speak, through whatever mouth.

Mr Spring went on to say that it was a duty of Cornish men and women to support our new venture, and indeed in the general atmosphere of goodwill it was almost impossible not to discern a feeling of success and expansion. Never much of a pessimist, anyway, I gave myself up hook line and sinker to this heady wine of success. The *Cornish Review* would triumph over all hesitant booksellers, it would sweep the county no, more than that, it would invade England too, soon it would be selling in London and other great cities, why, there might be no end to it. One bright and false morning, with the greatest unwisdom, I picked up the telephone and told the printer to reprint a further 1,000 copies. A day or two later, now completely in the clouds of cuckooland, I rang up again and said, 'Make that reprint 2,000'.

So in the end we printed 3,000 copies of the first issue of the *Cornish Review*: and the only comment really necessary on that piece of foolhardiness is that for several years after – during which we moved two or three times – wherever we went I had to lug them with me, those dozens and dozens of neat unopened parcels of new *Cornish Reviews*. Now and then some reader would order a

single copy, to complete a set perhaps, and this would involve opening one of the neat parcels a fatal move, as sooner or later the 50 or so copies would seem to get distributed about the home. Towards the end (of my patience) I remember that most of the parcels had split open, and anyway there was less space, and so I would spend hours trying to stack them up in higher and higher piles, none of which quite balanced, so that inevitably there was a crash and dozens of copies of that now unutterably familiar front cover lay splashed around. I can't think now why I kept them all that time, but in the end on discovering a secondhand bookseller in Mousehole who was glad to buy a few I developed a weekly habit of sidling in, saying: 'I just happen to have found a few more copies of this very rare first issue.' However, in the end even this source dried up, and the final ignominious end to that huge, and indeed largest ever, edition of the *Cornish Review*, was that I sold the remaining copies to a scrap merchant by the pound weight! I think it worked out at something like a farthing per 2s. 6d. copy.

So as I say the business end of the *Cornish Review* was woefully inadequate from the beginning. Strictly speaking we ought never to have come out at all, whereas in fact we did. What's more the magazine continued publication, sometimes almost flourishing, for nearly four years during which time, never one to learn a lesson, I was even obsessed enough with my editorial mission to launch a sister venture, *The Cornish Library*, which offered in permanent book form a series of limited editions of work by writers and artists in Cornwall. The first four volumes announced were *Paintings from Cornwall*, reproductions of work by about thirty well known artists; *Witchery of the West*, a recounting by Georgina Penny of some of the most famous Cornish legends; *Leaves from a Cornish Notebook,* a selection of essays by 'John Penwith' of the *Cornishman*; and *The Cornish Renaissance,* a critical study of Cornish literature by E. W. Martin. The painting book was useful because it pinpointed the fascinating breakthrough of the abstract movement now so prevalent in Cornwall; however, probably the most interesting of the books would have been *The Cornish Renaissance* – unfortunately Ernest never quite got around to writing it, and in any case I should

never have quite got around to publishing it, since by then the *Library*, like the *Review*, had come to an untimely end. I always felt it would have made a fascinating study, for there are very nearly as many writers working in Cornwall as there are painters (if one was to make the criterion of measurement publication or sale, then more writers!). Only a small proportion of these writers are Cornish-born, but they make an interesting group, ranging from A. L. Rowse, author of that fine autobiography, *A Cornish Childhood*, and also well known for his many studies of Elizabethan England, to young poets of such different but impressive achievement as Jack R. Clemo, author of *Wilding Graft* and *Confessions of a Rebel*, who has lived all his life in St Stephen's, a remote clay-mining hamlet near St Austell, and Charles Causley, a schoolmaster at Launceston, whose poetry, with its Kiplingesque lilt and expert use of colloquialisms, has a ready appeal to the mass public as witness the large sale of his naval poems, *Farewell Aggie Weston*. Then there's Anne Treneer and R. Glyn Grylls and Terence Tiller and Ronald Duncan and Geoffrey Grigson and J. C. Trewin and Ronald Bottrall and Frank Baines Oh, yes, the Cornish writers are a formidable bunch, even if much more loosely linked than their Welsh or Irish counterparts. But what is equally interesting is how Cornwall has drawn so many other fine writers, many of whom have paid a visit and stayed a lifetime. One thinks of the Scottish poet, W. S. Graham, whose striking poems are impregnated with Cornish images: of bestselling authors like Daphne du Maurier or Howard Spring, Winston Graham and Walter Greenwood, all of them then living in Cornwall, many of whose books make the fullest use of Cornish background and characterization; or of more scholarly writers like Phyllis Bottome, F. B. Halliday, Wallace Nicholls, Ruth Manning Sanders, and others like them who have found true creative inspiration in Cornwall.

No doubt it was the knowledge that as an editor I could draw on such a strong supply of literary talent which encouraged me to continue with the *Cornish Review*, after the smoke had cleared and revealed the financial chaos ensuing from that first exciting, disastrous publication. Among future contributions already lined up

were such articles as 'Planning a future Cornwall', by H. J. W. Heck, the County Planning Officer; 'Ben Nicholson' by J. P. Hodin; 'My World as a Potter', by Bernard Leach; 'Early Cornish Railways', by David St John Thomas; 'John Opie', by J. W. Scobell Armstrong; 'The Face of Penwith' by Peter Lanyon; 'Cornish Wrestling', by Tregonning Hooper; and a host of first-class poems and stories and reproductions.

As a writer myself I held firmly to the principle that contributors must receive payment, and although our average was small enough, about three guineas for an article or story, and half a guinea for a poem, this did not help the financial situation. Already money that I earned by my own writing was having to be poured into one of the innumerable breaches, to keep things going. Already we were involved in financial difficulties at home. At the same time manuscripts were coming in with almost every post, and also at that stage even more welcome letters from people not only in Cornwall, nor even just in England, but in Africa, South America, North America, Canada, New Zealand, Australia, everywhere, indeed, where a Cousin Jack (or his female equivalent) might be found. They were warm and friendly and encouraging, those letters, many of which enclosed subscriptions as a present to friends, and they always put new hope into me. I always felt that if somehow I could have got in touch with all the people who loved Cornwall but were exiles, then the *Cornish Review* would never have had to close down.

We carried out a lot of circularizing, but as we began planning the second issue, wondering how on earth we could try to catch up on the heavy financial loss so far, we had to think of something immediate and more effective: and so I began on yet another new career, touting for advertisements. I use the word touting in no superior tone, but as the most accurate description of what now took place. Nobody it seemed (how I was reminded of those booksellers!) wanted to advertise in the *Cornish Review* – and frankly I could not really see why they should, except out of a spirit of philanthropy. And of course this is precisely why in the end many of them did. They felt a certain sympathy for this lonesome,

doomed venture. Yes, perhaps it wasn't a bad idea to have a cultural magazine…all right, put us down for a quarter page. Since all my advertising rates were far too low this gesture was fairly easy to make (I think a quarter page originally was a mere 30s). However, slowly, laboriously, at the cost of a physical and psychological effort quite out of proportion to the results, I began to collect a few advertisements from local tradesmen and other organizations.

Then, thank goodness, Arthur Caddick came into the picture. Known sometimes as the Poet Laureate of Nancledra, Caddick, who looks like a Shakespearean actor (he also has the full-blooded booming voice of one), is best known as a writer of comic verse, several collections of which have been published. I was publishing some of his work anyway, but he was sincerely anxious to be of practical assistance as well, and he suggested that he took on the job of collecting advertisements. So one day, armed with some specimens of our first issue, Caddick set off to beard the business men of Penzance in their offices (I, so far, having only weakly covered St Ives). What's more, at the end of the day he re-appeared somewhat bleary-eyed but waving a pile of papers triumphantly. 'I've sold you five pages and more to come!'

In the end between us we raised about twenty pages of advertising for the second number of the *Cornish Review*: about the largest amount of advertising, had we but known it, we were ever to publish in one issue. Caddick continued collecting local advertisements for several more issues, often succeeding I imagine by an ingenious mixture of oral hypnotism, Shakespearean grandeur, outrageous flattery and sheer downright bullying where the more conventional approach would have failed. He was particularly good at impressing hotelkeepers and publicans although, as a single call might lead to a very convivial 'session', this can hardly be described as good economics. Some years later, on his own account, Arthur Caddick conceived the idea of an annual publication about the pubs of Cornwall, designed to interest the holidaymakers. It was called *A Hundred Doors are Open,* and represented the fruits of a series of expeditions down the highways and byways of Cornwall – a monumental saga of one-man enterprise if ever there was one!

Moreover a saga repeated once yearly. I love to think of the alarmed looks on various publicans' faces as from afar they heard the vast booming of Caddick's voice, probably declaiming one of his latest extremely pungent satirical poems.

My own advertising career followed a more cowardly approach. It was just not in me to beard a business lion in his den and convince him, against both his and my own better judgment, that he should pay out good money to advertise in a publication with such a small readership as the *Cornish Review*. On the other hand I am very good at writing persuasive letters. Face to face I am inclined to be mild and self-effacing, and certainly do not assert myself nearly enough: behind the screen of the postal services I become uninhibited, daring, powerful and even aggressive, all basic necessities for an advertising man. Thus, leaving local 'face to face' contacts to Caddick, I ventured farther afield. I composed cunning epistles seeking to persuade publishers in London that they should advertise their West Country books in our *Review* and ditto to any other business concern in London with the remotest connexions with Cornwall. I also focused these verbal powers of persuasion on a variety of unusual approaches in the county itself: in this way enticing such unlikely advertisers as a shop buying and selling old magic lanterns, a garden designer, a multispring mattress maker, a manure firm, a maker of ivory miniatures, a fabric printer and an Irish Catholic Association.

So between us Caddick and I furnished about £100 worth of advertising for the second number of the *Cornish Review*, and thus set things momentarily on a more even keel. It was, I flattered myself, a good meaty issue, including Bernard Leach's fascinating account of his life's work, a study of Richard Trevithick by Hamilton Jenkin and of Charles Lee by H. J. Willmott, a memory of the great Western Rebellion of 1549 by Ashley Rowe and an article by Ivor Thomas, 'County or Country?' which I had commissioned especially with a view to provoking some controversy. It was, however, an item in a small section of the paper at the very end, Readers' Forum, which really caused a sensation up and down the length and breadth of Cornwall. This was a letter from Sydney

Horler, the well known thriller writer, who happened to live at Bude in North Cornwall:

Sir:

Pick up any book about Cornwall, and you'll find the writer expatiating about the lovely coast scenery, the different points of interest, etc., whilst remaining very reticent about the natives. I have lived among the Cornish – the Bude variety in particular for years now, on and off, and I have been appalled by what I have discovered in the local character. I have found a certain class to be treacherous, twofaced, sly, deceitful, flagrant humbugs (more especially when they profess themselves deeply religious, as many of them do) and altogether undesirable. In fact, in sheer self defence, I now refuse to have anything to do with the 'locals', and if newcomers to the county take my advice they will adopt the same precaution. If they don't, they will inevitably learn the same bitter lesson as myself.

What is the reason for this deplorable antisocial behaviour? The principal cause, I believe, is that the Cornish, a primitive people at the best, cut off for centuries from the rest of the country, have always hated the intrusion of anyone from outside – the 'foreigner', as they call him. They like his money, but they keenly resent his physical presence. And the kinder and more generous he is on arrival, the more they will hate and fleece him. This is the stark truth. Perhaps being a very backward, illiterate and ignorant people, they develop a strong sense of inferiority when they come into contact with anyone of a different and better type; but the fact remains that the 'foreigner' is only safe if he leaves them strictly alone.

I have actually heard Cornishmen boast that their forebears lured ships on to the rocks by false lights; and their present actions are influenced, no doubt, by what is in their very blood. A man who should know (he served in the Intelligence Service during both wars) assured me that German submarines were refuelled in coves along the south and north Cornish coasts in 1914-18, and that the crews were allowed to come ashore and mingle freely with the natives. After living in Cornwall, I can well believe it: in spite of the crowded chapels or, perhaps, because of them – there is more

farmyard immorality in Cornwall than in any other part of England. Many of the stories I could tell you would be judged incredible by any ordinary standards.

Perhaps this sexual lust can be partially explained by the strange mixtures of blood in the Cornish; the frenzied chapel goer will deny it at the top of his voice, but in spite of the strenuous attempts to hush it up, there is undoubtedly a lot of foreign blood among the natives; you can see men in Newlyn and other places standing at street corners, unshaved and wearing filthy trousers, who are pure Iberian, and who might have stepped out of a picture by Goya. This may account also for the Cornishman's indolence, carelessness, and general shiftiness in some measure, at least; although the worst kind of Cornishman would be a natural rascal, I am afraid, in any case.

Sydney Horler

Such a letter speaks for itself, it is pretty obviously exaggerated and written in anger by someone who, for one reason or another, hasn't hit it off with his neighbours. Of course it contains within it sufficient half truths to make the wounds hurt. At least I can only assume this was the reason for the extraordinary aftermath! There was, literally, an explosion. First of all the West Country newspapers seized on what they spied as a good story, printing parts of the letter, and interviews first with Horler and then with others attacking him. The story was taken upon the radio, and in Sunday and weekly newspapers. After a few days, Sydney Horler, whom incidentally I never met, rang me up to say that he had received two threatening telephone calls. Meanwhile, letters poured in, both to papers like the *Western Morning News* and to myself. In the next issue I printed a selection of them. One was from a St Ives furniture firm cancelling future advertising, and the general tone of all the letters was the sooner Sydney Horler leaves Cornwall, the better it will be for everyone else. (In fact soon afterwards Mr Horler did leave the county, and subsequently I read of his death.) The last outward manifestation of the controversy which I witnessed was a highly emotional burning of an effigy of Sydney Horler at a huge Guy Fawkes' bonfire held at Newlyn and attended by thousands of people.

Sydney Horler's letter in our second issue certainly caught the public eye: but it was an item which in fact had literally to be cut out of our fourth issue which involved us in the greatest instance of national publicity. At this time the ancient art of mead making had been revived at Gulval, near Penzance, by a new enterprise, Mead Makers Ltd. The company seemed to have large financial resources, various well-known names figuring among the directors and shareholders, and under the leadership of the chairman, Lt.Col. Gayre, who had made a study of mead and its history, the company had big marketing plans for selling mead both in Britain and abroad. As part of the general publicity, the company had opened its own Mead Hall, where exotic meals were served by liveried waiters, each course accompanied by the appropriate type of mead. As another part of the publicity there had been introduced an elaborate 'blessing of the mead' ceremony, conducted by a local canon. In addition Colonel Gayre had written and published a history of mead, as well as a number of booklets, all of which were expertly distributed in the locality, also to visitors and farther afield. Whatever the qualities of mead itself, there did seem, to say the least, an element of pomposity about the way it was being put over to the public. When, therefore, Arthur Caddick sent me in a wickedly amusing take-off poem, entitled 'The Makers of Woad', I decided to publish it in the next issue of the *Review*. It was funny, it was clever, and it was very good verse, and surely not really harmful. As it happened the *Cornish Review* public were never given the opportunity to judge. Somehow Colonel Gayre and his friends got to hear that the poem was being published and, without bothering to approach me, the editor, went straight to our printers at Plymouth and thoroughly alarmed them so much so that just as I was anxiously awaiting delivery of the issue I received a long-distance phone call from the printers stating that in view of a threat to sue if they printed the poem, they felt unable to complete publishing the issue as it stood. I protested and argued, appealed to their sense of morality, liberty of conscience, etc but all to no avail. I was faced with an ultimatum: and at this very last minute, with the issue in print and everyone waiting for it, plus the fact of

an uneasy suspicion that if an experienced printer thought the poem was libellous, may be it was, I could see no alternative but to agree to the printers' suggestion. A day or so later the *Cornish Review* was on sale with the sheet containing pages 19 and 20 conspicuously absent, and obviously cut out by hand. Meantime the line still evident in the contents list – 'The Makers of Woad' by Arthur Caddick – raised an intriguing query.

I had, of course, told Caddick what I had been forced to agree to, and he was naturally upset. When, however, he roared out that he would take Mead Makers to court I did not altogether take him seriously. I was forgetting that in his youth Caddick had studied for the Law and had just missed taking silk as a barrister. He knew all the ins and outs of legal procedure and before long he had come up with his trump card. He would take out an action against Colonel Gayre and the mead company for conspiring to damage his reputation as a professional poet.

'It's plain as a pikestaff, dear boy!' boomed out Caddick. 'Look at this issue of the *Review*, appearing with my poem obviously cut out. What on earth is the average reader going to think? He's going to assume that this fellow Caddick must be so bad at his job that the editor had to leave out his poem at the last moment. But it isn't like that at all is it. It's Colonel Gayre who has unreasonably brought pressure to bear and by so doing damaged my professional reputation.'

For a long time the whole matter bordered on something of a joke, but gradually it became apparent that Caddick was in deadly earnest. Papers were served, writs issued, witnesses summoned, the whole paraphernalia. Caddick announced that he would conduct his own case, and, by now somewhat alarmed I fancy, the mead company briefed a leading West Country barrister. It had been hoped, at least by the Caddick faction, that the case would be tried by Judge Scobell Armstrong, judge of the Cornwall County Circuit for many years and nationally renowned for his witticisms and somewhat unconventional behaviour. Before it could take place, however, the judge's retirement was announced, and the mead case was finally heard by Judge Rawlins. As it transpired, this represented

no loss, and the judge's urbane handling of a most unusual and even unorthodox trial was a pleasure to behold.

Needless to say the case tickled the public fancy, and when finally it was held at Penzance County Court the national newspapers were well represented. So, too, were the local artists, both as legal witnesses, and as moral support for Caddick. The star performer was Caddick himself, making an auspicious and dramatic start to the day's events by standing up and reading out aloud the whole of his poem so that it then became legal for any of the national newspapers to reprint it in their reports of the case. (Many of them did just this, and so 'The Makers of Woad' received a thousand times greater publicity than it could ever have obtained confined to the pages of the *Cornish Review.*) I can still remember the hilarity of that episode, Caddick standing up and uttering the verses in his booming voice, while all around we strove to control ourselves, sometimes bursting into laughter and in their corner the representatives of the mead company endeavoured to look stern and unamused.

Evidently, though, they were not entirely unaffected for though the case was adjourned for lunch while I was being cross examined, when we reassembled in the afternoon there was a great deal of whispering and consultation, and then came an announcement welcomed all round. A settlement had been reached, said Judge Rawlins, smiling broadly to indicate his approval. Mr Caddick would withdraw his case, while the mead company for their part, as a gesture, had agreed to commission Mr Caddick to write for them an official Mead Drinking Song. I can't remember the more exact details, but I do know that we all looked on it as a moral victory for Caddick had not the judge congratulated the plaintiff on the manner in which he handled his case and we all went off to celebrate. But not in mead!

Such episodes, amusing as they were, though they certainly represented a great deal of useful free publicity for the *Cornish Review,* had little ultimate effect on the magazine's career. Or if they did it was an unfortunate one. Already I had made my own cross, had I but known it, by determining to bring out a literary magazine which set out resolutely to deal with cultural activities both among

Cornish and people living in Cornwall. 'Approximately one third only of your contributors are Cornish', wrote one reader angrily. 'Please give us a *Cornish Review* and not a review of the Cornish by a "passel of arty foreigners".' This is a parochial attitude with which anyone who lives for any period of time in the county becomes all too familiar. Its requirements are adequately met by the local newspapers, where all the minute trivia of local life is duly recorded. My own experiences with theatre companies, and in other spheres, had proved to me – and my experience with the *Review* alas, was to confirm this – that culture in Cornwall, while not quite a dirty word, needed a good deal of propaganda behind it merely to make it acceptable, let alone popular. This was one of the several reasons why, admittedly, we did concentrate on artistic activities in the county, whether in the spheres of painting, drama, or literature. (I must in passing point out that we printed numerous non-arty articles on such subjects as the Camborne School of Mines, Porthcurno Cable Station, Cornish Churches, Cornwall's Flower Industry, Cornish Language, and Cornish Nationalism.)

In focusing, in particular, upon the work of artists in Cornwall we were, of course, fortunate in the richness of our material. There can be few places in the world, let alone Britain, where so many professional painters live and work and earn their living (as well as reputation) as in the small peninsula of West Penwith. Looking through various numbers of the *Cornish Review* I see that we reproduced painting and sculpture by Ben Nicholson, Barbara Hepworth, Peter Lanyon, Bryan Wynter, John Armstrong, John Park, Dod Procter, Lamorna Birch, Mary Jewels, Charles Pears, W. Barns-Graham, Sven Berlin, Denis Mitchell, Hyman Segal, Leonard Fuller, Bernard Ninnes, among others. With our fourth issue I introduced a system of reproducing a woodcut or lino drawing on our front cover, and this also reflected the versatile talent abounding in West Cornwall. Art in fact was and is as commonplace a part of everyday life as, say, motor-car production is in Birmingham or Coventry. This has many good effects. For instance wherever you go in West Cornwall you are quite likely to come across original paintings adorning the walls of pubs and cafés

and hotels but there are also less happy by-products. An example of this was provided in St Ives at the time when the *Cornish Review* functioned, when the local traditional and abstract artists, after having been at loggerheads for years, finally came to open warfare and set up two rival societies. I was sympathetic to the new group, the Penwith Society of Artists in Cornwall, which in general sought to take a more progressive view of art and life, and for years I was a lay member. But after a while of watching endless committee wrangles and internal disputes – often over the most petty and hair-splitting points – I began to wish that painters would emulate writers, and get on with their own work rather than waste so much time in bickering.

Nevertheless, individually, I have great admiration for a number of painters in Cornwall, and like to think that we helped them in some way by publishing their *work* (not their personal poses!) in the *Cornish Review*. Some of them showed their appreciation, anyway, when as a last effort to keep the good ship *Cornish Review* from foundering, I hit on the idea of holding a Mock Auction. By one of those ironic twists of fate this was held in the long bottom room of St Christopher's, at that time a St Ives guest house, now our own home. I had a slight suspicion that we were not really legally entitled to run a public auction, but thought it wiser never to inquire at the time. Legal or otherwise, it proved a most entertaining experience. Previously I wrote round to a list of writers and painters who had contributed work to the *Review* in the past. Would they be willing to contribute a signed copy of an example of their work, to be put up for sale at a Mock Auction in aid of the *Cornish Review*? I can't think why I used the term 'mock', unless it was to salve my conscience about the regulations, for the fact was we were in dire straits financially.

By now we had published seven issues and while subscriptions had kept up encouragingly among the faithful, other sales had remained fairly static. It had become quite clear that the only way to maintain such a magazine was by running it as economically as possible, and being satisfied with a small but steady circulation of about 1,000 copies per issue, possibly increasing the price to 3s 6d.

or even 5s. My problem was to find a way of clearing off many hundreds of pounds of debts incurred on the earlier numbers. If we could have done this then I am pretty sure we could have kept the *Review* going to this day. I used to dream of some wealthy Cornishman suddenly appearing, pulling out a cheque book and saying: 'Here, will this put you straight!' Alas, life is never like that. As the next best thing at one stage I launched a Goodwill Fund, which was contributed to by many eminent Cornish men and women, and lovers of Cornwall. In all we raised over £150, but this was not nearly enough, and so we came to the auction which, as I have indicated, was far from mock, but in deadly earnest.

It was finally held on a Saturday afternoon. Word must have got round about possible bargains, for I fancy there must have been nearly two hundred people there by the time I rose to introduce the main speaker and opener, Winston Graham. Mr Graham delivered a short but fighting speech on behalf of such enterprises as the *Review* and then made way for the main protagonist, the very unin-stitutional auctioneer Arthur Caddick. Time blurs exact memories of the occasion, but I have a strong recollection of Caddick working desperately hard to liven up the bidding and of a curiously apathetic audience showing a surprising reluctance to enter into the fun of things. After all, the artists had freely given their pictures and sketches to help a good cause, just as authors had in many cases had to buy and sign a copy of their own books to give. Surely the sort of public that came to such a ceremony would be wellwishers, ready if anything to overbid rather than underbid? One would have thought so; but the event proved different. Whether it was the native Cornish eye for a bargain or what, the fact is that few of the paintings and sketches fetched more than a pound or so, and practically all the books, even signed by such names as Winston Graham, Howard Spring and Jack Clemo, etc., went at about half their published price. Only some of the crafts fetched even their normal price . . . I think the best sale of the day was a small table by Robin Nance. When all expenses, including advertising, had been met, the total profit was about £37. It should have been at least three times that figure.

This was in many ways the final blow. With the lack of a private (or indeed public) backer, the failure of our various efforts to raise capital in other ways, and finally this further confirmation of the very limited amount of genuine support for the *Review*, it became literally impossible for me to continue indulging in such an expensive pastime. I decided, as I put it in my last editorial, to go down with flags flying, and I like to think that the tenth and final issue of the *Cornish Review*, with contributions by Jack Clemo, A. L. Rowse, W. S. Graham, Norman Levine, Richard Gendall, Charles Causley, Arthur Caddick, Daniel Trevose, Gladys Hunkin, and others, was one of our very best. For myself I said very little in my brief editorial: I think everything was pungently summed up in the following 'Funeral Lines for the *Cornish Review*' by Arthur Caddick:

O Printers' error on a mammoth scale,
At sight of whom the local bank clerks pale,
O watcher of the skies for rains of pennies
From heavenly advertisers, Denys!

Attend me now, I have a tear to shed
Before your paper joins the silent dead
And you become, in solemn mourning hue,
Ex.Editor, Ex.Cornish, Ex.Review!

I hear low moaning rise round Carbis Bay
Where highbrows weep for what has passed away,
(And might one just dispassionately hint
Some mourn their last, lone chance of seeing print?)

I hear some craftsman, at Trebogus Cove,
Where soulful, simple, soapless creatures rove,
Exclaim: 'It's bust, and I've just written Baker
'My Lonely Life as FancyDoodle Maker'!'

In fact, dear Denys, it is weeks and weeks
Since misery laid low so many freaks.
Yet though exotic grief attends this funeral,
Far odder persons will not weep at all.

From Penzance Guildhall fat relief is rising:
'We needn't now go on *not* advertising!
We needn't now refuse to pay for space
When third-class Shakespeare Festivals take place!'

Ditto the civic feeling in St Ives:
'We give our help to anything that thrives,
We bless success, but struggling papers, no!
Let Art attract the tourists' cash or go!'

With lukewarm bookshops it is much the same:
'The paper's dead? . . . I didn't catch the name.
Cornish Review? That local thing? . . . Ah, quite!
The comic postcards, madam? On your right!'

So here's the crux, the one essential clue
To this quick dying of your young Review
Its friends, the artists, had no cash to spare
And those who should have helped it didn't care.

DAVID COX

PAINTING IN CORNWALL

At an Extraordinary General Meeting of the St. Ives Society of Artists on February 5th, 1949, called by ten members, a split which has been threatening for some years took place; broadly between the more progressive and the conservative elements.

As a result, seventeen members have resigned. They, and a number of supporters, called a meeting together to form a new Society, such as was visualized by the late Borlase Smart, which will aim at presenting exhibitions of the most vital art and craftsmanship, regardless of label, in the Penwith area of Cornwall. It will be called the Penwith Society of Arts in Cornwall.

Herbert Read has consented to be its President, and the foundation members are: Shearer Armstrong, Wilhelmina Barns-Graham, Sven Berlin, David Cox (Hon. Secretary), Agnes Drey, Leonard Fuller (Chairman), Isobel Heath, Barbara Hepworth, Marion Grace Hocken, Peter Lanyon, Bernard Leach, Denis Mitchell, Guido Morris, Marjorie Mostyn, Dicon Nance, Robin Nance, Ben Nicholson, Herbert Read, H. Segal, John Wells.

Cornwall has for many years been the home of artists. Since the days when J.M.W. Turner visited St. Ives in 1815 it has given to the world artists with views as far apart as Christopher Wood and Algernon Talmage. Today it continues to produce painters of many diverse views, but perhaps there is now a more common link than hitherto. This link may be described as an aesthetic value – an expression of an element of Cornwall. One is particularly conscious of this in the work of the abstract artists, where the contact is made direct to the mind of the beholder without the distraction of photographic realism, or where the subject is allowed to live without insistence. For instance, there is a common link of expression with artists such as Fleetwood-Walker and Peter Lanyon which may not at first be apparent. This lies in the implication of the subject rather

than its over-statement; and thus we can follow a logical sequence in the very apparent influence which is exerted by Ben Nicholson on Lanyon and Wells, who again draw their constructivist inspiration from the eloquence of Naum Gabo.

Due to this common link the work of Cornish artists, and particularly the St. Ives colony, is now perhaps more vital than ever before. Evidence of this has been provided in the past year at the regular exhibitions of the St. Ives Society of Artists at the Art Gallery, St. Ives, at the exhibitions of the Crypt Group, St. Ives, and at a series of individual shows held at Downing's Bookshop, St. Ives.

Visitors to the exhibitions of the St. Ives Society of Artists will have seen from the pictures that the Society is catholic in its outlook. As one would expect from a society having its home on the Atlantic, there are a number of marine artists who derive inspiration from the ocean and the rugged Cornish cliffs. Landscape painters have a choice from quiet pastures to wild, sinister spaces.

The Society held four local exhibitions during 1948, and these were very well attended. The exhibitions owed much of their quality to the work of such painters as Lamorna Birch, John A. Park, whose canvasses never fail to show true artistry, Stanley Spencer, Marcella Smith, Dorothea Sharp, S.H. Gardiner, Jeanne du Maurier, with her delightful sensitivity and feeling for the expression of atmosphere and brilliant colour, Midge Bruford, another sensitive painter whose work shows extreme delicacy of handling, Mary Millar Watt, Fred Bottomley, Dorothy Bayley and L.E. Walsh, a fine portrait painter of artistic integrity.

In addition to its general exhibitions, the Society has recently held a number of one-man shows, including those of the work of H. Segal and H.K. Jillard. The Crypt Group Exhibition was held in August in the Crypt of the Art Gallery, being opened by Francis Watson of the British Council. The exhibitors were Sven Berlin, W. Barns-Graham, Peter Lanyon, John Wells, Bryan Wynter, David Houghton, Adrian Ryan, Patrick Heron and Guido Morris. Another feature of the Society's activities has been the holding of exhibitions of travelling loan collections – notably the Albertina Collection, oldest and most important of the great collections of

prints of the past, including the works of Durer, Leonardo da Vinci, Michelangelo, Rembrandt, Titian, etc. A memorial exhibition of the work of Frances Hodgkins, who spent some time painting in St. Ives, was very popular.

The large contribution which the members of the St. Ives art colony make to the important exhibitions in this country and abroad is perhaps far greater than is generally known. It is interesting to consider that during the period 1948–49 dealt with in these notes well over 1,000 pictures have been exhibited by members in exhibitions *outside* St. Ives.

Artists from Cornwall were well represented in the Paris Salon, 1948, which proved to be a show rivalling in excellence those of pre-war years. The exhibitors included Marion Grace Hocken, well known for her flower paintings; Frank Jameson, with a characteristic painting of boats; Marjorie Mostyn, who excels in her portrayal of youth; Tangye Reynolds and Leonard Richmond.

In London there has been a strong Cornish representation at exhibitions of the Royal Academy, the Royal Institute of Painters in Water Colours, the Royal Society of British Artists, and the New English Art Club. At the R.O.I. exhibition notable features were Leonard Fuller's interesting figure painting, Pauline Hewitt's lovely colour, Leonard Richmond's grey landscape, like a sensitive little Corot, and Fleetwood-Walker's artistry in his painting of the nude. Also impressive were the works of Constance Bradshaw, Arthur Burgess, Marjorie Mostyn, Frank Jameson, Bernard Ninnes, Dorothea Sharp, W. Todd-Brown, and Norman Wilkinson.

Among individual shows, Dod Procter's exhibition at the Adams Gallery was well received. Ben Nicholson and Barbara Hepworth have again added to their many successful one-man exhibitions at the Lefevre Gallery; sculptings of Miss Hepworth's have also been a feature of the modern exhibitions at Battersea Park and the Institute of Contemporary Art. Two of the younger artists, Wilhelmina Barns-Graham and Bryan Wynter, have each had encouraging shows at the Redfern Gallery. Misome Peile, had a series of her theatre décor designs (for the Adelphi Players) exhibited at the Manchester City Art Gallery.

DAVID LEWIS

PENWITH SOCIETY'S FIRST EXHIBITION –
1949

At the time it seemed a pity that the motives most secessionists had
for leaving the St. Ives Society of Artists were hysterical and
obscure. They looked neither backward at a disgraceful past nor
forward to a constructive future. Rather, they looked at themselves
– so often a revealing and salutary thing to do.

They found not merely that the spongy amorphousness of bad,
really bad, painting can be physically overpowering but that sterility
in the arts is poisonous (and this was just before Sir Alfred
Munnings made that point patently plain to us). The few good
paintings the St. Ives Society had to show then were relegated to a
corner near the door, as if the painters who painted them were
being forced to make the undignified exits of a number of loutish
gatecrashers – gatecrashers who, anyway, had broken in on the
wrong party. And looking thus at their own positions, they arrived,
each artist more or less by his own route, at that most gentle of
Marxian hypotheses that hostility is more vital than inertia.

But, wisely enough, the equally Marxian tactic of trying to make
the dead live for the purpose of slaughtering it again was rejected
as suddenly as it had been assumed, and the secessionists knuckled
down instead to the sober task of forming their own society (The
Penwith Society of Arts in West Cornwall), of giving it a President
(Dr. Herbert Read), and a constitution, and of finding a gallery
(Fore Street, St. Ives). So apparent lack of motive transformed itself
quickly to one of solving at least an immediate problem, to start a
new series of exhibitions.

The impression that the new society begins where the St. Ives
Society ends is, I think, utterly false. The first of the Fore Street
exhibitions opened on June 18th; and it needs to be regarded
straight away as a complete unit in itself, demanding no outside
reference, working, as it were, pyramidically from the broader bases

of, for the most part, a healthy academicism to a sharp spearhead of experimental painting and sculpture. Commenting on the possibility of such a theme showing itself, one of the exhibition's organizers tacitly suggested that whatever in the way of unification might emerge must be allowed to emerge naturally, unforced. The comment is particularly just. This very first exhibition (allowing for a few canvases of the kind one refuses to look at a second time, inevitable with a largish and partly parochial membership) demonstrates a truly astonishing unity.

The tone of the exhibition as a whole is incredibly modest. But to explain this sense of unity by alluding to the exhibition's muteness is quite superficial, is to reveal oneself incapable of registering its subtler airs. Its modesty springs from a more profound sense of confidence, that the experiments of the last century are slowly being absorbed by a single and vital tradition. Notice that the chasm which twenty years ago would have divided the classical austerity of Ben Nicholson's three canvases from that literary and romantic horse of Bryan Wynter's is closing, for no better reason than they are not any more *fundamentally*, but only *theoretically* incongruous. Notice also that John Wells's landscapes can be seen at last in all the quietude that is their essence, like moths folding their wings. And it is worthwhile moving from W. Barns-Graham's oil of Tregerthen to David Haughton's oil of Zennor and his *Georgia Hill*, thence to Nicholson once again. And it is equally worthwhile seeing Peter Lanyon and Wells in their intimate thematic relation to Barbara Hepworth's two carvings in wood.

PENWITH SOCIETY – 1950

The second Spring Exhibition of the Penwith Society of Artists in Cornwall lacked something of the spontaneous excitement of the 1949 event, which marked the inauguration of the Society.

In a quiet and thoughtful speech Philip James, Director of Fine Arts, Arts Council, briefly but accurately gave a picture of the trend of art today, managing very successfully to put people's minds into the right condition for viewing a new exhibition.

As in 1949 there was much of interest, and once again, quite frankly, the crafts were the most popular item. This is not to decry the paintings, but to emphasise a point. At the Penwith Gallery, thanks to the Society's unusual policy of exhibiting paintings and crafts together on a large scale, there was an opportunity to study the reaction of viewers. Before quite a few pictures they stood in puzzlement, or often amusement and scorn – but before the grey and mottled pottery of Bernard Leach and David Leach, the hand-made furniture of Robin and Dicon Nance, they stood in immediate admiration. Printing is a craft less immediately compre-hended, but here too it is possible for the layman to really see that a type is beautiful or that a layout is well balanced: the exhibits of Guido Morris and Anthony Froshaug provided excellent examples of traditional and modernistic trends in printing.

It is significant, at least judging by this Spring show, that sculpture in stone and wood is also attracting particular attention, for here again there is a more immediate realisation of something made. Few were surprised at the sale on the opening day of a delightful wood carving, *Ballet Dancer*, by Denis Mitchell, for it had life and movement, shapeliness too, all the characteristics of a good carving. By contrast the carvings of Barbara Hepworth, technically (one felt) incomparably superior, lacked such an immediate popularity. For those prepared to make the effort of study and concentration, a

great deal of pleasure and satisfaction is to be obtained from these works. They are difficult, though, for the beginners.

Among the paintings it might not be far wrong to suggest that the best of the lot was also the very smallest – a tiny strip painting by David Haughton, *Houses at St. Just*. As in his larger painting, *Zennor*, Haughton does seem to have attempted, at least with partial success, to penetrate into the iron-and-grey soul of Cornwall. His subdued colours, his bleak skeleton-like shapings, indeed the whole grim simplicity of both his pictures struck home to me more than any of the more colourful landscapes and seascapes. From this criticism I would except Mary Jewels, Tom Early, Ben Nicholson, Peter Lanyon and John Wells, all of whom – though their work does not appeal to me equally – are obviously painters with the serious purpose of capturing the Cornwall that is felt, rather than seen. None of them, however, created quite such a perfect grey picture as J. Coburn Witherop, in his painting, *Polperro*. How different to the usual picture-postcard interpretation!

Portraits were few and far between, and this may have contributed to my enjoyment of those by Leonard J. Fuller and Marjorie Mostyn. There is evidence here of a specialisation in portraiture, which can have its drawbacks – but, oh, what a pleasure to see portraits that were alive and (almost) breathing. A few more might make a better balance to future Penwith shows. In concluding, I was interested in the Swiss drawings by W. Barns-Graham and the little miniatures by 'Fish'; I thought the idea of showing a number of paintings by sponsored non-members a good one carried to excess with the presumptious inclusion of Pablo Picasso; and I missed the gouaches of Bryan Wynter and the sculptures of Sven Berlin, resigned. Perhaps it is only fair to mention here that among other founders of the Penwith Society who have resigned are Peter Lanyon, H. Segal, Isobel Heath, David Cox and Guido Morris. The works of such members are therefore not now on show at the Penwith Gallery, but should certainly be sought out at the artists' own studios.

D. H. LAWRENCE IN CORNWALL
I. LAWRENCE AND THE CORNISH

'We go to Cornwall on Thursday. There is the beginning.'

There is the beginning … And there is Lawrence, in a nutshell, always beginning, always dreaming of that new era of his; always looking towards that colony – in Florida, Italy, Cornwall, Australia, or New Mexico – that colony which would be 'a move outwards into the uncreated future', a modern Pantisocracy.

At this time, the end of December 1915, Lawrence thought that he was on his way to Florida, where a few chosen friends would join him. Meanwhile no time should be lost in starting the new life. It should start in Cornwall. A week later, from J. D. Beresford's cottage at Porthcothan, Lawrence wrote eulogistically of Cornwall and the Cornish:

> There is a rare quality of gentleness in some of them – a sort of natural, flowering gentleness which I love … I do like Cornwall. It is still something like King Arthur and Tristan. It has never taken the Anglo-Saxon civilization, the Anglo-Saxon sort of Christianity. One can feel free here for that reason – feel the world as it was in that flicker of pre-Christian civilization when humanity was really young.

A month later he was less enthusiastic. He was still satisfied with the Cornish scenery, but not with the people. Nature was magnificent – the seas broke against the rocks 'like the first craggy breaking of dawn in the world'; and this comforted him after 'all this whirlwind of dust and grit and dirty paper of a modern Europe'. But what had happened to the people? They had become 'detestable, and yet *not* detestable'; they had lost the sense of magic and the aristocratic mystique which an ancient race ought to have; they had become 'like insects'. 'Not that I've seen very much of them,' he adds,

somewhat ingenuously. (He had been in Cornwall exactly one month.) 'I've been laid up in bed. But going out, in the motor and so on, one sees them and feels them, and knows what they are like.'

He had *felt* what they were like. There is your typical, infuriating, and unmistakable Lawrence. But had he felt what they were like – or had he made the Cornish conform to his feeling?

Like any genius of the prophetic type, Lawrence remained faithful to his intuitive gift; and in attempting to express his sometimes almost inexpressible 'feelings' he was driven to those abominable repetitions, those turgid redundancies, those infuriating pig-headed convictions which no fact could substantiate. But his general conclusions, his prophetic insight, his desperate call to mankind, are unassailable precisely because of their nature. They carry conviction because they appeal to the source from which they emanated in Lawrence – the blood and the heart and the racial memory of man.

Like all geniuses, nothing could satisfy him. He wanted the impossible. The fact that the Cornish country and its people had changed less than almost any other part of England, was not enough. He did not seem at all thankful for the fact that in this outthrust leg of the British Isles much that is 'detestable' in southern England is kicked vigorously into the Atlantic. The man-made scenery, the arterial roads, the metroland architecture, the tawdry seaside resorts, the catchpenny cafés and motorist's hotels – most of this twentieth-century automobile world is left behind when one crosses the Tamar (or it was left behind in Lawrence's day). And there is little significance in pithead machinery or steam-driven vessels compared with the tin in the hills and the fish in the sea and the reckless spirit which has sought them out from one age to another. Scarcely touched by the Industrial Revolution, the Cornish people, a race of fishermen and miners, almost islanded upon their narrow peninsula, never lost their pride or their status as human beings in that fool's paradise of a black gold rush. But this was not enough for Lawrence. 'They ought to be living in the darkness and warmth and passionateness of the blood, sudden, incalculable. Whereas they are like insects gone cold, living only for money, for *dirt*. They are foul in this. They ought all to die.'

They live only for money …I haven't noticed it. I have noticed that Cornish men and women work to live – but that is permitted, I believe, in the most ideal society. The work to live, to extract the matter of their lives direct from soil or seas they plunder for fish, than with all the artificial claptrap of an industrial-ridden twentieth-century England; for they have behind them centuries of fearless men who have gone out daily among jagged rocks and swirling waters; strongly, superstitiously, religious; shrewd, parochial and inbred; strongly independent; but kindly and, above all, leading what I can but feebly describe as balanced lives, taking their just place within the rhythms which surround them, man in control of Nature yet in close contact with it and with the roots of all life.

On the eve of his departure from Porthcothan to Tregerthen, Zennor, Lawrence wrote to Beresford:

> I don't like these people here. They have got the souls of insects …
> They are all *afraid* – that's why they are so mean. But I don't really
> understand them. Only I know this, I have never in my life come
> across such innerly selfish people.

He gives no reasons, of course, for any of his statements – that would be too much to expect; but it is possible that the natural suspiciousness of the Cornish for any 'foreigner' irked him. However, there were very few Cornish at Zennor, he wrote, and 'they seem decent'.

And 'decent' they were, apparently. At any rate, Lawrence liked Tregerthen, and felt at ease there. And when he went up to Bodmin to register, he atoned for some of his former remarks by writing of the Cornish as 'most unwarlike, soft, peaceable, ancient. No men could suffer more at being conscripted.'

The dark features, the round heads and the almost universally lovely eyes of the women and children are nearer to their Breton counterparts than to the English; and although modern transport has brought the English and Cornish closer together, so that the ancestry is often indistinguishable, yet the roots of separatism run deep, for it is but five generations since a Cornish language was

spoken, and there is even now a handful of 'Cornish nationalists'. An insularity both racial and geographic accounts for the clannishness and apparent 'inner selfishness' of the Cornish people.

This 'inner selfishness' is no more than the shrewd self-preservation of a hard-living people intent on scratching a living from the rocks and the soil, with little time, and perhaps little inclination, to speculate on life beyond the border. It is the self-preservation of a small country against a greater; for until comparatively recent times the Cornish knew little, and suspected a great deal, the sophistications of Anglo-Saxon civilization. And when they became acquainted with this civilization, it was through artists, rich affected idlers, speculators, salesmen, and the inevitable tourists who looked for a larger Hampstead Heath in the beautiful Cornish country. The first artists who migrated to St. Ives from London were received with jeers and, on occasion, with stones, by the local fishermen. These good men were amazed at what they, no doubt, considered a completely unnatural, and therefore barbaric, species. If, later, they put away hostility and at the same time found that these colonists and tourists brought money with them, who can blame them?

It was not to be expected that Lawrence, even if he appreciated these facts, would have or could have altered his way of life. And where many who were familiar with the cantankerousness of certain artists were unable to excuse, or even to suffer Lawrence, it was not to be expected that these simple and suspicious people would be able to understand him. However, they accepted him, and no doubt he would either have repudiated his 'insect' gibe, or would at least have applied it generally to mankind, if he had been asked. He was happy at Zennor, happier than he had thought it possible to be in England; and it is possible that he might have settled there indefinitely. But that was not to be.

He had seriously contemplated entering into one of those 'blood brotherships' which were a constant preoccupation with him. The intended partner was a young Cornishman who worked with Lawrence in the Zennor fields. In attempting to explain his purpose and theories to the young man, Lawrence must have puzzled him considerably. No doubt he also provided him with an enthralling

subject of conversation among the villagers, who became increas-
ingly curious and suspicious of this bearded 'foreigner' with his
German wife and weird ideas. There was always the possibility of
finding a particularly curious and daring villager lying within
earshot of the cottage to collect the latest titbit of outrageous
dialogue between husband and wife. And when Lawrence bought a
piano and his wife added to her other provocations and indiscre-
tions a repertoire of German songs, while German submarines were
active in the English Channel, any village in the England of 1917
could have been excused for its suspicions, especially as the
Lawrences' cottage had a flat-roofed turret overlooking the sea, and
a coal boat had been wrecked at the foot of the cliff.

It says much for the local people that the Lawrences remained
unmolested for as long as they did; and when the blow fell, its
instigator appears to have been some half-demented creature who
was a stranger to the district. At first the Lawrences' letters were
withheld and examined. Then their cottage was searched by the
military in their absence; and finally they were ordered, without
explanation, to leave Cornwall in three days ...

A Zennor farmer who recently talked with a friend of mine
described Lawrence as 'that writer chap who was here in the first
war'. I think Lawrence would have welcomed this description, in
which genius and ordinary labouring man are not distinguished by
any acquired refinement, but are regarded as human beings moving
in a landscape which cares little for the achievement of the
specialist, because it is a hard task-master in the art of acquiring a
simple living. For here all life is centred in earth and sea, men carry
the mark of the sun and the clouds in their faces, and live a life
sympathetic to the rhythms of Nature, in whose eyes the transitory
greatness of an individual is no more than an outcrop of rock
thrown up by the ages, and soon forgotten amid the daily toil.

D. H. LAWRENCE IN CORNWALL
II. THE TREGERTHEN EPISODE

In his essay on Edgar Allan Poe Lawrence made, among others, two very revealing statements. 'The central law of all organic life is that each organism is intrinsically isolate and single in itself.' 'In spiritual love the contact is purely nervous. The nerves of the lovers are set vibrating in unison like two instruments. The pitch can rise higher and higher. But carry this too far, and the nerves begin to break, to bleed, as it were, and a form of death sets in.'

There is no doubt Lawrence believed in these axioms. He respected his own inviolability to such an extent that it was his own 'vibrations' that set the pace. Of this he was fully aware. He was a man self-consciously profligate of his moods, acutely effusive, bitter: when he considered himself provoked he was combustibly provocative, when he felt enamoured his passions ran to the extreme of bestowing his all on his friends found in favour to entice them to his side: this last he stretched as far as he could, as if to test the elasticity of illusion. The urgency of a working basis for his vibrations of spiritual accord caused Lawrence to pursue, with astonishing integrity of purpose, his felicitous idea of forming a colony of such 'instruments', somewhere away from the chance of interference. After the Cornish failure (Lawrence-Murry & Co., then Lawrence-Peter Warlock & Co., crashed at Tregerthen) untiringly he chased the idea to Italy, Ceylon, Australia, the Mississippi basin, etc., until finally, in Mexico, he achieved Taos, with Lady Brett.

Tregerthen, 1916, 'our Rananim', was his idea's first failure. Reciprocally, one might blame the Murrys for their part in it. Katherine Mansfield should have known her Lawrence better. She and John Middleton Murry had edited a paper with him previously, for two months in 1915. And his plans were never long cashiered from his talk or his correspondence. She paid for trusting a short

circuit not to shock. Only Frieda Lawrence has left a sweet account of Miss Mansfield's little Cornish visit: 'I see Katherine Mansfield and [J. Middleton] Murry arriving on a cart, high up on all the goods and chattels, coming down the lane to Tregerthen. Like an emigrant, Katherine looked. I loved her little jackets, chiefly the one that was black and gold like bees ... I can remember days of complete harmony between the Murrys and us, Katherine coming to our cottage so thrilled at my foxgloves, tall in the small window seat.' The passage suggests all the suppression-out-of-sympathy necessary to salvage Lawrence, to sweeten the rancour which anyway Katherine Mansfield surprisingly managed to transcend, to resuscitate, if resuscitation be needed, the Lawrentian ideal of human conduct and relationship.

With Lawrence and actuality sat enthroned in magic principalities set uncommonly far apart. His life was not, as he might have had it, spent as a courier passing between the twain; but as a perpetual wanderer in no-man's-land conjuring consolatory images. Had he lived longer his prophetics may have turned into embittered ironies. Possibly quicker to probe, the second time, the truth about Lawrence, in her letters on the Tregerthen failure Katherine Mansfield blamed everything but Lawrence's symptomatic contrariness. One of these, to S. S. Koteliansky, dated May 11th, 1916, about a fortnight after she arrived, reads: 'I have not written before because everything has been so *unsettled*, now it is much more definite ... It is not a really nice place. It is so full of huge stones but now that I am writing, I do not care, for the time. It is so very temporary. It may be over next month, in fact, it will be.'

At this particular moment, March 1916, Lawrence found himself on singularly good terms with J. Middleton Murry. I say this, because of all Lawrence's relationships, in that with Murry he proved most cruelly fickle. Thus, to Middleton Murry and Katherine Mansfield he turns a few days after his arrival in Zennor; from The Tinners Arms on March 5th, 1916, he wrote an hypnotic letter:

I feel we ought to live here, pitch our camp and unite our forces, and become an active power, here, together ... It is a most beautiful

place, a tiny village nestling under high, shaggy moorhills, a big sweep of lovely sea beyond, such lovely sea, lovelier than the Mediterranean. It is five miles from St. Ives, and seven miles from Penzance. To Penzance one goes over the moors, high, then down into Mount's Bay, all gorse now, flickering with flowers; and then it will be heather; and then hundreds of foxgloves. It is the best place I have been in.

We have been looking for houses. There is nothing satisfactory, furnished. And I am terribly afraid to take a big place.

What we have found is a two-roomed cottage, one room up and one down, with a long scullery. But the rooms are *big* and *light*, and the rent won't be more than 4s. It isn't furnished, but with our present goods we shall need so little. One pays so little rent.

The place is rather splendid. It is just under the moors, on the edge of a few rough stony fields that go to the sea. It is quite alone, a little colony.

There are two little blocks of buildings, all alone, a farm five minutes below. One block has three cottages that have been knocked into one, and the end room upstairs made into a tower-room; so it is a long cottage with three doors and a funny little tower at one end … The other block is at right angles, and is two tiny cottages. But it is all sound, done up, dry-floored, and light. I shall certainly take the little cottage. What I hope is that one day you will take the long house with the tower, and put a bit of furniture in it; and that Heseltine [Peter Warlock] will have one room in your long cottage; and that somebody else will have the second cottage; that we are like a little monastery; that Emma is in your kitchen, and we all eat together in the dining-room of your cottage, at least lunch and dinner; that we share expenses. The rent will be very little, the position and all is *perfectly lovely*. Katherine will have the tower room with big windows and panelled walls (now done in black and white stripes, broad, and terracotta roof) and Jack would have the study below, you two would have the *very charming* bedroom over the dining-room; and then there are two bedrooms over the kitchen and pantry. The tower room is not accessible, save from Jack's study.

> There is a little grassy terrace outside, and at the back the moor
> tumbles down, great enormous grey boulders and gorse … It would
> be *so splendid* if it could come off: *such* a lovely place: our Rananim.
>
> Write and tell me how you feel … We mustn't go in for any more
> *follies* and removals and uneasiness …

It is his methods, not the sincerity (singlemindedness of purpose) of
Lawrence's intention that might be questioned. In his selectiveness
he had chosen the vibrations of Middleton Murry, Katherine
Mansfield and Peter Warlock to unite with his own. His next letter,
written after a further three days, shows how thoroughly confident
he was that the citadel was being stormed.

> Really you must have the other place. I keep looking at it. I call it
> already Katherine's house, Katherine's tower. There is something *very*
> attractive about it. It is very old, native to the earth, like rock, yet dry
> and all the light of the hills and the sea. It is only twelve strides from
> our house to yours; and we can talk from the windows: and besides
> us, only the gorse, and the fields, and the lambs skipping and
> hopping like anything, and the seagulls fighting with the ravens, and
> sometimes a fox, and a ship on the sea.
>
> You must come, and we will live here a long, long time, very
> cheaply …
>
> And don't talk any more of treacheries and so on. Henceforward
> let us take each other on trust. I am sure we can. We are so few, and
> the world so many, it is absurd we should be scattered. Let us be
> happy and industrious together …

Should one pause to inspect these two letters it becomes
abundantly clear how Lawrence convinced the Murrys to accept.
Or rather, how convinced they would have been had they refused.
Phrases such as 'dark jewel' referring to St. Michael's Mount, and
'lovelier than the Mediterranean' to describe the Atlantic off the
Cornish coast; words like 'Rananim' and 'monastery' applied to the
Tregerthen group of granite cottages, and skipping lambs and ravens
and gulls applied to the fields; all this cheek by jowl with such

practical details as the positioning of rooms, furniture, Emma, meals, rent, etc., are as obviously persuasional as the illegitimately elysial atmosphere he was at pains to compare, silently, because he was cunning enough to know the Murrys would, with the Murrys' own London background, from which, he would like them to assume, he had, as always, contrived successfully to escape. Europe had been grovelling in its own guts for two years, and there was no indication, then, that the grovelling should not go on, and on and on. But at Zennor peace, solid, pagan peace. Houses close to the earth, work to be done, work started and not complete. Katherine Mansfield was in the habit of saying 'I don't want to earn a living, I want to live!'

Here the Murrys are blameworthy also. During October and November of the previous year, 1915, Lawrence, Murry and Katherine Mansfield combined in editorship to produce three numbers of a periodical they called *Signatures*. 'It was a thin, tan-covered pamphlet, written entirely by the editors, and was published by subscription only, price 2s. 6d. for six copies … Of the 250 printed, 120 were destroyed. Katherine Mansfield wrote under the *nom de plume* of Matilda Berry and contributed three sketches, of which two were collected in the volume entitled *Bliss*.' Undoubtedly the perennial difficulties that bestride under-capitalled papers (there was a small-time Jewish printer, an office with sparse furniture) would of their own have caused the paper's death. But that the editors temperamentally backbit into the bargain is hinted at, darkly, but quite plainly, in the two letters I have quoted, leaving them all 'uneasy' afterwards, a feeling Lawrence was longing, of course, to obliterate. Years later, in his autobiographical piece *Reflections on the Death of a Porcupine*, published in 1925, he made his parting gesture of forgiveness, for that, and presumably for Tregerthen too, by omitting to mention his and his collaborators' wounds.

When *Signatures* failed Katherine Mansfield left London for Bandol, southern France, to escape the worst of the English winter. She was a very sick woman, dying, almost imperceptibly, of consumption. So that, for instance, Lawrence's breathless

comparison of the Cornish seas to the Mediterranean – made, mark, in March – was not merely poppycock but (Lawrence was no purposeless liar) a deliberate delusion. His 'few rough stony fields' give scarcely the impression of fields broken through by ominous boulders floating in their deep greens like icebergs, an entire coast of *carns* and cliffs charged with winds and sea rages. The spindle-grass moors he engarlands with foxglove and gorse, and says nothing of the cold gales and uncomfortably wet descent of mists. He speaks of the cottages assigned to the Murrys as big-roomed and dry, yet the room Katherine Mansfield, the consumptive, was to take as her study, the Tower, leaked so much it was considered uninhab-itable, until a few years ago, when its flat roof was replaced by the pitched roof it now wears. The thing about the affair to italicize is Lawrence's energetic confidence that once he got the Murrys to Cornwall he could persuade them to put up with these and whatever other appalling discomforts a prolonged stay in 'Rananim' entailed by conscripting them as instruments in his essential spiritual love. As an isolate organism Lawrence also was selfless. By removing his jacket and cleaning out the house from ceiling to doorstep, he showed his good faith. It is said that no one scrubbed like Lawrence. And he got Frieda to festooning the staircase to the Tower with a 'jolly adornment' of painted flowers.

But if Miss Mansfield should have known her Lawrence better, Lawrence grossly misjudged his feminine Miss Mansfield. Following her letter to Koteliansky she wrote to Beatrice Campbell:

Today I can't see a yard, thick mist and rain and a tearing wind. Everything is faintly damp. The floor of the Tower is studded with Cornish pitchers catching the drops. Except for my little maid (whose *ankles* I can hear stumping about the kitchen) I am alone, for Murry and Lawrence have plunged off to St. Ives with rucksacks on their backs and Frieda is in her cottage … I feel as though I … have drifted out to sea – and would never be seen again.

Again to Beatrice Campbell:

Nothing but the clock and the fire, and sometimes a gust of wind breaking over the house. This house is like a ship left high and dry. There is the same hollow feeling. The same big beams and narrow doors and passages that only a fish could swim through without touching. And the little round windows at the back are just like portholes …

To Lady Ottoline Morrell a week later:

We are going to leave here as soon as we can. We are at present looking for a little cottage where we can put our pieces of furniture for we must have a tiny home and a garden and we must live again …

Before May was out the Murrys had moved to Mylor, near Penryn. Lawrence went with them most of the way, helping them with the stuff and preventing too deep a rupture in their relations:

Lawrence has gone home again. We walked with him as far as the ferry and away he sailed in a little open boat pulled by an old, old man. Lawrence wore a broad linen hat and he carried a rucksack on his back. He looked rather as though the people of Falmouth had cried to him as the Macedonians did to Paul, and he was on his way over to help them.

Nonetheless, Lawrence was injured. His epitaph on the episode was bitter.

Unfortunately the Murrys do not like the country – it is too rocky and bleak for them. They should have a soft valley, with leaves and the ringdove cooing. And this is a hillside of rocks and magpies and foxes.

JACK R. CLEMO

THE SHADOW (TO D. H. LAWRENCE)

There was a day
When I slept unknowing, an infant here in Cornwall,
And you passed so near, your living breath
Terribly near me, and your shadow
Upon the unconscious seed for the brief touch,
The impress and delineation
Of its stain and flow within the fixed channel
Where yours had fretted and was rousing still,
Ablaze for potency. And the shade
Of your passing was marked by Fate, the dire dual course.

For there were hours in after years
When I felt the vague stirring, the bruise
Of the dark unrest around Tregerthen.
It came up with the west wind
And with the amorous mists when the grey peaks
Of my clay-dumps sank to oblivion.
And I felt the chill fear
Lest your end should be mine and a strange god find in me
His way to Isis in her Cornish form, Isis
Of the grit-hard mystery,
Isis of the crag-clotted womb,
And my night-black pit become
A shrine where the unknown god might heal his wounds
In the intimate lapse.

This was my fate, I knew, unless the cleared veins
Of my clay were given back, and the clear skies
Showed the live mood, the untiring purgation
Breaking the natural channel, peeling

Your shadow from the slit cliff.
And the fog lifted, the wind changed course.
I was not deceived in my vision;
I was not for Celtic Isis or the gods
Of your stricken shade, but for the Word
And white light on the breasts.

IMPREGNATION

Youth's tide was sluggish: but a sudden fire
Like soft June lightning makes the waters heave,
Illuminates their bounds, burns weeds that weave
A net of death for her untaught desire,
And bares my vision of the sea-bed mire
Beneath us, where there is no God to grieve
Over dead bones of lovers. Storms bereave
Young hearts, strange growths entice them if they tire
In this vast sea of passion. Why is ours
A fate so different? Nature's sky is grey
Above us too; we know there's heat that sours
The jaded currents. Yet both worlds obey
The Word of fire that cleanses and devours,
Taming the alien courses of the clay.

JACK R. CLEMO

INITIATED

No, I am not afraid
To trust this sign
Of nuptial corn and wine.
Let the sullen grit descend
On the miraculous blade,
It will not bend.
Let the refuse fumble and fume
Where the fiery seed lies hid –
We shall feast beyond the gloom
Of the cold pyramid.

Let the field be fenced from me,
The winter wash of gravel foul the road
Where her guileless gesture showed
The gate to fertility –
I trust and affirm:
When the destined flash recurs
We shall be there, beyond grit and worm,
Where the full harvest stirs.

J. W. SCOBELL ARMSTRONG

JOHN OPIE, RA

The modest object of the present article is to explore somewhat further than has yet been done a single short period of Opie's life, namely, the last years before he left Cornwall and went with Walcot to London; for it is to his work during this period that his fame was initially due, and competent critics have thought that none of his maturer work as a portrait painter surpassed the best of his achievements during those years. Owing to the fact that most of his early portraits still hang in the secluded country seats in Cornwall, where they were painted, Opie's genius as a boy has not been fully realized. He is known chiefly through his later painting, which, fine as much of it was, never had quite the same *élan* as is shown in his earlier work.

In these days, the world is so ready to welcome the youthful prodigy, and to stifle his budding genius with its embraces, that the eulogies poured upon him when he first appears must always be taken with more than a grain of salt. In the eighteenth century, however, the road to recognition was far harder and steeper than it is today, and one may therefore safely assume that there were good and solid grounds for the widespread chorus of admiration with which the rising of this new star in the world of art was greeted in 1782.

We find the Cornish boy painter described in that year by art reviewers as 'this wonderful youth … beyond even Rembrandt,' as 'a genius whose works rival the greatest masters ancient and modern,' as one from whom 'we hope that Sir Joshua Reynolds will take some lessons.' Nor is it the opinion of art reviewers alone that is involved. Reynolds himself made two recorded comments on the young artist's qualities at this period, which abundantly confirm the general view as to the merits of his work, describing him to Northcote as 'like Caravaggio but finer,' and saying of him on another occasion, 'This youth begins where most artists leave off.'

Since it can hardly be contended, even by the warmest admirers of Opie's later work, that, fine though it be, it wholly justifies the extravagant prophecies current with regard to him in 1782, one is curious to know a little more than the biographies contain with regard to those early works which gained for him as a boy his appellation of the 'Cornish wonder'.

Opie was born at St. Agnes, near Truro, in May, 1761. His first attempt at painting in childhood seems to have been in some degree inspired by jealousy, which Fuseli, rightly or wrongly, held to be the dominant trait of his physiognomy in later life. At the early age of ten he felt a strong desire to outshine a schoolmate who had gained some celebrity in the village by his clever painting of butterflies. Little John made the attempt and succeeded. A year or two later he did a portrait of his own father, having, it is said, first irritated the old man to such a degree as to secure a thrashing, and this, for the express purpose of getting the proper sparkle and fire into the eyes of his unwilling and intractable subject.

In 1775, at the age of fourteen, the boy first came into contact with Wolcot, who had at that time just set up a practice as a physician in Truro. The contact seems, in the circumstances, to have been so startlingly opportune that many might regard it as an instance of divine intervention in human affairs. Every obstacle had been placed in the boy's way, for his father strongly objected to his becoming an artist.

It is recorded that shortly after his discovery by Wolcot the boy 'painted a portrait of a parrot walking down from his perch so cleverly that the artist received the greatest compliments that possibly could be paid to him by all the parrots in the town continuing to notice it whenever it was presented to them.' Not very long after his introduction to Wolcot, Opie began his career as a travelling artist, charging at first 7s. 6d. each for his portraits, which modest demand was soon, in deference to the advice of Wolcot, increased to half a guinea. In 1778, the boy, who had been unwell, was invited to the Place, the country seat of the Prideaux family, near Padstow, where he was put in charge of the housekeeper to recuperate. While there he painted the whole household, including

the dogs and cats, and returned home in a smart suit with twenty guineas in his pocket.

In the following year Wolcot moved to Helston and took Opie with him. By this time the latter had so far advanced in his art that he was able to obtain a guinea each for his portraits from well-to-do sitters. During the next year and a half, and before he had attained the age of twenty, he painted nearly all the best of his early works. Of his last achievements before leaving the west country, Farington writes thus, in his diary while at Exeter in December 1810:

> I afterwards went with Mr. Patch to the Hospital where I saw two portraits painted by Opie, one a half length of the late Dr. Glass of Exeter, who first prepared magnesia, the other a three-quarter of the late Mr. Patch, the surgeon. These portraits were painted by Opie while on his way from Cornwall to London before he had seen any other works of art but those he had met with in Cornwall and Devonshire, yet are these pictures, especially that of Mr. Patch, equal in merit with those which he executed in the latter period of his life. It would perhaps not be going too far to say that the portrait of Mr. Patch is both in respect of drawing, close attention to nature, and care in execution, one of his best pictures, having more truth and delicacy in it and less of manner such as every artist has more or less of after long practice.

It is probable that the first house in which Opie resumed his activities as a painter, after his arrival at Helston, was the neighbouring Cornish mansion of Penrose, whose owner, Mr. Rogers, one of the largest landlords in the county, became one of his most helpful patrons. After painting a number of portraits in the Helston district, the boy decided to go further afield. Passing through Penzance, he found his way to Castle Horneck, the ancient country seat of the Borlases – to whom he probably bore an introduction either from Mr. Rogers or Lord Bateman. Here he seems to have been well received and liberally patronised. Captain Samuel Borlase, the then owner, was just the sort of sitter whom he liked painting – a man of striking features and strong personality – one who had, not many

years before, with a handful of militia, rescued the stranded ship *Mercy* from a mob of tinners in Mount's Bay, and had received a silver rapier from the American owners in recognition of his gallantry.

It is probable that, after leaving Castle Horneck, the young artist proceeded along the old coast road towards the Land's End, and on reaching the neighbourhood of St. Buryan, presented himself at Boskenna, the last country seat of any size in Cornwall. His portrait of its mistress, the aged Mrs. Paynter, is an example of Opie at his best. He has often been reproached, not perhaps unjustly, with lack of tenderness; but if that defect made itself apparent at times in his later work, it may confidently be said that few painters have ever painted old age with greater tenderness than Opie did in those early years. His portrait of Mrs. Paynter is a good illustration of this, and the portrait which he had recently done of old Kneebone of Helston is another striking example of his understanding of the old. This last is owned by Mr. J. A. D. Bridger, who also possesses an interesting letter written by the artist to his mother just after his first interview with the King.

About the end of 1779 Opie found his way to the little village of Sancreed. The vicar, Mr. George Pender Scobell, a kindly ecclesiastic with a comfortable income of £1,500 a year derived from the two livings of Sancreed and St. Just, either took him in at the Vicarage or found quarters for him near by. Here Opie stayed for some time, painting no less than seven members of the Scobell family. The Scobell collection is of considerable interest in that it shows Opie at his best and at his worst – revealing, in a striking way, both the merits and defects of his painting and of his character. Thomas Lawrence writing to a friend with regard to Opie's picture of the *Death of Rizzio* in 1787, says:

> He has studied, and that to a great degree, the beauty of chiaroscuro and fine colouring, but has not, I think, sufficiently attended to the great end of painting – the expressing with truth the human heart in the traits of the countenance.

In three, or possibly four, of the Scobell portraits, Lawrence might have found abundant confirmation of his criticism; but in the others he would have found none. Opie's portrait of little George Scobell, a rather plain child, is full of tenderness and comprehension, and has a striking freshness and vitality. Probably, however, the most remarkable thing in the collection is the face of Mrs. Scobell looking down at the baby in her arms. She, too, was plain, but Opie, who loved his own mother, was able to discover 'the intention of her soul' and to paint it. When he came to the baby itself, his *modus operandi* was very different. Boylike, he evidently did not think a baby worth painting, and had no hesitation in indicating this view on his canvas. It may be of interest to note that this baby afterwards became Colonel John Scobell, and was painted in early middle age much more creditably by the younger Opie, who, just as his great-uncle had done in an earlier generation, painted the whole family, who were then living at Nancealverne, near Penzance.

Opie's next best performance at Sancreed Vicarage was his portrait of the handsome, sulky-faced younger brother of the vicar. This portrait is painted with sympathy, and is very much alive. When he came to the vicar's two sisters the young painter evidently found his work far less congenial. Of 'Mary' he painted a stiff and rather unkind portrait, which is, however, by no means without merit. 'Melloney,' a strikingly handsome girl, fared much the same at his hands. His portrait of the elderly John Scobell, the vicar's uncle, has little to recommend it. The boy's patience with his sitters was evidently by this time exhausted. The vicar himself seems to have been the last straw.

Opie's portrait of the last-mentioned, when looked at side by side with the first three portraits above referred to, hardly deserves to be called a portrait at all; it is little more than a perfunctory representation of a pink-faced cleric with eyes resembling gooseberries. It would never occur to any casual observer that the portrait of Mr. Scobell and of his little son were painted by the same hand. The vicar, from what is known about him, can hardly have been quite such a nonentity as he seemed to Opie, and it is strange that an

instinctive sense of obligation did not lead the boy to make a better effort for one who had proved so appreciative a patron.

Of his movements after leaving Sancreed Vicarage nothing is known. It is not recorded whether he continued his wanderings, or whether he returned to Helston and resumed them afterwards. His pockets being by now well lined, he probably desired to select a model for himself without regard to pecuniary advantage and to paint someone who seemed to him really worth painting. Such a person he not long afterwards found in Mr. Quick, a 'humble parishioner of Zennor' that romantic and remote little village which lies in a fold of the hills on the Atlantic coast not far from St. Ives. His portrait of this rugged old Cornishman is, in the opinion of the writer, one of his masterpieces. It was bought by Mr. Rogers of Penrose.

Early in 1781, Opie left Cornwall, and travelling with Wolcot to Exeter painted a number of portraits in that city and its neighbourhood. Thence the pair proceeded to London, where they arrived in November. Very soon after they had taken up their quarters in Orange Court 'the enjoining streets became thronged with carriages filled with the highest rank and beauty to sit to the Cornish wonder.' It has often been told how the boy was made a show of and decked in outlandish attire by that artful advertiser Wolcot. The latter, who, however great his merits as a critic of art, was little qualified in other respects to be a mentor of youth, designedly made no effort to improve the manners of his *protégé*, who was himself by nature unadaptable, yet sufficiently clever and sensitive to feel the indignity of his position acutely and to resent it.

The remainder of Opie's life does not fall within the scope of this article, but a word must be said in conclusion as to the effect of his emigration from Cornwall upon his character and subsequent work. In 1785, the *St. James's Chronicle* laments the falling off in Opie's painting, which it ascribes to the flattery of Sir Joshua and others. This criticism is unfair to the painter. His was not the kind of character that could be spoilt by praise. He was very diffident of his own powers, and suffered all through life from what would be called to-day an inferiority complex. Courage and pertinacity he

most certainly possessed in a high degree, but in later life, after he had been transplanted from Cornwall, he seems to have become intensely self-critical. This diffidence of himself may well explain the fact that, great as were his achievements in later life, his native genius did not survive undamaged its contact with the schools.

Although, at his best, he was undoubtedly one of the finest painters of his age, one cannot help wondering whether he might not have become an even greater one had he never crossed the Tamar. Plunged into a puzzling and uncongenial environment, superciliously patronised and subsequently dropped by smart folk who enjoyed the novelty of being painted by a young barbarian with a green feather in his cap, despising his new patrons, most of whom were persons of social rather than mental distinction, it is not surprising that he grew harsh and bitter. What is really astonishing is the fact that in such surroundings and faced with such temptations he still continued to pursue his art with so much perserverance, truthfulness and sincerity. He was probably just as anxious to excel his more popular rivals as he had once been to excel his little school-fellow at painting butterflies: but this ambition never induced him to swerve by a hair's breadth from the truth as he saw it. He would under no condition paint people as they wanted to be, and not having sufficient sympathy and insight to discern the 'intention of the soul' in an outwardly insignificant countenance, he did not always do justice to them as they were. He was in his painting, as in his conversation, entirely natural and free from affectation, a quality as regards which Samuel Rogers, the poet, who was no mean critic of Art, compared him favourably with Lawrence.

An illustration of the contrast between Opie's later and earlier work is to be found in one of his last portraits, that of Mrs. Armstrong. At the time of his death, it was lying in his studio waiting for the hand to be finished. His sitter in this case was a young Quakeress of rare beauty. The freshness of the skin and sweetness of the eyes he has portrayed with great tenderness and delicacy. She had, however, something more than beauty: she was a woman of strong intellect and wide culture. There is no hint of this in the portrait.

In 1807 the painter's career was cut short by death at the comparatively early age of forty-five. To the last he was working with the same determination and desire for self-improvement that had marked him in boyhood.

When Wolcot, on first meeting the young genius from the sawpit, asked him how he liked painting, the lad's dark eyes lit up, and he replied with startling enthusiasm, 'Better than my bread and meat.' If, as he lay dying, the angel of death had asked him the same question, he would probably have given the same answer with the same fervour.

IVOR THOMAS

COUNTY OR COUNTRY?

The train journey down from London is a tedious business, especially after Exeter. It is not merely that the traveller is tired and the hours seem to go more slowly. It takes half the train time to cover the final third of the distance. For at Newton Abbot we leave behind for ever those level stretches, so inviting to the railway, which beckon the traveller westward past the chalk and limestone scarps of Wessex; and we are carried high over one valley after another barring our progress farther into the fastnesses of these denuded mountains of Armorica. Those viaducts are a lasting monument to European engineering skill ('European', since the greatest was a Frenchman). The valleys which they bridge are at once the key to the character and the disunity of the South-West. They are always barriers and rarely routeways, for the roads of the South-West are ridge roads. They stopped the Roman and, for a long time, checked the Saxon penetration of the peninsula, and made road-building so hopeless that the railway virtually followed the pack-horse instead of the wheeled vehicle. But while their upper courses hindered human intercourse, their lower reaches were drowned by the sea, and, until the railway came, the only level roads were sea-roads. The sea was the highway along which the South-West trafficked with the rest of the world.

This land of wind-swept moor and sheltered creek is the 'Cornouaille' of the French geographer. It was probably the region over which a fifth-century Artorius assumed the leadership in the wars against the invader. There is a tradition that Totnes was once its capital, and to-day Plymouth is its unquestioned centre, a city just as Cornish as it is Devonian.

The modern regional administration of Devon and Cornwall from Bristol is artificial. It perpetuates the annexation of the area by Wessex in the Dark Ages, and is no more effective. The South-West

is quite another region from the West Country. How true this is was evident to any one who listened to the B.B.C. series 'The West in England's Story', with a prior knowledge of the South-West's history. Equally, the effectiveness of the Tamar as a boundary has been much exaggerated. North of Launceston it never stemmed the tide of Saxon colonization, and the upper Tamar basin to-day is much more within the orbit of Devonian Exeter than the rest of Cornwall. South of Launceston it is plainly the boundary between Saxon and Celtic place-names. The large majority of these names go back a thousand years – so that it *was* an effective natural frontier. But to-day this deepest of south-west valleys, crossed as it is by bridge and ferry at a score of points, unites rather than divides the people on its banks. The villages and small towns of south-east Cornwall are dormitories for Plymouth. Their inhabitants speak a dialect regarded as 'Devonshire' by the West Cornishman; and they themselves, when travelling west, say they are going 'down Cornwall', as if the Fowey and not the Tamar were the county boundary. At least the Fowey has fewer bridges. It is the cumulative effect of a succession of nearly parallel valleys which makes the South-West, and especially Cornwall, in an increasing degree as one travels westward, a region difficult of access. The moors are more easily crossed as long as they are not snowbound. And it is these same valleys which give the South-West its parochial character, and have made it impossible for any one Cornish town to dominate the others.

The annexation of West Wales, as our region was known to the Saxons, took place between the eighth and the tenth centuries. By the end of the eighth what is now Devon was a part of Wessex, and by the end of the tenth (or early eleventh) Saxon (later Norman) landowners were firmly established in the far west of Cornwall. Binnerton, Connerton, Henliston (Helston) and Wineton (Gunwallo) were royal English manors. For centuries a Celtic language, a Celtic system of land tenure, and a variety of Celtic customs continued in much of Cornwall, and always a strong sense of moral, if not legal, independence, to be demonstrated in the rebellions of 1497 and 1549, in both of which Devonians joined.

English influence in Cornwall is as old as England itself. It began during those formative years when the various kingdoms of Anglo-Saxon Britain were struggling towards unity, and Cornwall has always been an integral part of England. Its upper classes have always spoken the language of the English court, and education, where it existed, has always meant education in English. Cornish remained the language of the masses up to the seventeenth century, but Cornish literature hardly existed.

In the sixteenth century a Welsh king of England brought about the union of England and Wales. With the rise of Tudor England to a position of leadership in Europe, English influences in Cornwall were strengthened. Cross-Channel ties with Brittany, which had lasted since the Cornish colonization of the fifth century, weakened, and the intellectual gulf between Cornwall and its earlier 'Atlantic' associates, Ireland and Brittany, widened with the years. There was a large immigration of Welsh miners into Cornwall at this time. Another wave of Welshmen came in the eighteenth century, and it was in this century that Methodism triumphed in both Wales and Cornwall. To-day both are Radical and Nonconformist, while Southern Ireland and Brittany are Reactionary and Catholic. The mining element in the populations of Wales and Cornwall, and its absence in Southern Ireland and Brittany, is probably a controlling factor. In Cornwall it has always been the miners who have taken the lead in intellectual matters, whether in inventiveness during the early Industrial Revolution, or in their active interest in the Workers' Educational Association in recent times.

Cornishmen rebelled four hundred years ago when the English Prayer Book was imposed on them. Yet the adoption of the English language was among the greatest of their blessings, and very few Cornishmen have any interest in the revival of a Celtic language. English is the Cornishman's mother tongue. It has been his passport to the greatest literature in the world, and with it he has taken his unparalleled skill as a mining engineer to every corner of the world. The great majority of Cornishmen are, in fact, scattered about the earth. They are deeply conscious of their identity, and filled, it

seems, with a nostalgia for everything which reminds them of Cornwall. By their contact with other people they have come to realize their distinctiveness. So they form their Cornish associations, sing their Cornish songs, eat pasties and saffron cake (which we no longer can, except in austerity form), and amuse each other with dialect stories and plays. Notice that. It is *English* dialect which these exiles love. Few of them have any interest in the Celtic language of pre-Reformation Cornwall.

The Cornishman who has stayed at home is not really aware that he is in any way different from other Englishmen. Least of all is he conscious of being Cornish. A Camborne man, a St. Ives man, yes, but not *especially* a Cornishman. 'Furriner' is only used in jest now, and formerly the next parish was just as foreign as any place beyond the Tamar. But much that he says in fun is taken in deadly seriousness by the 'visitor' of many years standing, especially if his 'holiday' has been spent in one of those parasitic seaside 'Chinatowns' where nothing is Cornish except the air they breathe and the food they eat. Most Cornishmen are suspicious of those who declare they are not English. They regard as cranks both the sentimentalists with their dialect stories and outworn superstitions, and the more academic with their serious researches into language and history. To the average Cornishman a Breton is just as much a foreigner as any other Frenchman. A Welshman is to be distrusted as much as a Londoner – and that, in Cornwall, is saying a great deal! A generation ago Camborne was 'up-country' to a St. Just man, but to-day a Devonian is a sort of close relative (especially if he's an Argyle supporter) who happens to live on the other side of the Tamar, a river crossed twice daily by thousands of Cornishmen, and of no more significance to them than the Fowey or the Fal.

All this is as it should be. We are living in days when the size of human societies is expanding, ever widening to include larger areas and bigger groups of people. Regional councils may soon replace county councils, and Devon and Cornwall, or the South-West, is a compact region with a personality all its own, essentially British in its Anglo-Celtic character. Plymouth is the regional capital, the sign and symbol of its unity.

Our common British heritage is the result of the fusion of English and Celtic elements, the latter probably increasing westward and northward. Nowhere can we draw a line and say 'Here is Celt and there is English'. That union exists even in the remote fastnesses of the western highlands, and failure to recognize it has produced the narrow retrograde nationalism of so many Celts. Our way lies forward and not backward. For four hundred years our Anglo-Celtic heritage has been transmitted through the medium of the English language. We should use our historic associations with the Atlantic pockets of Celtic culture as bridgeheads towards a United Europe, and not as avenues of escape from the realities of the present to the narrow unreality of a Celtic ghost world.

CHARLES CAUSLEY

SERENADE TO A CORNISH FOX

As I sailed by the churchyard
All on my wedding day
The bells in the seasick steeple
Leaned over the side to say:

'Hurry to the harbour sailor
Fetch the parson by noon
Or the fox will lie with your lover
Under the sheet of the moon.

'Polish your ring, my captain,
And crease your trousers well,
Take your crack at the tiller
Or you'll crack your wedding bell.'

But the sea is the matelot's mistress
With her big blue baby eyes,
And many a master's ticket
Has she torn in two for a prize.

Many a mariner's compass
She has boxed with her watery hand,
As the fish jumped over the mountain
And the ship sailed over the sand.

Into the fleets of morning
Under the guns of day
My ship sailed out of harbour
All through the dancing day.

Down by the springy river
Down by the shrieking locks,
Watching love die like a doctor
Is the patient Mr. Fox.

Down in the waving meadow
Under the hanging tree
He is waiting as my lover
Comes weeping in from sea.

See in her hand are flowers
Of rosemary, and bay
Bright as the faithless water
That took her love away.

Mr. Fox, your topper is handy
So put it over your ears.
Take the lace out of your pocket
And dry her innocent tears.

Your coat is made of satin,
Your wallet as gold as a harp,
The gloves on your delicate fingers
Hide your nails so sharp.

O whisper the sea is randy
And runs all over my head!
That she pulls me all so willing
To her oozy marriage bed!

Farewell my love, my honey
As my ship sails through the dark,
They have said the same of sailors
Since Noah built the ark.

May your daughters wear like diamonds
Their virtue at their throats.
May your sons, like brave sea-bandits,
Never take to the boats.

Only the fool or the poet
Cuts down the flashing tree
To burn its belly with fire
And take to the jealous sea.

CHARLES CAUSLEY

SONG OF THE DYING GUNNER AA1

(To John Betjeman)

Oh mother my mouth is full of stars
As cartridges in the tray
My blood is a twin-branched scarlet tree
And it runs all runs away.

Oh *Cooks to the Galley* is sounded off
And the lads are down in the mess
But I lie down by the forrard gun
With a bullet in my breast.

Don't send me a parcel at Christmas time
Of socks and nutty and wine
And don't depend on a long weekend
By the Great Western Railway line.

Farewell, Aggie Weston, the barracks at Guz,
Hang my tiddley suit on the door
I'm sewn up neat in a canvas sheet
And I shan't be home no more.

A. L. ROWSE

CHARLESTOWN HARBOUR BY MOONLIGHT

Dear Hardy, dear spirit, dear ghost,
Here I come, worn out with moil and toil
With cark and care you knew so well,
Down by the water's edge to the little port
Lit by the light of the moon in late September,
To refresh the spirit. Giving myself up to watch
The cruel crawling sea that creeps towards me,
The moonbeam, the moontrack pointing where I stand –
Where the quay's neck joins on to the land –
Absorbed by the spectacle of moon and sea.
The blunt dark nose of Napoleonic fort,
Gull Rock, Trenarren and Black Head in échelon;
The lights of Polkerris answer the lights of Trenarren,
The dear delicious days of the war over at last,
Though the beat of returning bombers at sea
Awakens nostalgia, the rumour of apprehension.
Far out, the Eddystone and the horizon
That beckons ever on and outward
To illimitable seas of boyish adventure.
Turning round, I confront the harbour,
The little boats dipping and plunging,
Jibbing and slacking, bobbing and bowing,
That keep perpetual dance
With the pull and motion of the tide;
Coastguard Terrace and the old cottages
Moonwhite moonblue in the ebb light.
Beyond, the hills of home, with that
Inextinguishable reference to the heart
That speaks of innocence, purity and hope,

Lost innocence, lost purity and hope
That yet means happiness now:
And over all, the inscrutable comment of the Plough.

SPRING AFTERNOON AT CHARLESTOWN

Behold the gulled and gorsed rocks,
Afternoon honey in keen wind sunlight
Myself on an ultimate stone
A water world about me
All movement and wind and sea
Bobbing seaward flotsam and spars
Waves heaving and dipping
Making uncertain the Napoleonic land
Little port with deserted fort –
Beyond, ranked and ranged headlands
Trenarren, Chapel Point and around to Dodman
The Gribbin milk-haze in sea-mist
White peninsular coves along the flank
The erect forefinger standing serene
Over the ebb and flow of tides
Over the bell-rung flowered sea.

H. J. WILLMOTT

CHARLES LEE

When Mr. Sven Berlin writes [in the first number of *The Cornish Review*] that he has found Cornwall among the most primitive of places, he says plainly and truthfully what some say furtively for fear of giving offence. Yet there is nothing offensive in the description. The long peninsula (still remote from the rest of England), the bare granite moorlands and their craggy tors, Stone Age and Iron Age remains, round barrows, hut circles and monoliths, traces of the habitations of ancient but not quite uncivilized man; the sea-thrashed coastline and the little ports where the fisher-folk and their neighbours still live a kind of tribal life in mingled co-operation and conflict with sea and weather – this environment and the elemental forces have moulded the character of the Cornish people. It is not surprising, therefore, that they combine strength and ruggedness of character with an innate shrewdness and cunning, naivety with subtlety, fire and ice in the same temperament, taciturnity with a love of rhetoric, candour with caution, and openheartedness with an ability to shut up oyster-like in an instant if the visitor seems about to take a liberty. It is in the sense of belonging to one of the oldest surviving racial elements of which the British people are compacted and living in the most anciently civilized and industrialized part of the British Isles that the Cornish people can be described as primitive – as Mr. Berlin and many another creative artist and creative writer have discovered.

This is all of importance in considering the work of Charles Lee. Between fifty and sixty years ago, in his early twenties, he came to West Cornwall to study the Cornish people, to live side by side with Stanhope Forbes, Chevallier Tayler, T. C. Gotch, Frank Bramley, the Birches (Lamorna and his namesake) in Newlyn. Whether Mr. Lee came to Cornwall in order to gather material for

novels – for he disclaims any intention of being a creative writer –
or whether he regarded himself as a kind of literary anthropologist,
in the result he wrote several short novels about the people among
whom he stayed and came to love and understand. The remarkable
thing about him and his work is that he has not written a novel
since he completed the long unfinished *Dorinda's Birthday* nearly
forty years ago; nor, so far as I know, has he written any book that
is not Cornish. Mr. Lee is one of the rare examples of a born writer,
whose work has an enduring quality, who has confined himself to
one county and whose creative talent flowered only in his young
manhood. Perhaps he was wise in disbudding any later growth; in
rejecting the temptation to go on writing according to pattern after
the first freshness of his talent had faded or become – as with some
writers – fat and flabby. Yet how big a hand he has had in helping
to get other writers' works published it would be difficult to hazard;
he reads for a distinguished publishing firm, and his pleasant
Hertfordshire house (where I have been privileged to meet him and
his wife) still proclaims by its name – Lanvean – his love of
Cornwall. Indeed, the name Lanvean testifies to his delight in the
village of Mawgan-in-Pydar, where he lived for a year. There he was
organist at the beautiful tree-girt church, so rich in its memorial
brasses and notable also for the four-sided, elaborate cross of
cataclewse stone in the churchyard: each of the sacred figures carved
within its arch of the lantern-stone. Mr. Lee had so happy a year at
St. Mawgan, where he was a friend of the Brydges-Willyams family,
that he named his house after a St. Mawgan place name. And it is
not difficult for those who know the village and his stories to see
the influence of St. Mawgan in at least one of his idylls.

Rather as the careful Arnold Bennett did in his passion for
accuracy in description and dialogue, Mr. Lee took notes of what
he saw and of the gossip he heard as he sat in the cottages where
he stayed. It was as 'a chiel amang ye takin' notes' that, as a mixture
of reporter, anthropologist and literary artist, he recorded Cornish
people's habits, their nuances and tricks of speech, and so gave his
tales their authentic savour. From this mass of notes in his pocket-
books he selected the material for his stories. There must be an

immense variety of notes which have never been, and perhaps never will be, published – just as he has cast into oblivion an old story of his, published in an almost forgotten magazine, in which he wittily dealt with some of the figures of the Newlyn art colony in the 'nineties. It is true, I think, that Mr. Lee was most sure of himself and his gift for delineation in rendering into his precise prose the lives, customs, habits of speech, and fun and games of the working and lower middle-class people of Cornwall. Clear-cut as is his portrait of Mrs. Pollard, who is *The Widow Woman*, she is rather a figure of fun. Indeed, in his limning of his women characters, Mr. Lee is less kind than in presenting his men: yet the women in his stories live quite as vividly as do the men.

The Widow Woman, that diverting novel of prosaic middle-aged love, convinces most of its readers – it convinced even Q himself – as an authentic cross-section of life in Newlyn between fifty and sixty years ago. Mr. Lee does more than that. He shows us the set pattern for behaviour in the Newlyn (Pendennack) of that time; and it was because the conduct of the comfortably bodied and moneyed Mrs. Pollard – a little like that of the female spider in setting out to capture a new mate – was against the accepted code in its ritual that she failed. How could she expect that the younger widower John Trelill would prefer her, wealth and all, to the servant maid Vassie? Well might Uncle Billy Jenkin, whom Mrs. Pollard had rejected in favour of John, complain, 'Mis' Pollard, your conduck edn' but light'. Her conduct would have undermined the social values and altered the sexual standards of life in Pendennack.

That pattern had not then been destroyed. It had something to do with Methodism – or rather, with the emotional vitality of Cornish people, of which Methodism was an ordered expression and vehicle for spiritual experience. There was a proper way of courting, whether the lovers were young or middle-aged. The married man shaved on Sunday morning, before church. The man who was thinking of looking for a wife shaved on Saturday night; it was important that he should present a clean, smooth face to the girl of his choice: and that is how Mrs. Pezzack discovered John's intention towards Vassie, from which he is almost dissuaded by his

comical virago of a sister, Mrs. Poljew. The ritual was, as it were, almost tribal; woe betide any who tried to flout the conventions. If it fitted Methodism, so also did the delight in food which Mrs. Pollard had prepared – 'billet fowl and bacon' – to show proper respect to the man and the occasion. But all to no purpose.

It was of *The Widow Woman* that Q wrote, in his preface to *Cornish Tales*, how he opened the book at home 'and hailed at once a writer who could use our speech as we natives use it, understand our ways generally, who – perhaps above all – justified himself as an artist'. Q's praise must bring us to some consideration of Charles Lee as a stylist. A modern critic has blamed him for a facetious humour which obtrudes upon the humour of the story and for holding up the action of the story by a display of literary affectation. But that is to blame a writer for being in harmony with his age: the late Victorian age when Englishmen had not lost the occasionally pompous sense of dignity with which the Victorians showed that they were men of consequence in the world. Anyhow, in Cornwall you do not even now use the method of the direct approach; you go to Paradise by way of Charing Cross! In a more leisured age the indirect method had its uses; moreover, it was not mere cleverness but rather a proof of his trueness to the temperament – the often oblique mind – of Cornish people that Mr. Lee delayed the action of his stories by his wit and by that display of flowery eloquence in which the Cornish take some delight even now.

That, after all, is half the art of *Our Little Town*. In this short novel – or series of episodes, any of which could stand alone and yet seem complete in itself – Mr. Lee let the comic spirit play many pranks to disturb the relations of the men and women, married and single, of Porthjulyan, which is Portloe so thinly disguised that you might still discover Penticost's and the place where James-over-to-Shop dwelt with his wife. This to-ing and fro-ing between the sexes, even the 'battle' of the Amazons (for the women of Porthjulyan attacked their menfolk in that citadel of exclusive masculinity, Penticost's cobbler's shop), is almost like a kind of bird display in the breeding season. And in one of his stories Charles Lee does describe the curious courtship display of the oyster-catcher to illustrate his

understanding of the art of courtship in Cornwall. Yet, by a contra-
diction, while the men ran after the women in Mr. Lee's Cornwall,
it was the women who were emotionally and mentally the inferior
of the men. Though, as old Uncle Hannibal (who makes all too
brief a comical appearance in *The Widow Woman*) says, 'When a
chap an' a maid do come together, chap shuts his eyes tight:
maid aupens hers a bit wider. How should a chap look to have a
chanst? Man's human, but woman's woman – 'at's what I'd say in
my smart way.'

Courtship leading to marriage is a sixfold ritual, and Mr. Lee
convinces us that it was this ritualistic pattern of behaviour in
courtship and marriage which made for stability; certainly marriage
founded on passion lacks stability, however romantic it may appear
to the audience. The Priapean impulses were kept under control by
this Methodism in sexual selection; only the misfits rebelled against
the ritual, and suffered as misfits must.

Nevertheless, as we see by the mass philandering, and male and
female display, at St. Hender in Mr. Lee's lovely idyll *Dorinda's
Birthday*, once a year, on feast day, romantic passions were given a
few hours' liberty. In this delectable tale, which Q thought not
unworthy of comparison with Thomas Hardy's *Under the
Greenwood Tree*, and I have compared with Jefferies' *Amaryllis at
the Fair*, Dorinda, on her seventeenth birthday, has an almost
incredible sequence of amatory adventures. But she finds she had
better stick to Hubert – even though she did cause him, in the
tower, to jangle the church bells in the ringing festival. The
celebrated 'snake walk' which was St Hender's own method of
giving Priapus an airing, under the general vigilance of the village,
is even now practised at one Cornish hamlet only a few miles from
the original village of St Hender. It is known as the 'serpentine
walk' – and perhaps still has its traditional use in letting the young
people meet and laugh and walk together, under the eyes of their
propriety-observing elders. I am sure that the people of
Rosenannon up on St Breock Downs, like the men and women of
Rupert Brooke's Grantchester, do all they ought and observes the
rules of thought in upholding the properties!

Of all Mr Lee's stories *Paul Carah, Cornishman* is most nearly the pure novel: though that was, as it were, taken down at Coverack. This story of the homecoming of the long-absent seafarer, who can't get back on terms with his fellow Porthveanians and will not allow himself to be completely caught by the young woman whose widower father gives him lodging, is well worth reprinting; though, as Q wrote of it, there is no necessity to add 'Cornishman' after the name in the title, for the story and the characters are all Cornish enough. As in nearly all Charles Lee's stories, there is a distrust of letting the heart direct the affections. This is apparent, also, in the short story *Mr Sampson* – the man who takes a cottage next door to two spinster sisters who come to quarrelling over him; but Mr Sampson, too, doesn't trust his heart – 'mazy old organ, b'lieve', he says. Mr Lee makes his Cornish folk trust their intelligence rather than their emotions in arranging their lives; that leaves to the chapel the emotional excitement which, in more sophisticated communities, is apt to be the unsafe directive impulse in sexual selection.

The bibulous sketch *Pascoe's Song*, the fragrance of *The White Bonnet*, the irony of *The Strong Man* who pretended he wasn't, the naïve fun of Thyrza Theophila Trounce, whose 'news-letters' to the local paper can still, almost, be matched – they are the very poetry of the English mis-usage! – are other tales of this land which Mr Lee, as much as Q, found so delectable. Cornwall did something for Charles Lee that it has done for many another sensitive writer and artist: it liberated his spirit in these tales which are so near to perfection. Perhaps he was right in ceasing to write when he did – before his talent staled and while his stories had all freshness, youth and enchantment in them to give them their tunable qualities.

BIBLIOGRAPHY OF CHARLES LEE'S BOOKS

The Widow Woman, James Bowden, 1897, after being serialized in *The Leisure Hour* in 1896. *Paul Carah, Cornishman*, Bowden, 1898. *Our Little Town, and Other Tales and Fancies*, Gibbings & Co., 1909. [In 1911 J. M. Dent & Sons took over this, and *Paul Carah* and *The*

Widow Woman, and issued the *Our Little Town* series, with *Mr. Sampson* and the not previously published *Pascoe's Song*, in the Wayfarer's Library, 1928.] *Dorinda's Birthday*, Dent, 1911. *Cornish Tales* (containing *The Widow Woman*, *Our Little Town*, *Dorinda's Birthday*, and a few short stories), Dent, 1941. Two plays, *Mr. Sampson*, Dent, 1912, and *The Banns of Marriage*, Dent, 1927. Charles Lee also edited and annotated Smollett's *Humphry Clinker* in the Everyman Library, 1943.

BERNARD LEACH

MY WORLD AS A POTTER

I was born in Hong Kong, and my first years were spent in Japan in the care of my grandparents. To this fact, and the subsequent reading of Lafcadio Hearn, was due the impulse which took me back to the East at the age of twenty-one, after a training under Tonks at the Slade and in etching under Frank Brangwyn. I went back to find out for myself what this strange Eastern art, and the life behind it, meant. I taught etching and, with my wife, English, but fortunately it was not long before I abandoned the idea of teaching in favour of learning, and it was due to this fact that the younger writers and artists treated me as one of themselves. Little did I imagine at the party of artists to which I was invited in 1911 that the excitement which I felt at the first sight of pots being fired, which had just been painted by the guests, including myself, would eventually lead a Tomimoto or a Hamada to become potters, or to my own setting up as a potter in Cornwall, and the subsequent teaching of Michael Cardew and others, but so it happened.

After that experience, I set about finding a master, and was eventually introduced to Ogata Kenzan – the sixth in succession of one of the most famous lines, or schools, of potters – and became his sole pupil. Later Tomimoto also worked with him, and to us both he gave the traditional knowledge and recipes with which passes mastership. This studentship of ours did not resemble traditional Japanese apprenticeship, because both of us were mentally and culturally far removed from our master. The young artist and architect Tomimoto and I were certainly closer in friendship and depth of common interest than ordinary brothers, and we each had an affectionate regard for old Kenzan.

For most of nine years Tomimoto and I were friends and rivals. Being the first in this quest, and at that time having little knowledge of living craft movements in other countries, we had no set guide

to thought and prowess, so we bought our experience expensively, but what we learned thereby we really knew. The search after form and pattern occupied our nights and days, for we never supposed that the mere imitation of old styles would lead anywhere. We were, in fact, gropingly, with occasional flashes of light (quickly and gladly shared) synthesising on racial, cultural and personal lines, each according to his own very different inheritance. He was my only companion in this adventure and search until the end of my time in the East, when Hamada arrived from the Kyoto Pottery School wishing to escape from its atmosphere of pedantic scientific exactitude towards a more intuitive and basic means of expression. He came to England with me in 1920, and for three years helped to start the St. Ives pottery.

When we started in Cornwall with the helpful understanding of my partner Mr. Horne, who a year or two earlier had founded the St. Ives Handicraft Guild, we neither of us had any experience or first-hand knowledge of crafts in England. Our ideas were more or less bounded by conditions of craftsmanship in Japan, whether of the traditional countryside or of the individual art-trained variety which it so happened that I, as a foreigner, precipitated. For in 1909 when I went to Japan as a young artist there were highly-trained craftsmen – some of them even attached to the Court – but not one was aesthetically conscious in the international and contemporary sense. Thus when they, and still more the peasant weavers, lacquerers, potters, etc., attempted to graft foreign ideas on to an already weakened national stem, the results were disastrous.

The conclusion we subsequently came to was that making and planning round the individuality of the artist was a necessary step in the evolution of the crafts. So at St. Ives, at the outset, we based our economy on the studio and not on the country workshop or the factory.

For some years our main revenue came from enthusiasts and collectors in London and Tokyo. We worked hard, but with the irregularity of mood. We destroyed pots, as artists do paintings and drawings, when they exhibited shortcomings to our own eyes (what Hamada called 'tail'). We only turned out two to three thousand

pots a year between four or five of us, and of these not more than ten per cent passed muster for shows. Kiln losses in those days were high − quite twenty per cent. The best pots had to be fairly expensive. What was left over was either sold here or went out on that usually unsatisfactory arrangement of 'sale or return' to craft shops up and down the country. Nevertheless, our work became known, students arrived, critics were kind, my Japanese friends held repeated exhibitions of my pots and drawings, and sent all the proceeds to help establish this pottery in my own country.

In 1920 Hamada was 28, I think, and I was 33; he had not yet exhibited, whilst I had been launched in his country as an artist and as a potter for ten years. He had had a scientific training whilst I had made a lot of mistakes and gained thereby some experience. Like his own pots, he was well ballasted. For three years we had a good partnership. The background of thought which we brought to the undertaking was that of the artist turned craftsman; or, at least, of the educated and thinking man perceiving the largely unconscious beauty of material, workmanship and general approach which preceded the industrial revolution, and his desire to recapture some of the lost values through the work of his own hands. So it was with Morris, Gimson and Edward Johnston. East or West, this is the counter-revolution, the refusal of the slavery of the machine. Both movements started here in England − the return wave of artist-craftsmanship from Japan has a character of its own − it has gained richness, a reflection of other and different philosophy and culture. Behind the failure of arms, competition and politics the world shrinks towards unity and cohesion.

At this early stage we were making a lot of rather uneconomic experiments in the Japanese low-temperature faience called 'Raku', in middle temperature English slip-ware and in high temperature Oriental stoneware and hard porcelain. The Raku technique was used for Thursday afternoon demonstrations during summer months, at which we allowed visitors to paint their own pots, which we glazed and fired before their eyes. We were still using wood, and there were not a few occasions when the beginner's struggle with the unforeseen, without the experience and advice of old hands,

made me realize the truth behind the friendly warning that in Japan twenty years were regarded as about the time requisite for the establishment of a new pottery.

Between 1920 and 1931 we had 'one-man' shows in London – about seven altogether. They were moderately successful, but it became gradually clear to me that the solution to the underlying problems of craftsmanship, or, at any rate, those which presented themselves to my mind most forcibly, were not likely to be discovered in the expensive precincts of Bond Street – that springboard of virtuoso and showman.

Meanwhile our pots had been shown at various national and international exhibitions. At the invitation of a group of students of Harvard University, I joined with Murray, Cardew, Bouverie and Braden in a combined Anglo-Japanese individual potter's exhibition. It was spoiled, however, by delays and by rough handling in the Customs, but I think it worthy of mention because of the newness and breadth of the idea.

When the remnants of this show went on to Japan a penetrating, disconcerting, half-hidden criticism found its way into a letter from the leader of the craft movement: 'We admire your stoneware [in the Oriental mode] but we love your English slip-ware – *born, not made.*' That sank home, and together with the growing conviction that pots must be made in answer to outward as well as inward need, determined us to counter-balance the exhibition of expensive personal pottery by a basic production of what we called domestic ware.

Student apprentices followed one another at intervals of about a year apiece. In 1930 my eldest son, David, decided against university and for a potter's life. My second son, Michael, also worked with me for a time. Besides long-term apprenticeship, which is the only real way of learning a craft, we did have short courses, which more than one hundred must have attended at one time or another.

In 1933 I went to teach, part-time, at Dartington School, leaving David in charge for a month or two at a time. The Elmhirsts built a small pottery unit for me at Shinner's Bridge, in which I developed the English slip-ware technique, using the chocolate-coloured

Fremington clay from north Devon, which is the same as that used at Lake's Pottery, Truro – the last of the traditional Cornish kilns.

My old companions of art in Japan, particularly those associated with what had become a national craft movement, invited me in 1934 to revisit them and work in their several centres for a year. Leonard and Dorothy Elmhirst felt that such an invitation should not be refused, and they financed my journey. This is no place in which to attempt to describe the happenings of that year. As far as work was concerned it was the fullest and most rewarding in my life, and humanly in sharpest possible contrast to the terrible apparition of Japan which war has brought to the mind of the West. With Hamada at Mashiko, Tomimoto in Tokyo, Kawai in Kyoto, and Funaki in Matsue, and in three other potteries, the pots and drawings were done for eleven exhibitions. Besides that, with Yanagi as leader, we travelled four thousand miles collecting examples of folk art, planning, lecturing, criticizing. This work resulted in the promise of adequate funds for the building and maintenance of a beautiful National Muscum of Folk Art. This building and its contents fortunately escaped damage from incendiaries during the bombing of Tokyo.

Whilst I was in the East David was sent to Stoke Technical College for a two-year course, and St. Ives was left in charge of Laurie Cookes and Harry Davis, who carried on the production of domestic slip-ware with great energy. Samples were taken by car far afield, personal contacts made, and the orders were carried out forthwith, involving sometimes half a dozen kiln firings without a break.

Some time after I got back I began to write *A Potter's Book* for Faber & Faber Ltd. At the same time I resumed potting and a little teaching of adults besides making periodic visits to St. Ives, where David was making a number of technical improvements, including the successful installation of oil-firing in place of wood in 1937. We gave up slip-ware in favour of stoneware, because it suits the conditions of modern life better and offers a wider field of suggestion and experiment. The following year we engaged our first two local apprentice lads. It was a good move.

In 1940 my book was published. Despite the war it has sold well, both here and in the U.S.A., and it has brought me friends and contacts with potters far and near. I am now working on a further book.

Late in 1940 I made St. Ives my headquarters once more in response to my son's appeal. Not only did he anticipate his 'call up', but he was also feeling at a loss in interpreting my shapes and patterns at a distance of a hundred miles. By this time we had issued our first catalogue of domestic stoneware and ovenware as well as a tile catalogue.

One night in January, 1941 the pottery had the bad luck to get in the way of a parachuted land-mine intended for the nearest airfield, ten miles away. It fell in the garden, blew down George Dunn's cottage, and shook or sucked off slate roofs, glass, doors, etc., and broke pots, etc., to the tune of £2,000. Personal injury was light – what to do next was the problem. With difficulty we hired canvas to cover the pottery proper, but the house was condemned by St. Ives, Plymouth and Bristol (three times). Not only that, but we were blamed for the happening by local people, and we were not permitted to protest in the press that the pottery had *not* been signalling to German planes by kiln-fires! Eventually our Member of Parliament took the case up, and it was fairly and sympathetically reviewed by the Board of Trade, after three years' uncertainty, during which we had lost all but one of our workers to the Forces. Repairs were thorough, and we were even granted a special licence to make and sell outside 'utility' regulations, and to employ seven workers – if we could find them! We did – twelve in all at different times – but only two or three partially trained, so production lagged.

We were granted David's release in November, 1945, old hands returned, and new ones want to come in unprecedented numbers. We are comparatively fortunate, but the war hit British craftsmanship hard. Out of the two thousand or so craftsmen of peace-time (excluding rural crafts), there were at one time fewer than twenty workshops left. The thread of continuity upon which traditions of right making depend wore very thin during those six years.

Crafts such as pottery depend, as it were, upon a slow passage of time: the gradual transfer of the bodily knowledge of the right usage of material and the intimate co-operation of small groups of workers. Break those threads and disperse the men and their tools, and a heritage is lost for ever. This is one of the contingent tragedies of total war, and it is the more poignant because craftsmanship in its essence is the antidote of mass production, and the craftsman is the residual type of fully responsible workman.

At the Leach pottery we have aimed at a high common denominator of belief and in the sharing of responsibility and profits. By accepting the Cornish motto 'one and all', and by making the workshop a 'we job' instead of an 'I job', we appear to have solved our main economic problem as hand-workers in a machine age, and to have found out that it is still possible for a varied group of people to find and give real satisfaction because they believe in their work and in each other. To me the most surprising part of the experience, which now covers about ten years, is the realization that – given a reasonable degree of unselfishness – divergence of aesthetic judgment has not wrecked this effort. When it comes to the appraisal of various attempts to put a handle on a jug, for example, right in line and volume and apt for purpose, unity of common assent is far less difficult to obtain than might have been expected.

The other thing it has done which I would like to mention is to lessen the inevitable dominance of Eastern shape and décor by the health-giving effort to answer *need* – the practical tea-pot, porringer, egg-baker and pitcher requirements of the English people who buy the pots.

In conclusion, I would like to refer to some deep-seated truths stated by John Farleigh, the President of the Arts and Crafts Society, in a recent lecture to the Royal Society of Arts. He dwelt on crafts-manship as an experience – as a way of life. He spoke of the equation of creative concept and its projection into and through material. He made the case for the modern craftsman whom he calls the fine craftsman. He stressed the timelessness and universali-ty of the language of art, including the crafts: 'In the timeless moments of creative execution the potter is guided by his material,

clay, as much as he guides it.' To which one responds feelingly and with unquenched hope, 'life flowing for a few moments perfectly through the hands of the potter'. Mr. Farleigh concluded with the statement that 'no civilization has been great without the culture which springs from free expression in the arts'.

Creative work is an intensification and worship of life, and conversely no arts find expression without conviction and faith in its meaning and value, even if some contemporary expression appears to have a destructive character. For everyone to-day this is the underlying problem – the meaning and shape of the life ahead. The immediate outlook is dark enough, but the potential exceeds by far any historic precedent. Least of all can artists and other men of imaginative vision afford to be reduced to impotence through fear, for it is through their perceptions that the inchoate future falls into rhythm and pattern.

The educated craftsman ever since the time of Morris and Ruskin, let us say from about the middle of last century, has by force of circumstance been more or less of an artist, that is to say, he had often received previous training as an artist, or as an architect. He follows a craft as a vocation for the enthusiasm of the thing made by hand to the best of man's ability. Whether it be pot or poem, painting, music or sculpture, the type of man and his processes of thought are much the same. The social circumstances which have thrown him up as a reactionary against the over-mechanization of labour at a certain stage following the Industrial Revolution, have been similar in all modern countries. This kind of man or woman is possessed of an insight into the epochs of man's culture and in his or her own workshop passes such influences through the mesh of personality.

Our problem is to preserve those qualities of concept, of material and of method, belonging to pre-industrial civilization which are still valid to-day, adding to them an individual responsibility and a width of outlook which is our peculiar Western inheritance. This constant straining after perfection in the thing made may either continue alongside industry, as a stimulus and example, or it may serve within the factory to redeem it from sheer commercialism.

We in England are the parents of industrialism. As such we have had more time to observe the effects of mechanization and to begin to take its measure. It is but just that the evils inherent in the misuse of science should be understood and countered first by us. All over the East, all over the world, in fact, the same thing is, or has been, taking place. Broadly, the same sequence of events follows close upon the establishment of factories or the large-scale importation of mass-produced goods; local handcrafts are displaced, the close contacts between maker and consumer, between heart and hand, man and material, art and life, all these are forgotten or lost in a very few years. The fabric of life is torn, faith weakens, culture itself – the soul of a people – disintegrates.

The artist-craftsman should be the natural source of contemporary applied design, whether he works in conjunction with industry or prefers, as most of us do, to carry out our ideas in clay, cotton, wood, glass, metal or leather, etc., mainly with our own hands and at our own tempo. The hand is the prime tool and it expresses human feelings intimately; the machine for quantity, cheapness and, at best, a marvellous efficiency, but it turns man into a modern slave unless it is counterbalanced by work which springs from the heart and gives form to the human imagination.

W. J. STRACHAN

HUDSON MEMORIAL[1]

Up on this moor above the Zennor road
I, as you once were, a stranger trod,
Casting about among the granite boulders,
Haunted by your lean limbs, the caped shoulders,
The birdlike eyes through which we saw so much,
As we see more stirred by a poet's touch,
Came to the smooth rock cliff that suddenly rose
Out of a whipping sea of thorn and furze
Where simple words as simply carved on stone
Perpetuate your rich communion
With all the moods that change this vast expanse
And give expression to its permanence.

1 'W. H. Hudson often came here' is inscribed on a rock on Zennor Moor.

FRANCES BELLERBY

HOSPITAL CAR

Impossible to forget sliding down, down
Into the starry pool of that little lighted town
Whilst black fog towered on the moorland side;
Nor the curious way in which I was forced to interpret
The gesture of the accustomed hand closing his gate –
A month before he died.

I had no knowledge of him, nor he of me.
We had travelled together without speech, weary
In our separate fashions; parted with a word and a smile.
Then how could hands' quiet ordinary gesture
In the March dusk have made me so blindingly sure
Of what tongue would never tell?

CHARLES MARRIOTT

MEMORIES OF CORNWALL'S ART COLONIES

My first sight of the real Cornwall, the real Cornwall for me, that is to say, was from the little tower of Carn Brea Castle. Does it still exist? That would be in 1889, when I lived for six months or so in Truro. Climbing the hill to the castle I caught a scrap of conversation that has stuck in my mind. A man said to the little boy with him: 'This is where the Druids worshipped their idol gods.' The boy asked: 'How long ago?' And the man replied: 'About a hundred years, I s'pose.' It was a clear afternoon, and from the tower of the castle I had a complete view of the Land's End peninsula. Both St. Ives Bay and Mount's Bay, with their frilled edging of white foam, came into a picture that was a perfect illustration of Tennyson's 'vision of the guarded Mount'.

Not unnaturally, it is the Cornwall of the Arthurian legend and of prehistoric remains that is the real Cornwall for me. All later impressions are dominated – if you like, distorted – by my vision from the tower of Carn Brea Castle and what I heard on the way up to it. In comparison the Cornwall of the artistic and literary colonies, the Cornwall of heavy-cake, saffron buns, clotted cream, pilchards, the Furry Dance, and the Knill ceremony, though I was to have intimate acquaintance with them, seems like the gloss on a palimpsest by a hand imperfectly acquainted with the original text.

It was not until the autumn of 1901 that I settled in Cornwall, for a year at Lamorna in a cottage found for me by the late Dr. Harry Roberts, of Hayle, and now owned and occupied by Lamorna Birch, and then for seven years on end at St. Ives.

Probably readers will be most interested in what I remember of the painters and writers in Cornwall. At Lamorna I did not see much of the Newlyn colony, though I met Stanhope Forbes at Newlyn and Norman Garstin at Penzance. My great friend was Lamorna Birch, who used to come down from Lancashire to stop

at the farm at Boleigh (the 'Place of Slaughter', I believe), hard by the Nineteen Merry Maidens and the Pipers, who were turned to stone for 'dancen' 'pon Sunday'. The winter of 1901 saw one of the rare heavy falls of snow in Cornwall, followed by brilliant sunshine. I shall never forget Birch's delight at the novel effects created by the deep drifts in the Lamorna valley and on the surrounding gorse-clad moors. Birch taught me all I know about trout-fishing. I have seen him cast a fly against the wind through a hole in a blackberry bush and drop it exactly over the rising trout. At the end of a year the problems of school for two little girls of seven and eight, and another child on the way, decided me to move to St. Ives. Birch, who was just about to get married, snapped up Flagstaff Cottage, and he is there still.

The painters who lived at St. Ives or came there regularly in my time included Sir Alfred East, Sir Arnesby Brown, Julius Olsson, Algernon Talmage, T. Millie Dow, Moffat Lindner, Fred Milner, Louis Grier, W. B. Fortescue, Lowell Dyer, Elmer Schofield, Will Ashton, Hayley Lever, Hilda Fearon, Annie Fearon and John Park. Whistler, Sickert and Anders Zorn were not very distant memories. There was a come and go of students from the London art schools, including Milford Norsworthy (killed in action in the First World War) and Arthur Watts, the *Punch* artist (killed in a flying accident). Harold and Laura Knight and Ernest and Dod Procter belonged to Newlyn, and I only met them casually in the streets of St. Ives. Sir Alfred Munnings, Augustus John and Frank Dobson, the sculptor, had not yet, I think, descended upon Cornwall.

One of the most talented and certainly the most popular of the St. Ives painters was Algernon Talmage. He was, indeed, a most attractive personality; modest, slightly reserved but always ready to do a kind action for a friend. His right hand had been injured in a gun accident – he was rather sensitive about this – and he painted with his left, as did, incidentally, Stanhope Forbes. It was Talmage who told me a story reflecting the days when relations between the artists and the fisherfolk were not as cordial as they afterwards became. A fish cart was being driven up Skidden Hill, and the horse jibbed. After exhausting an extensive vocabulary of abuse, the

driver, walking in the road, exclaimed, as if with his last breath, 'You – you Pygmalion *artist!*'

Occasionally Henry S. Tuke and, more frequently, Napier Hemy would come over from Falmouth, and I remember the amusement we got out of the rivalry between Alfred East and Hemy as raconteurs. Each of them was full of reminiscences of about the same period, and I can see them now glaring at each other across our sitting-room in Porthminster Terrace.

I don't propose to discuss in detail the work of the painters – some of them still going strong – I knew at St. Ives. Most of them practised the broad impressionism that derives ultimately from Constable, and there were hints of Bastien Lepage, Whistler, Sargent and the Glasgow School. 'Values' were in the air, so much so that I have heard one layman say to another 'Your brown boots are a bit high in tone, old chap'. The New English Art Club, founded in 1885, was still young enough to be thought 'rather advanced'.

What strikes me now in looking back is that, from their very pre-occupation with tone and atmospheric effects, most of the excellent St. Ives painters of my day missed to a certain extent the local character. They painted west Cornwall as if it were the Constable country. No doubt my persistent vision from the top of Carn Brea was coloured by literary associations, but, literary associations apart, it does seem to me that west Cornwall is a draughtsman's rather than a painter's country. Seen from a height, such as Trencrom or Carn Galva, the landscape runs to decorative pattern; a sort of *cloisonné* effect of little green fields inset in a network of gorse-clad 'hedges'. I have a notion that, even in their 'abstractions', the latest recruits to the colony, such as Ben Nicholson, get nearer to the peculiar magic of west Cornwall than did the painters of my day.

They were a genial crowd, working reasonably hard and playing with zest – chiefly golf at Lelant. The Australians, Will Ashton and Hayley Lever, organized cricket, which, owing possibly to the scarcity of level pitches, was not then much played in Cornwall. Olsson was a daring yachtsman, making deep-sea voyages. He, by the way, never forgave Konody the critic for speaking of his marines as Neapolitan ices – 'Damn it, what, what?' he would say

in protest. Olsson was responsible for the concoction of Swedish punch, a mystic ceremony, for the New Year celebrations at the Arts Club in a converted net loft near the harbour, where we met every Saturday night.

Lowell Dyer, a Boston Swedenborgian who painted angels combining Swedenborg with Botticelli, was the wit of the community. On a famous liar, who lied for the fun of the thing, he wrote this epitaph: 'Here lies Blank Dash. As usual.' Dyer played croquet. One afternoon he said to the then vicar, a rather solemn person, 'Why, Vicar, you're a regular dab.' 'Dab, dab,' said the Vicar, crossly. 'What's a dab?' 'Quite common place,' retorted Dyer, turning away impatiently. Of a painter known as Wicked Willie, on account of his extreme mildness, Dyer was heard to observe reflectively: 'Here comes Wicked Willie, looking like a fresh-water mermaid in a cow pasture.'

While I lived at St. Ives there was a good collection of writers, residing or visiting. I was much too late for Leslie Stephen, the eminent man of letters, and father of Vanessa Bell and Virginia Woolf (if I am not mistaken there are hints of Godrevy in her *To the Lighthouse*), who lived in the house occupied in my time by T. Millie Dow. Has anything been done in the way of a tablet commemorating Leslie Stephen? Our most distinguished visitor was W.H. Hudson, who was brought down by Morley Roberts. Hudson was not expansive, and he excited the hostility of the fishing community by condemning, in print, the practice of setting baited hooks in gorse bushes to catch birds. I never heard the rights of it, but I believe that the explanation of the practice was that a very hard winter had reduced the fisherfolk to near starvation. But Hudson's preference for birds over human beings is well known.

Dr. and Mrs. Havelock Ellis lived for several months of each year in a converted mining 'count house' at Carbis Bay. He was tall and bearded, with a 'Jovian' head, very silent and shy. She, a pillar of feminism, was small, round and bustling, with a quick temper and the lightest eyes I have ever seen. I was deeply touched and flattered when, after her death, the shy and silent man asked me to write

some personal reminiscence by way of a preface to some reprinted stories of hers.

Mrs. Ellis bought up several miners' cottages, put in Liberty curtains and let the cottages to summer visitors. This brought down some celebrated people, including, until I found them a permanent home at Trewoofe, at the head of the Lamorna valley, Alfred Sidgwick and his wife, Winifred James, author of *Letters to my Son*, Conrad Noel, later famous as the Socialistic Vicar of Thaxted, in Essex, and his family, and the Cayley Robinsons.

Hugh Walpole came with an introduction, bringing me the manuscript of his first novel, *The Wooden Horse*, and became a close friend of my family. He decided, with some reason, that the young people of St. Ives needed discipline, and prescribed mixed hockey. I have a vivid memory of Walpole being pursued over a muddy field on a drizzling day by a small girl who barked his shins and broke his pince-nez. There was no more mixed hockey. Concurrently with Walpole as a visitor was Ethel Colbourne Mayne, author of one of the standard works on Byron.

Compton Mackenzie, then writing his first novel, with his mother, Virginia Bateman, and his sister, Fay Compton, then a solid and sedate little girl with beautiful auburn hair, were living at Riviere, Hayle. Mackenzie and Fay were frequently in St. Ives plotting mischief with our two girls, who were about the same age as Fay. The year I happened to be President of the Arts Club, and gave the presidential party, Mackenzie wrote for me a brilliant parody of Maeterlinck, *The Princess Migraine*. In the list of characters appeared 'Quarrels, as rehearsed daily by the Sisters Marriott', which was perhaps an exaggeration.

Ranger Gull, who as 'Guy Thorne' bamboozled the then Bishop of London with *When it was Dark*, lived at Carbis Bay, and Elliot O'Donnell, now one of the leading authorities on 'spooks', was running a private school in St. Ives. A stray visitor I remember was Fergus Hume, author of that very successful thriller *The Mystery of a Hansom Cab*. He had some dodge for warming his feet and legs by suggestion, and his secret ambition was to write poetical drama on classical themes.

Two of my greatest friends in St. Ives were Bernard Walke, the universally beloved curate of the parish church and later vicar of St. Hilary, whose Christmas broadcasts of Nativity Plays in aid of the home for juvenile delinquents he had started there will be remembered, and Herbert Lanyon. Besides being a first-rate photographer, Lanyon was a brilliant pianist. Injury to one of his hands in a train accident in America had cut short his professional career, but to the layman no disability was evident, and Sunday evenings at Lanyon's were a regular institution. He also composed, and a short piano piece of his was broadcast not very long ago. It was at Lanyon's, by the way, that I met Flora Annie Steel and the widow of William Sharp (Fiona McLeod), who were on short visits to St. Ives.

I never met Quiller-Couch, though I had a letter from him about one of my stories, and his name is associated with a totally undeserved compliment I received. With Lewis Hind, then writing his *Days in Cornwall*, I undertook a mad mid-winter walk following the whole course of the Tamar, from its mouth at Saltash to its source in Woolley Barrow. We started on Boxing Day, it rained most of the time, and we ended up at Bude on New Year's Eve. At the hotel the only other guest to dinner at the long table laden with turkey and other good things of the season was a barrister, come there on some election business. He was companionable, and I suppose I talked a lot about Cornwall. Anyhow, when we parted after midnight he said: 'Excuse me, sir, but are you Q?'

During my eight years in Cornwall, not counting the six months at Truro, I suppose I walked almost every yard of the country west of a line from St. Ives to Penzance, with diversions to the Lizard peninsula and the north coast from Padstow to Tintagel. A favourite haunt of mine was the wild moorland punctuated by Lanyon Quoit, the Mên-an-Tol, the Mên Scryfa and Ding Dong Mine. In the neighbourhood of Ding Dong I was assured by an ancient man: 'This was the mine from which the tin was raised to make the saucepan out of which Our Saviour had His bread-and-milk.' Less than ten years ago my son, who was born at St. Ives, was in the neighbourhood of Ding Dong, where another ancient man assured

him: 'This was the mine from which the copper was raised to make the brass for Solomon's temple.'

So I end as I began, with prehistoric remains. Pleasant as were my days in the colony at St. Ives, it is the Cornwall of the Arthurian Legend, the Cornwall of Riolobran the son of Cymbeline, the hut circles at Chysauster and the Merry Maidens at Lamorna, that remains the real Cornwall for me.

SVEN BERLIN

MY WORLD AS A SCULPTOR[1]

In the library at home when I was a boy there were two thick, red volumes called *Trans-Himalayas*: these were an account by a Swedish uncle of mine of his adventures and discoveries in Tibet. I remember pictures of him being charged by a wounded yak, of him fighting his way through a blizzard and crossing an unknown mountain pass. He was an explorer, emblematical of the spirit in mankind that has led us down the centuries, finding new continents, entering forbidden cities, unearthing forgotten temples, discovering images – to this tribe also belonged Lancelot, Columbus, and the medieval alchemists.

I wanted to be an explorer.

Once this feeling had awakened it never died. I grew to love the beautiful and strange things made by men of past civilizations all over the world.

It is evident now that images are buried everywhere, not only in the earth, the rock, the forest, but also deep in the mind: images that have been made already and those not yet created. A sculptor explores the heart of his stone to discover the image there buried – buried also within himself. An image that is there but not yet created always lives within the potentiality of the stone or wood in the same way as thunder dreams in the heart of each drop of dew.

My father showed me the solar systems on a frosty winter's night. His head was filled with stars as he stood there on the hill telling how many light-years was Venus away, how a star may still shine upon the earth for centuries after it has been extinguished, like the soul going on its journey after death. I was filled with the wonder and awe which the contemplation of infinite space will inspire in the least of mortals, and of the heavenly bodies moving in space,

1 Notes for *Disturbance in the West*.

dying, being born, whirling on beyond the limits of time. This, too, was a discovery. One day men would be fired in rockets to find the hidden things of other worlds …

But it was still a long step to realizing I could carve a new world out of my dreams.

There would seem to be little congruity between these experiences and the fact that I was trained as an engineer. That this happened was no doubt lack of insight on my father's part and lack of foresight on my own. It made me restive and unhappy. I was trying to paint with a persistence that amounted to obsession. Horrified by the sudden realization that I was trapped in the cities, working in factories and offices, I broke away and became an *adagio* dancer on the music halls.

This I took very seriously and greatly enjoyed. From the stage came a renewed sense of life, comedy, adventure, above all I had discovered a way of expression. The work was hard and dangerous, needing considerable concentration and skill. To be burlesqued by comedians like Nervo and Knox did much to help one laugh at oneself and the best one could create.

But as yet there seemed no connection between these things that were happening.

Turning and turning in the widening gyre
The falcon cannot hear the falconer.

At least I had come to realize that all experience is valuable to an artist, particularly so when it stirs the inner places of the mind. And my dancing, in spite of its nature and environment, became a genuine art-form through which I was trying to speak.

Engineering had developed my sense of structure and form, order and space, just as had my father's revelations about the universe; moreover, it gave me a love and care in the use of tools and in the building of a workshop. This was good, for sculptors are not prophets, they are workmen; it only so happens that what they make, if it is worth while, becomes permeated with the hidden forces of life. There is a peculiar delight in doing work for its own

sake, if that work is creative. It was for such things that I cared, and I was determined to do them.

Sculptors are carvers of stone and wood, or any other material from tallow to Perspex – but carvers. *Sculptura*, from the Latin word 'to carve': that is a precise meaning.

It has always seemed to me a mistaken idea that modelling for bronze is a department of the art of sculpture. It is not. It is something on its own, like pottery: much closer to pottery, in fact. Although it is a plastic and spatial art, and may be of use to the sculptor, its whole process is opposite to the process of carving: a building up from a centre instead of cutting into one. It is also concerned with the translation of the poetic idea through mediums foreign to one another, whereas, in carving, stone is your road, your guide and your journey's end. I am a carver in stone – a sculptor, therefore.

Now, a word more about dancing, and we will begin to see how all this fits together.

Adrian Stokes pointed out to me that dancing was the true link between the plastic arts and music. His own pictures, he said, were like the closing scene of a ballet: it is not strange, then, that I first understood them when listening to Mozart one summer afternoon in his sitting-room.

Dancing is also the human form and the poetic image in space seen and inwardly experienced from many viewpoints in time, developed on the laws of gravity, rhythm, colour, tension, the spiral and the arabesque. It was a flash of real insight on the part of John Irwin when he thought of having Ram Gopal to dance before the images at the re-opening of the Indian Section of the Victoria and Albert Museum after the most recent war. Much in this field – and the link with music – offers work of discovery to some questioning mortal somewhere.

Carving is a dance over and under and round and through a piece of stone during the creation of a three-dimensional image in space, which is worked out in a series of kinetic relationships of form that force the observer to move. It is also a journey over an unknown landscape.

Although my work on the stage was a kind of bastard dance, I worked hard and with enough devotion over eight years to make me realize that to dance was to know the stress and strain of a steel-constructed bridge, the law of moving water and the behaviour of the heavenly bodies.

My early passion for discovery not only led to reading philosophy, poetry and the religious writings of the world, to become also a student of human life, but it led me into the museums among the early Coptic, Assyrian, Egyptian, Spanish and African carvings; I developed a love for the sculptures of ancient China and for the medieval English alabasters that look as though they are flattened against the space that surrounds them; for the religious carvings of Chartres and of early India. My taste, in fact, was always for the primitive and early creations of any civilization.

It led to Cornwall, the most primitive of all places, where one can recapture the delight of playing with a crystal as a child, and watching the arms of the lighthouses divide out the nights when the sea is oily with moonlight and the angels and dragons are slumbering in the cliffs. This is truly a sculptor's country, itself made of granite, but few have realized it. The terraced landscape of the little fishing towns and the geological nature of the rock at once become operative, along with the submarine cargo of shells, skulls, fish and plants, in orientating one's vision back to the fundamental shapes of nature as was the case with the sculptors of earlier civilizations. This, added to the peculiar influence Cornwall has upon the unconscious mind of man (of which I have spoken at greater length elsewhere), brings into line once more the ancient forces of creation which, it may be surmised, have a close affinity with the spirit of life. In such an environment it becomes possible for modern man to make a statement about humanity penetrating its mechanical armour and seeing it once again as a dynamic part of the universal order governed by the mystery of God.

From the beginning of my quest I had searched into the structure and form of things, finding, as a reward, that each image of nature was built on the same laws. I could draw everything: trees, women,

hills, animals, birds, rocks, the sea. The wonder of the world opened up: the great storehouse was mine.

When the sea gets into a leg I am carving what excitement there is! It goes charging through the whole of the stone, and a man, as if by magic, is transformed into an ocean with rocks and tides, shells and caves – a sea-dragon. The whole galaxy of one's experience pours in upon him: one works in a kind of dream as though someone else is making the image. Is it not true that the doors of life, when open, release shapes and forces hidden inside us for ages? Be that as it may, there is no *reasonable* explanation of what happens.

The realization that I could carve in space came quite late. It began about ten years ago, when I found some blocks of sandstone green in a stream which ran through an old feudal estate near Camborne.

... worn out with dreams
A weather-worn marble Triton
Among the streams ...

These I carried to my cottage on the North Cliffs and carved them into primordial heads. It was extremely difficult. I remember the enormous effort, unlike anything known before, of trying to realize the conception of an image in the round. My first carvings were little more than drawings on the four sides of the stone. It took the next eight years to understand the meaning of spatial form with its volume, its infinite difference of direction: to create a living thing in stone, the stone an entirety in itself with a centre of vitality and tension that can be made to exist in space.

It was Cornwall that helped to release and develop this thing, which, I began to see, was an extension of my painting and drawing – even of my dancing. Now I am so deeply rooted in the Cornish landscape that to go and carve in a city, in a forest, or among mountains, would so alter my vision that it would probably be impossible to work for a considerable time. Painting, drawing, and sculpture is seen as a developing process of which each is a part –

painting an extension of form into colour, carving an extension of form and colour into space, each having their origins in drawing. As one advances these methods become almost a ritual practised on a way in search of understanding, much in the same way as the experiments of the ancient alchemists were necessary in releasing the fantasy that would reveal to them the secret of life.

The war, perhaps, made me care even more for the things I had always loved; it gave me a greater devotion for the growth and shape of a flower – taught me to be patient in battle.

I met Naum Gabo: from him I learned the meaning of space as an elemental fact.

But my forms, when I came to carve them, were spatial mainly in the sense of volume. There was no desire to construct a relationship of spaces with my Russian friend; nor, with Henry Moore, a wish to scoop the space out from inside the form. The character and limitation of my vision, from the beginning, was one of forms folding round themselves and round each other: the spiral rather than the arabesque, the Spinning Dervish rather than the Dancing Siva. Flower-forms, seashell- and foetus-forms: not the womb, but the child in the womb. The grown man was a tree or a sleeping sea. From that point I worked.

That things happened in this way was good. Just as in drawing I had learned my laws without being moulded into a school caste, so I learned my carving naturally, from my own point of view, and was able to absorb the ancient and contemporary sculptures without aping them.

It seemed that suddenly I could carve, almost as if a miracle had happened. But the truth (apparent now) is that the first carvings in space were preceded by a long period of unconscious gestation. I had gone through my influences to maturity as a painter. When it came to carving my vision was quite clear and personal. And it seemed that I had had long experience with the tools I was using.

Early days in engineers' workshops were not forgotten, nor the even earlier place I built as a boy to make a dolls' house for my sister: this love and understanding of tools is a private, almost

primitive experience of delight which every craftsman knows – it seems to be ingrained in one from the beginning.

For an artist, the quality of his craftsmanship must be judged on the degree in which, through perfection and through imperfection, it enables him to express his vision. One may be charged with bad craftsmanship for leaving marks where the chisel had bitten into the side of a foot or a rasp grazed the bridge of a nose. But to me the fashion (almost a fetish, and nothing to do with craftsmanship) for a machine-like finish which destroys the tool-marks is a heresy peculiar to the remote cold-bloodedness of our times and against humanity. The unconscious gesture of the hand passed down the ages by some unknown sculptor is emblematical of the creative energy of man – a universal signature.

My work is already ancient when it leaves my hands. I believe it has always been buried in me and in the stone. From having the potentiality of many different shapes it is revealed finally in a crystallization of these in the only way it could have been done.

I cannot say with Nietzsche 'for me an image slumbers in the stone', partly true as this is. It appears to me that there are at least three worlds of fantasy which fuse together in the final work of art – they come from the objective world, the mind and the material being used.

Let us say there is a point of life when the inner world explodes into the normal waking life and integrates all the reaches of the mind in the vision of a single poetic image, projected into the stone (conversely from the stone into oneself). From then on one is imprisoned by the stone – there is no escape. Drawings are made – sometimes they are done weeks before – perhaps not at all: the drawing for sculpture is a notation of that moment of explosion. But the instant the chisel starts its work yet another adventure has begun; moving into a third world of fantasy which grows from the material being used are the first two worlds which have already united, and this is the period which brings cohesion and life.

The artist submits entirely to the law and drive of his inner life and to the law of the stone, its grain, tension, gravity, and strength. He becomes an instrument through which these two sets of natural

laws are co-operating, rather than conflicting, to find a union in the created image, potential in the moment between all these forces.

He is not, therefore, working in a state of conscious will, using his intellect alone, but with it he is using his physique, instinct, emotion, and unconscious mental force, from which emanates his experience of the whole drama of human life. It is precisely this union of the worlds through the material that explains the paradox of unreasonability and illuminates our understanding through more senses than one.

In this way he is enabled to be *in* the stone yet looking at the image – which is also within himself – from many points of view at one time. The stone becomes a valley, a mountain, a twisted road; it is the curve of a falling wave, a dance, a journey to the stars. All these experiences are lived out in submission to a poetic idea, which, when it is made concrete, is something grown out of the fusion of objective, mental, and plastic fantasy, made to live in space by the mysterious force we call creative energy, the source of which we know nothing.

Perhaps that is one reason why, like the Tibetan mystical runners who fixed themselves on a star and could see it long after it had set, an artist will pursue his obsession to the end.

Each time a new idea thunders down, like a wounded yak, I tremble with fear and excitement – another adventure has begun.

From Denys Val Baker's 'Editor's Commentary'

St. Ives is one of Cornwall's most lovely holiday resorts. It also happens to be the home of Britain's largest art colony, outside London. This fact has undoubtedly added to what one might term the commercial 'glamour' of the town. Visitors have come from all over the world to see the work of various St. Ives artists, and while in the town they eat, sleep, drink, make purchases and generally bring profitable business to the tradesmen and hoteliers. Few of the latter would deny this; indeed, most of them are on the most friendly terms with the artists. This makes all the more disturbing the revelation that the St. Ives Town Council is contemplating

development action which may involve giving notice to quit his studio to Mr. Sven Berlin, the well-known sculptor. According to Mr. Berlin the council wish to turn his studio into a public lavatory. No alternative accommodation has been offered and after more than five years' work in the same studio, during which time photographs and reviews of his sculptures have appeared in newspapers and magazines all over the world, with resultant publicity for St. Ives, the artist is left with his future uncertain.

Without going into personalities, here is a case, and a possible precedent, which must give the most serious concern to all artists in St. Ives. Studios are hard enough to find without their being converted into lavatories by an over-zealous council. In fact, Mr. Berlin's studio stands in open ground on the Island, St. Ives, and there is ample space anywhere around for the erection of the required lavatory. It is difficult to believe – remembering the friendly way in which aldermen opened this year's summer exhibitions of the St. Ives Society of Artists and the Penwith Society of Artists in Cornwall – that the St. Ives Council really wish to pursue an action which will undoubtedly antagonise a large number of local artists, art-lovers and their friends. Now that Christmas is approaching, let us hope for a change of heart about this matter, so that not only Mr. Berlin but many other St. Ives artists may embark on their future projects unworried by the thought that their local council is unsympathetic to their efforts.

STOP PRESS

As we go to press St. Ives Town Council has issued a statement in regard to the studio controversy. The Council's view is:

Since the war the area has been inspected by several committees of the council concerned with its development and the pre-war plans discussed in detail. The provision of adequate public conveniences in a central position is an essential item, and the council have decided to build them on the site adjoining the studio let to Mr. Berlin. In this connection, the council gave an undertaking to Multi-Spring Mattresses, Ltd., when the rebuilding of the factory was discussed, to

remove the inadequate conveniences standing against the factory wall.

When the scheme is further proceeded with it will be necessary at some stage to take possession of the studio, and in order to enable this to be done the council have decided to change the terms of tenancy from a quarterly one to that of a tenant from month to month. The council have done no more than this, but obviously will require possession when development of this improvement scheme proceeds.

FRANCES BELLERBY

ARTIST IN CORNWALL

The bones of this land are not speechless.
So first he should learn their language,
He whose soul, in its time-narrowed passage,
Must mirror this place.

Then, speak as he ordered
In the clear and formal rhythm
Of soil and rock whose wisdom
Is the Word

Made Bone; command the sea-light
To release the pent, ingenious
Elements; precise, fastidious,
Sure, interpret

By arrangement, by choice. Meanwhile, blind-
Fold, fingertip, the true veins
Will hasten eager as fond slaves
To chart this land

By way of his own body – prove
The plan of the Bones, the fashion
Also of the changing Flesh, on
His image of Love.

W. S. GRAHAM

THE VOYAGES OF ALFRED WALLIS

Worldhauled, he's grounded on God's great bank,
Keelheaved to Heaven, waved into boatfilled arms,
Falls his homecoming leaving that old sea testament,
Watching the restless land sail rigged alongside
Townful of shallows, gulls on the sailing roofs.
And he's heaved once and for all a high dry packet
Pecked wide by curious years of a ferreting sea,
His poor house blessed by very poverty's religious
Breakwater, his past house hung in foreign galleries.
He's that stone sailor towering out of the cupboarding sea
To watch the black boats rigged by a question quietly
Ghost home and ask right out with jackets of oil
The standing white of the crew 'what hellward harbour
Bows down her seawalls to arriving home at last?'

Falls into home his prayerspray. He's there to lie
Seagreat and small, contrary and rare as sand
Sea sheller. Yes falls to me his keptbeating, painted heart.
An Ararat shore, loud limpet stuck to its terror,
Drags home the bible keel from a returning sea
And four black, shouting steerers stationed on movement
Call out arrival over the landgreat houseboat.
The ship of land with birds on seven trees
Calls out farewell like Melville talking down on
Nightfalls devoted barque and the parable whale.
What shipcry falls? The holy families of foam
Fall into wilderness and 'over the jasper sea.'
The gulls wade into silence. What deep seasaint
Whispered this keel out of its element?

W. S. GRAHAM

HYMN

White is our net but white the sea
That roars between us and the bay.
Haul to the nets. Now comes to me
His word that walked the ancient sea.
 Think us not lost, the sea that roars
 Is but His everlasting doors.

The sky is hidden and the gale
Falls on us with the stoning hail.
Haul to the nets. He hears our cry
And on the sea He walks us by.
 Think us not lost, the falling light
 Is but the shepherd of the night.

The night falls misty on the sea
And blinds the watchers on the quay.
Haul to the nets. So soft I heard
The loving kindness of His word.
 Think us not lost, the streaming foam
 Is but the blood of Jesu's lamb.

(To be sung to the tune of 'Eternal Father', Hymn No. 370, from *Hymns Ancient and Modern*, 'Melita', composed by Rev. J.B. Dykes.)

GUIDO MORRIS

CARNCROWS

High on the green headland, the white house;
Beneath, an ensanguined sea ...

High on the deep-scarped rock, the great room;
Without, a disquieted sea ...

High on four-square base, the white tower;
Withheld, the pondering sea ...

Above all, the lichen-coloured chapel;
And fishermen spreading the nets
Against antimonious sky.

GUIDO MORRIS

MY WORK AS A PRINTER

When I began printing in Saint Ives it was eleven years, to a week, from the time when I set up my first press in Somerset and proceeded to learn by experience how to print. For five years I had worked under difficulties; Army service had interrupted things by another five years; a year of hardships had followed in which I struggled to re-establish myself in London; and then, by sheer chance, I had come to Saint Ives. Like so many others, I expected to make only a short stay, and found myself rooted in the place. Saint Ives is like a fly-paper – or is it the lamp that attracts the moths?

I was lucky enough to find a large empty room on the edge of the sea – what is called a net loft; in mine nets had actually been made until a few years before. I installed myself in one corner; brought in a few large tables, a single chair, and a safe; and built myself an elaborate system of bookshelves and pigeon-holes for papers, out of margarine boxes hoarded from before the war. I spent several days with putty and flat white, and in the end my corner rather resembled the office of a business magnate with ideas about art; only the telephones were lacking – one imagined them concealed. The rest of the room was bare except for a divan and an old ship's tank turned on its side for a kitchen table and washstand; this had been salvaged from the beach below the house. I had gas installed, but for the first year I fetched water in buckets from my nearest neighbour's cottage.

Into this place on an afternoon in April 1946 my 'iron soul' (as Sven Berlin termed my press) came in a Government lorry from London, along with some three tons of miscellaneous impedimenta and a few hundred books. My troubles were by no means over. By this time I could always print with certainty of at least achieving a respectable job; my difficulty was still to find enough work. But I

had not been in Saint Ives long before I realized that I had come to an ideal town for The Latin Press eventually to flourish.

I had absolutely no capital and had to ask for advances on my first orders to buy paper. I was fortunate, however, in being in a position to get all the hand-made paper I could pay for, since I was on friendly terms with the people who make it.

Paper is the heart of my job; the rest of printing is its architecture. And the hand-made papers of England are unique; their *stuff* is what dreams may be made of – yet so little appreciated by printers in general that the bulk of it goes into filter papers and account ledgers. But from the beginning paper has fascinated me, and the genuine hand-made has always been my choice. Modern machine-made paper is beautiful and consistent, but it has relatively no character. Hand-made paper is full of character; and in mills where the same families for generations have employed the same families of workers, there must be an atmosphere of friendship inseparable from the feeling of the paper they make.

The first thing that I printed in Saint Ives was an alphabet. Using my largest type, the 72-point size of Bembo (the face I use exclusively), I printed a few copies on a specially attractive thin paper left over from before the war. It was just the twenty-eight letters of the Roman alphabet, and I only set up the type so as to have a forme to print with which to try out my ink and rollers. But I sent it to Gordon Craig a few weeks later. 'Like a piece of organ music …' he wrote. I still have a framed copy of the job in a corner of my room – where I do my typesetting close to the window overlooking The Island, Porthgwidden Beach, and the mutable, everlasting sea.

I had received a few orders before my equipment was even installed; some people from Richmond with an antique shop wanted stationery and a trade card. And 'Saint Christopher's', a most delightful sort of 'pension' in Saint Ives (one doesn't know how else to describe it, for it is not a hotel and not a boarding house), kept by Philip and Sally Keeley, friendly to all artists – had ordered notepaper, cards and various advertisement slips. They were my first local customers.

While waiting for paper to arrive I filled in time by printing a display notice for The Latin Press, framed copies of which eventually found their way into hotels and cafés in the town. The design was cruciform. The words of the notice – under the heading 'THE LATIN PRESS, The Private Press of Guido Morris' – ran 'HERE FINE PRINTING OF EVERY DESCRIPTION, INCLUDING HAND-MADE NOTEPAPER, IS UNDERTAKEN TO THE GLORY OF GOD AND OF THE ARTS OF PEACE'. It was a fitting announcement from one who had just found sanctuary after the long years of war.

The next exciting thing I did was an Invitation to the 26th Anniversary Exhibition of The Leach Pottery, held at the Berkeley Galleries in London, followed by a Chinese dinner. Of this job forty-five copies were required by Bernard Leach, and I printed almost every one on a different paper. The job was designed as a tall oblong, with the wording in smallish capitals running sideways down the centre of the sheet. From a distance it suggested Japanese or Chinese printing (as was, of course, intended), and it has always irritated me when people have turned it on its side to read it. I had a collection of Japanese papers, and used up the best of my collection in printing this job; while a few were printed on antique English papers collected over a period of years. It was well worth the expenditure of paper, because even now I occasionally meet people who tell me that they saw the invitation in London in 1946, and have remembered it.

That first summer in Saint Ives was one of brilliant sunshine, of mad crowds in the town, of festivities in the evening. Saint Ives was at its most 'Continental' – and this was a character of the town which struck one very forcibly on arrival from London. It was the first summer after the war, and people had money to spend.

One evening in the late summer I was introduced to The Toymakers – who had just settled in Saint Ives and were going to make wooden toys. I wrote them copy and printed a display notice announcing 'The Wooden Toys of Saint Ives' – which I redesigned about a year later. The second version, printed on an early nineteenth-century paper, was better than the first; it and another

done about the same time for Robin Nance are two of my most successful displays.

The 'Basket of Flowers' – the pressmark of The Latin Press – figured in all these jobs. Its history is not without interest. The block – a piece of boxwood beautifully carved (I say 'carved' deliberately, because it seems more than engraved) – was sent to me by Gordon Craig in 1937. He had found it in a printing office in Lucca many years before and carried it around with him. He sent it to me in case it should, as he put it, come to life in my hands. I straightaway used it on a job – the second of the series of quarto catalogues I printed for R. E. A. Wilson – and it was so successful in relation to my type that I used it on another job, and then others, and so gradually it came to be adopted as my signature.

The block is presumably late eighteenth-century French or Italian. It is evidently one of those little devices which are used in books of about that time as ornaments at beginning or end of chapters, but it is one of the nicest of these that I have ever seen. I always wonder if it is to be found in a book, as it is quite likely that it was used. One day I may make a pilgrimage to investigate the archives of printing in Lucca, to discover some sign of it. I have had a metal replica made of the little block now, but I still often use the original.

In July 1946 was held the first annual exhibition of what became known as the Crypt Group. I printed a catalogue, on very white paper, measuring 7^1/$_8$ by 3^1/$_2$ inches, and this tall, narrow shape gave me scope for a most interesting cover; it was printed in black, with red sparingly used. I employed a device which has precedent at least from the earliest sixteenth century. The word CATALOGUE was too wide to fit the measure of the page, and I set CATALO in large capitals, duly letter-spaced, and in much smaller capitals on the next line GUE OF AN EXHIBITION. For some time the 'catalo' was spoken of with relish!

This first exhibition held in the Crypt of the New Gallery, 1946, consisted of 'Drawings, Paintings & Sculptures by Sven Berlin, John Wells, Peter Lanyon & Bryan Wynter, & Printings by Guido Morris'. It was perhaps the first time anywhere that printing had

been exhibited side by side in an art gallery with drawings, paintings and sculpture. The exhibition was followed by another in August 1947, for which a not quite so successful catalogue was printed by me. In August 1948 the Group gently expired, with its third exhibition.

This constitutes a fragment of the history of the Saint Ives artists' colony; all the members of the original Crypt Group, and all those who became allied to it in successive years, are now members of the new Penwith Society of Arts in Cornwall. Unlike the old Saint Ives Society of Artists, the new society at last embraces the craftsmen – Bernard Leach, Robin and Dicon Nance and myself in Saint Ives, and several others in other parts of Cornwall.

In the spring of 1947 I began a more ambitious job. Mr. G. R. Downing had opened his bookshop in Fore Street, and having a spare room at the back of the shop he decided to use it as an art gallery. Here were held small one-man shows of the work of the younger group of artists and I was asked to print the catalogues.

Nine catalogues appeared in the rather lavish form used by me exactly ten years earlier for R. E. A. Wilson's exhibitions in London. They are not all as good as I would like them to have been; I rather overdid the thing in trying to make each different in appearance, and they had to be produced at short notice; but at least five of them are wholly successful. They were instrumental in getting me work for London galleries in the following year.

In 1947 and 1948 I did a considerable amount of London work, notably for the Marlborough Galleries in Bond Street, for whom I have printed catalogues and posters. Among these are some of my first experiments with colour, and a poster printed for their exhibition of early water-colours and drawings by Toulouse-Lautrec has been several times exhibited. The order for a catalogue for the Tate Gallery's centenary exhibition of the Pre-Raphaelite Brotherhood came at a time when I was struggling with financial and other difficulties; there was a delay in delivery, and the presswork was inferior, so that an otherwise fine catalogue was marred. It was not until this year, 1949, that the addition of some much-needed capital made possible a total reorganization of my

workshop, with installation of new equipment and the institution of adequate routine.

Posters have been a favourite job of mine in Saint Ives, made possible by the finding of a second and larger Albion press. This had formerly been used for printing the *Hayle Weekly News*, a local newspaper emanating from a small jobbing office in Hayle. The precedent for my posters was established by the series I printed for the Repertory Theatre at Northampton on the eve of my entry into the army. A member of a university dramatic society happened to see them while on holiday in Saint Ives, and I was commissioned to print bills for their twice-yearly plays. Besides working for the Marlborough Galleries, I have made posters for several other London galleries and for many exhibitions held in Saint Ives, notably those at Downing's Bookshop.

The first thing I always do when I get an order for a poster is to induce the customer to leave out most of the copy! This is not a personal fad; the result is a far more arresting display, for most people tend to say too much.

For the Saint Austell Brewery Company Limited, an enlightened and progressive business organization, I am printing a series of broadsheets; these are being fixed in weatherproof frames outside certain of their houses, and explain the origin of the inn signs and other points of interest concerning the history of the inns. They afford an opportunity for the use of larger sizes of text type than are ordinarily called for, and those examples which were exhibited in a recent exhibition of inn crafts, in London, won prizes.

As a result of my connection with the brewery, I am now about to submit designs for the redrafting of their general stationery, including menu cards; and I have no doubt that this will lead to work in the same direction for other firms who value the effect that may be produced by discreet and careful printing.

I am often asked why I prefer 'job printing' to the printing of books. Partly it is because a book is too large an undertaking for so small an office, and for the present I shall continue with the kind of work I am doing. The field of book *design* is one which cannot be so easily escaped; and it is probable that in the near future I shall

increasingly undertake such work for publishers. In doing this, however, I shall work not as a 'typographer' but as a craftsman printer who handles type; I have never made a 'layout' in my life.

Above all, I find job work interesting, because of its variety; and I believe it is important, because it has been so much neglected by fine printers as a whole.

E. W. MARTIN

'Q'

In the course of his life Sir Arthur Quiller-Couch exhibited an energy and an enthusiasm for literature not surpassed by that of George Saintsbury. But whereas Saintsbury was invariably true to type, always the scholar and researcher, Sir Arthur's impact upon his generation suffered by the very variety and abundance of this novelist, short-story writer, poet, critic, anthologist, and journalist.

It is too early yet to make up one's mind about 'Q's' position in literature, to winnow the more permanent of his works from those which were mere preparations or promises. In his excellent biography Dr. Brittain is only incidentally occupied with literary criticism; he has salvaged from a wealth of personal memories and by industrious research a whole portrait of this stoical and captivating man of West-country stock who was born at Bodmin in 1863, and whose life thereafter was bound up indissolubly with Cornwall.

The brevity of an article, however, does provide an opportunity for tentative enquiry into some of the reasons for supposing that this life so full of causes and purposes, had two dominant ones; and for the belief that the critic and lecturer, the poet-citizen of Arnoldian stature who did so much to mould the taste of his juniors, spreading culture lavishly as the daily adornment of full living, will outlast the writer of fiction.

The first of 'Q's' purposes is to be seen in his fiction-writing phase, which began in 1887 with the Stevensonian romance *Deadman's Rock*, and ended with *Foe-Farrell* in 1918. His first novel, therefore, was written in imitation of *Treasure Island*, and his last bears some resemblance to Stevenson's bizarre schizophrenic study, *Dr. Jekyll and Mr. Hyde*. On the basis of such facts the reader might bracket 'Q' with such romancers as the irresponsible Rider Haggard and with John Buchan, though he is as much their superior stylistically as he is Stevenson's superior in intellectual toughness.

Quiller-Couch was never merely an aesthete. He constantly kept in mind the social function of literature, but one cannot escape the conviction that he chose novel-writing not because inherently adapted to the form, but in order to acquire an audience, to get a platform from which to speak with Attic grace on a variety of themes. In his development 'Q' can be compared to Thomas Hardy. Hardy gave up writing novels because of hostile criticism and because his approach to literature had always been poetic. He was at that time fifty-seven years of age; 'Q' was fifty-five when he ceased to write imaginatively. Change in the nature of his responsibilities, due to a university appointment, no doubt influenced him considerably, but an examination of his novels does not suggest that he ever gave himself fully to fiction. In some of his short stories, like 'The Paupers' from *The Delectable Duchy*, the quality of the man is movingly felt; and in his novels there is style, dignity, humour, and yet the narrative is not always moulded to the theme, the tales do not seem like unities and are saved from mediocrity by their style and eccentricities.

'Q' disliked and distrusted all indiscriminate usage of such terms as 'classical' and 'romantic', but he defined them, when forced to do so, as follows: 'It amounts to this: some men have a sense of colour stronger than their sense of form.' 'Q's' sense of form was never highly developed; he was not the supreme technician as Stevenson was; but his sense of colour was notable. He was a romantic; his world was a supremely human world; he never forgot that it was life he was writing of as a novelist, that reality which, if mirrored artistically, produced Literature.

When all is said, 'Q' is much too large a figure easily to occupy the particular corner in imaginative literature which somehow has become his own. In the course of his thirty years as a novelist 'Q' created literature. He was the greatest of the Cornish novelists; his second novel, *The Astonishing History of Troy Town*, with its comic characters and gentle irony, deserved to be what it has since become – a Cornish classic. Even this book and the historical romances do not rise to greatness; they cannot be compared with Hardy's Wessex chronicles.

If we read now *The Splendid Spur*, *The Westcotes*, *Hetty Wesley*, or any of the novels dealing with particular periods of history there is a recognition that here was one who could tread 'Alp-high among the whispering dead'; a historical novelist as colourful as Hewlett, with as broad a sympathy, a greater scholarship and an equal love for old manners and customs. It would be an error to say that 'Q' failed in *The Splendid Spur* or *Hetty Wesley*; more correct to observe that he never attempted a full-scale historical novel, remaining content with a narrow canvas compared with the vast backgrounds of historical novels like *The Cloister and The Hearth* or Scott's romances.

Two novels for which 'Q' himself had an affection are *Sir John Constantine* and *Foe-Farrell*. In the preface to the first-named, 'Q' writes: 'If you would know anything of a friend who has addressed you so often under an initial, you may find as much of him here as in any of his books.' And what we find is a youth in love with adventure, easily moved to kindness, fearless and full of an insatiable curiosity about life. The narrative is slow-moving, but the book is full of facts about Cornwall, and 'Q' is as prodigal with tit-bits about his beloved Duchy as Phillpotts is with his descriptions of Dartmoor antiquities.

Foe-Farrell is a more complex work of art, the mode of its telling not such as to make for easy reading. The novel has real power, however, something of 'Q's' sense of the evil of war and the futility of hatred; the theme indeed might well be not the futility but the danger of hatred, which binds one as close as love to the object of the emotion until, like Foe, we become what we hate. The first world war brought grief to 'Q' in the loss of his son, and this loss of buoyancy may have caused him to turn in his maturity to other things than the writing of novels.

Never given to over-confidence, 'Q' took up his work as a Professor of English Literature at Cambridge warily. This Oxonian had a fortress to scale when he delivered his inaugural lecture. He brought the trained and practical literary sense of a professional writer into the halls of Cambridge, confounding with his eloquence and erudition those who supposed that a popular novelist would be

deficient in classical knowledge. Ever a fighter in the cause of learning, 'Q' soon earned respect in Cambridge as he had earned it in Cornwall. At this stage began what appear to be his most natural and fruitful tasks: the education not only of students at the University, but of that wider audience he had gathered round him as a novelist.

Perhaps the best known of his critical writings is the volume of reprinted lectures *On the Art of Writing*. In this book 'Q' speaks with undisputed authority. His style is ideally suited to his subject; and he brings to that subject a great wealth of knowledge, a contempt for pedantry, and a gentle humanity ever full of wonderment for the riches of the past. Here is a mind enriched with the heritage of a universal culture, capable of carrying forward the work that other scholars had begun. In the companion volume, *On the Art of Reading*, 'Q' is perhaps even more personal in his approach. He speaks of the work of Furnivall, Skeat, and Aldis Wright, men who were pioneers in the teaching of English, provincially-minded men who had to extol Anglo-Saxon culture because Europe had ignored it. Although he knew their weaknesses 'Q' did not share them, he saw culture as something above nationality, and he could say with pride and humility: 'If I presume to speak of foibles to-day, you will understand that I do so because, lightly though I may talk to you at times, I have a real sense of the responsibilities of this Chair. I worship great learning, which they had; I loathe flippant detraction of what is great; I have usually a heart for men-against-odds and the unpopular cause.'

The proper teaching of English was for long such an unpopular cause, and throughout his career as a writer and lecturer 'Q' was the enemy of all pedants and unintelligent schoolmasters, never accepting the notion that learning was for the few: 'I say to you that Literature is not, and should not be, the preserve of any priesthood. To write English so as to make Literature, may be *hard*. But English is *not* a mystery, *not* a Professor's Kitchen.'

'Q' never tired of reiterating that literature is a personal thing that cannot be divorced from life. He wanted it to illumine and to stimulate all life: 'I believe that while it may grow – and grow

infinitely – with increase of learning, the grace of a liberal
education, like the grace of Christianity, is so catholic a thing – so
absolutely above being trafficked, retailed, apportioned, among
"stations of life" – that the humblest child may claim it by indefea-
sible right, having a soul.' So, when he addressed students in the
University, 'Q's' mind's eye would picture a group of little children
in cold Cornish schools, monotonously droning out meaningless
passages to a weary teacher; or he would see a poor scholar, lonely
as Jude, striving to overcome insurmountable obstacles.

'Q' takes his place naturally among the great critics – Sainte-
Beuve, Coleridge, Matthew Arnold, Hazlitt, and even Saintsbury –
who brought to their criticism something new and memorable.
'Q's' contribution was his thoroughness and his range, his attention
to background and detail. As Sainte-Beuve was a natural historian
of minds, 'Q' was an explorer and a collector. He could write on the
poems of Hardy, the novels of Henry Kingsley, the poetry of
humble William Browne, and always he left his subject larger than
he found it. 'Q' will be remembered as a great critic and as the
editor of *The Oxford Book of English Verse*. His anthologies of prose,
ballads, and sonnets are still read with pleasure by those who have
come to rely on his judgment. 'I like to think,' he says in his preface
to *The Oxford Book of English Prose*, writing of his predecessors
Cannan and Waller, 'that, when my time comes in turn, I shall
survive in the Oxford Books of English Verse and English Prose
along with these two good men.'

The career of this scholar is a remarkable testimony to versatility
and integrity. He loved Cornwall much, and was editor of *The
Cornish Magazine*, which ran for four numbers and set a standard
difficult to maintain. During his lifetime it is not too much to say
that 'Q', populariser-in-chief among the Duchy's worthies, was its
major novelist and critic, its chief educational adviser, a vigorous
political figure, a yachtsman and a lover of the sea who was, in the
words of Maarten Maartens, King of Fowey. In fact, for those who
wanted a general view of the county, to become familiar with its
alien atmosphere, 'Q' *was* Cornwall. When he died the pilgrims still
came to look at his house by the harbour, where he had spent so

many useful years. It is a safe bet that the generation 'Q' helped to educate will carry his ideals with them in their work and, remembering his teaching, will honour his memory and return at times to renew their faith in one who threw so much light on their age from the torch he carried.

JACK R. CLEMO

THE HOCKING BROTHERS

Some of the finest imaginative writing of the past century has been produced through the revolt of sensitive minds against the close pressure of organised religion. Personal insight has outgrown the formula, or the current 'climate of opinion' has befogged it, and the resulting quest for another medium of faith has involved literary self-expression in a variety of moods and forms. Sometimes the explosion of creative life has come from an individual in solitude; here and there several members of the same family have defied the authority of tradition and written out their protective heresies. And where the revolt has been most intense the new vision has drawn to itself the aesthetic tone and idiom of the landscape amid which it was evolved, and fused with the deepest strata of racial inheritance. The Brontë sisters rebelled in their Haworth parsonage, and Emily, whose protest was most vehement, imbued her work most powerfully with the bleak spirit of the Yorkshire moors, as well as with the mystic melancholy that was in her mother's Cornish blood. Later the Powys brothers reacted against the conventional life of the Montacute vicarage and produced novels that blend the Celtic romanticism of their Welsh ancestry with the living soil of contemporary Dorset.

The revolt of Joseph and Silas K. Hocking against the shackles of the Methodist ministry belongs to the same period, and, in its degree, reveals the same process. It was a symptom of Victorian restlessness, the growing distrust of the pulpit, the craving for new ideas and new methods. But their motive in abandoning the ministry in order to write popular fiction was entirely wholesome, and I approach their work with the diffidence of one whose revolt has been of the less respectable kind. I have met the greatest of the Powys rebels, Theodore, and felt completely at home with him in his Dorset cottage. The Hockings I never met, and had I visited

either of them I should have felt embarrassed. Despite the fact that they and I are sons of the same parish, and the probable derivation of my talent from them, I feel that I have lived all my life in a Cornwall they never knew and could never have attempted to describe. But they were Christian rebels, and this brings a sense of spiritual kinship across the temperamental gulf.

The course followed by Joseph and Silas from the miner's cottage in which they were born to the college in which they were ordained has too many parallels to be worth detailed notice. It is their subsequent break with the ministry and their emergence as best-selling authors that gives them their niche among Cornishmen who have achieved something unique. Had they been rebels of greater stature they would have been more recognizably Cornish; but their rebellion was not sufficiently profound to release the deeper racial truth, or the intimate awareness of the land in which they were nourished. They wrote for the masses and were read by the masses, and their Cornish origin was almost irrelevant to their aims and accomplishments. It is significant that when they first came before the public as novelists they were not immediately disclosed as Cornish writers at all. Their service in the Methodist ministry had taken them away from Cornwall; they had studied social conditions in large cities – Silas in Pontypool, Manchester and Liverpool – and they wrote in a mood of moral indignation, and evangelising fervour. Silas's early stories, *Her Benny* and *Dick's Fairy*, were tales of slum life in the Midlands. Only when they had established themselves as representatives of the 'Non-conformist conscience' did they entertain their readers with novels of adventure and romance in Cornwall.

In considering them as Cornish writers, therefore, we have to notice certain inhibitions that may have resulted from the early struggle which made the associations of their childhood distasteful to them when they had escaped to a higher social level. In Silas's reminiscences, *My Book of Memory*, there are practically no Cornish scenes; he records nothing of those poverty-stricken early years in the dour little cottage on Terras Moor, the narrow flat waste between Meledor and St. Stephen's. The clayworks with their

powerful symbolism, the idiom of the new, industrial Cornwall, were beginning to scar the hillsides all round when Joseph and Silas left home for college. This fresh land, teeming with craggy and purgatorial images, awaited its interpreter: there was religious mystery in the crossed tip-beams pointing skyward; erotic mystery in the sharp white breasts of rock that were cleansed for the kiln-bed. But the Hockings saw these features only as signs of a messy industry with which they had no concern. They turned away to the fashionable world which provided them with material for naïve tales of society life and for Silas's book of amusing anecdotes about the celebrities he had met.

To accuse them of dishonesty to the Cornwall they had known would be easy, but hardly just; for they had known it only with the surface of their minds, that surface which registered normal tastes and reactions. They were rendered impotent as creators and inter-preters by the very wholesomeness of their mental texture. Silas in his later years condemned modern novelists of the D. H. Lawrence calibre as 'excessively morbid'; but the key to all original interpre-tation lies in the abnormality of approach that is usually called morbid. Lawrence evoked more of the essential Cornish character in a dozen pages of *Kangaroo* than the Hockings could do in a score of novels – precisely because he was 'morbid,' reacting simply and sensuously with the living flow of his subconscious mind. But the Hockings did not even attempt the superficial yet detailed portrayal of the Cornish background which we find in such novels as Crosbie Garstin's *The Owl's House* and Compton Mackenzie's *Carnival*. When they relaxed from their moral propaganda they could give a convincing sketch of the more conventionally romantic areas of Cornwall – the St. Ives district in Joseph's *The Sign of the Triangle*, Pentire and its environs in Silas's *Nancy*. But such passages are brief, journalistic impressions, done from without. The following extract from the former book is a fair sample:

The sun was shining gloriously as he left Tregenna Castle Hotel, and as he passed through Carbis Bay he could see nearly thirty miles of the north coast of the county ... The car passed through the quaint

little village of Lelant, after which, until he reached Helston, there was little to attract his attention. After he had passed this pleasant little town, however, and then turned aside from the main Lizard road, the beauty-loving eyes of the young fellow were charmed by the scenes through which he passed. Someone had once told him that Cornwall was a treeless county, that it was bleak, barren and forbidding. While this might be true of the north coast, it was utterly untrue of the scenes through which he was now passing.

It will be noted that even here the admission of bleakness is made concerning the north coast, not the clay-bearing region in which the writer's boyhood had been spent. The inhibition was complete, and was probably complicated by his Methodism; for although there is a grey intensity in some of his writing it reflects the general Nonconformist spirit rather than anything specifically Cornish.

What, then, of the Hockings' revolt? It seems petty enough, that break with the connexional rules of a denomination; and the break did not come because they were in the throes of a spiritual upheaval out of which a new concept or synthesis might be born in solitude. They became more than ever involved in public life after they had left the ministry. Silas admitted that he had resigned 'because I found that many of the beliefs that I had held in my youth had inevitably changed.' But he had no vision of his own to substitute for them, no poetic or mystical insight; he could hand out nothing but a watered-down statement of the creed held by other Nonconformists. His later novels became rather tediously ethical as his grip on theology loosened, and his rebellion fizzled out in a tired idealism and a vague hope that the League of Nations could do something to put the world right. 'We should be happier if we could keep our illusions,' he wrote in his reminiscences, 'but they fall from us one by one. I started out with drawn sword to slay the giants of intemperance and impurity and war, and I have lived to see them increase in strength and grow more formidable year by year.' He was really bewildered, but he kept up the fight. He entered politics, being defeated as Liberal candidate for mid-Bucks in 1906 and for Coventry in 1910; he lectured and travelled widely, though

seldom visiting Cornwall. Joseph was the better Cornishman: he lived for many years in the county and died at St. Ives; he preached in Cornish chapels, served on Cornwall County Council, and in 1924 returned to his native village to open the Recreation Ground which borders the churchyard in which his ashes are now buried.

To condemn such energetic and adaptable men for not being mystics would be absurd; but the absence of the genuine Celtic spirit in their outlook does call for comment. Obviously they would have gained nothing by brooding among the clay-dumps. It was not for them to spend their lives 'in outlawed glee amid the squelching mud,' as I was destined to spend so much of mine. Nor could they have joined the company of those rural authors who, in Theodore Powys's words, 'read not the fantastic artistry of the modern story, nor yet the wordy wisdom of the schooled pen, but read instead the human writings writ in the mud by the terrible One who stoops to write in the crust of the earth.' Yet this is the true Celtic vision, the vision that should rise instinctively in an imagination which is an offshoot of centuries of semi-tribal blood-intimacy under the Christian symbols. D. H. Lawrence felt this primitivism in the Cornish people, yet until recent years no Cornish writer had even hinted at its existence. 'Q' wrote on a far higher intellectual and artistic level than the Hockings, but he was as devoid as they of this elemental mystic awareness, the sense of 'mud and Godhead' in the Cornish texture. Did they leave the county too soon before it had really spoken to them? Or was there an innate fastidiousness that made them recoil to the protection of civilized and cultured life? They certainly lacked the Celtic capacity for obsessions which might be expected to show itself in Cornish writers no less than Welsh and Irish ones.

Like many able and earnest men, the Hockings sacrificed depth to versatility. They knew that the Protestant faith was being assailed from numerous standpoints, and they wished to defend it all along the line. Thus Joseph wrote several novels warning Free Churchmen of the danger of Roman Catholicism, then switched his attack to spiritualism and theosophy (*Zillah*), to the materialism of Big Business (*God and Mammon*), to Modernism (*The Man Who Was*

Sure). Sometimes in his crusading zeal he countered two anti-Christian forces in the same book, as in *Strange Inheritance*, where he takes his chief characters to Palestine in order to refute cultured scepticism, then brings them back to the Midlands to meet the menace of Communism among factory workers. All these novels were written with an integrity and sincerity which deserves respect, and as stories they enthralled thousands of readers. But because of the continual dashing from one part of the battlefield to another, there is a mere skirmish at each point; the basic issues are scarcely touched.

This superficiality in the Hockings' work is most obvious when they attempt to 'slay the giant of impurity'. Their revolt had not gone far enough to rid them of Victorian sex-taboos. Silas in his old age advocated divorce law reforms, but here again it was only a surface rebellion. There are a few touches of realism in the Hocking novels – an illegitimate child, a forced marriage, a reference to sexual vice – but they are introduced with the utmost decorum and the reader's interest is immediately switched to the 'wholesome' world of virtuous normality. One may applaud the stand for true wholesomeness – which is a matter of belief, not of temperament – and still regret the Hockings' adherence to the Victorian type. It limited their grasp of reality; for the great movements of Christian truth always synchronise with a renewed penetration of erotic mysteries. It is no mere coincidence that when Lawrence left Cornwall to write *Kangaroo* with its reiterated theme: 'God is God and man is man and every man alone by himself,' the same conclusion was blasting the European theological world through Karl Barth's terrific onslaught on idealism in his *Epistle to the Romans*. There are marked affinities between the Barthian doctrine of the transcendent 'otherness' of God and Lawrence's final assumption of his 'dark gods' into 'the living God'.

This is not irrelevant to the Hockings' careers; for the chief purpose of their writing was the maintenance of the Protestant faith. And that faith could only be preserved in the way in which Barth and his followers have, in fact, preserved it – through a fresh probing of the perilous and unknown depths of the Word of God

and the whole personality of man. It is a task for rebels only; and when the Hockings broke the shackles of ministerial routine, the chance was theirs. Perhaps they took it to the limit of their capacity: I am not sure. They made a notable contribution to the Evangelical witness of their time: Silas's early work, and all of Joseph's religious novels, must have strengthened the faith of many. In their combined output of over a hundred and fifty books there is much shrewd observation and comment upon current problems. They probably did not expect their writings to survive; they had no illusions about their literary stature. Joseph's work will, I think, outlive his brother's, not only because he was on the whole the better story-teller, but also because he was less dated by fashionable dilutions of his theme. He came nearest to the ideal of the Christian rebel in the literary world, and if he failed to realise the complexity of that ideal it may have been because in his youth he did not, and could not, receive the piercing message of the clay-lands.

JACK R. CLEMO

THE AWAKENING

Fate meant that I should walk our earth
In derelict disguise,
Shuffling beneath these icy Cornish skies,
Aware of menace from some hudden sea,
The flicker and pulsation, magnetism
Of cold inhuman currents working schism
In the sharp thorn's shadow, sagging fast
Over the silent clay-world dearth,
The scabbed anomaly
On which the ironic stars look down
With baleful frown
To await the last
Convulsions of the smitten heart
When hopeless trust has failed,
Thorn pierced too deep and pull of the tide prevailed.

There is but one escape from Fate's dream-sodden groove;
With its direction all the moods of our existence move
Once we are set apart.
Even genius sinks,
Swallowed within the vortex of its nature's need
And thrusts to light putridity decreed
By rootless fibres' friction with the tide that slinks
Through every cleft of our mortality.

I might have sunk so, helplessly, and lent
To mediumship of the dark unknown
A sickly soul's integument
Of poisoned blood and furtive bone.
But I found, besides my thorn, another Tree

In the clay-waste, and an answering surge
Of the pure female stream
Rocking and flooding to submerge
My fate, impassioned to redeem.

JACK R. CLEMO

ALIEN GRAIN

Two worlds and yet one substance:
The grey sand of refuse, the yield
Of machines in a dark pit,
And close to it,
Dwarfed on the spring-sunned field,
Brown glistening heaps of sea-sand, like a chance
Deposit of alien tides
That leave a far sea's fertilizing grain
To challenge dereliction's stain.
Wave-washed injection, the salt sand divides
The clay field from the fate of clay:
Harvest from gold shall rise, defy the grey.

If my world then be sand it need not
Be sand of the pit, the outcast
Scab of sterility, left to rot,
Ignoble. What though my past
Be a clay-land folded in,
Shuttered by refuse from the inexorable
Scarred womb of mortal sin?
I have a soul, a field ever bared
To the Heaven of miracle,
Lying within the ancestral vomits, yet
Fresh with the tang of surf where seaweeds fret
Unblasted rock. Thus I am spared;
And to my gravelly land
Christ brings from margins of His sea
The golden treasure, spilling secretly –
His fertilizing sand.

ARTHUR CADDICK

THE LIGHTHOUSE

Assuming turn of duty from the day,
The lighthouse flashes intermittent light,
Which carves the Cornish sky, then dies away
And leaves behind the emphasis of night.

Doctors of Calvinistic chemistry
Resolve our virtues, sins, our lives, our whole,
To vile predestination of the glands,
Their lens reveals invisibility,
Intangibles touch antiseptic hands,
The indexed specimen's the human soul.

Man, on tormented odysseys of hate,
Sees, with his sad and scientific eyes,
Vast beams of hope and peril alternate,
Nor looks for bearing from the ancient skies.

No longer trusts his navigating heart
That regal movements of a hand sublime
Have plotted him some final port of call,
Since chance-fused molecules became the start
Of meaningless trajectory through time,
And left no point in compasses at all.

Give me my simple darkness, cries out man,
Blind in the glamour of a million amps,
Give me my darkness back, that I may scan
My shadowed home by soft, mysterious lamps.
Where are my genial gods, where are they fled,
Before whose wrath the stiffest neck might bow,

Who smiled on harvests and the vine-leafed head,
Where are my kindly gods, where are they now?
Must that sick fungus on the human brow,
Must Jean-Paul Sartre play Jupiter instead
To mirthless hedonists, obsessed with crime,
Who crawl to death through putrid wastes of slime?

Life's landmarks gone, faith's beacons failed, distress
Stammers through space its endless SOS.

J. P. HODIN

BEN NICHOLSON

It was at the end of the war when for the first time I saw one of Ben Nicholson's more important exhibitions. They were paintings from his most recent period of work, compositions, some smaller some larger, of circles and rectangular forms, sensitive lines, intense colours, then again complete white pictures, in which the only tones came from shadows, which appeared on closer view to be bas-reliefs. The exhibition left an impression of the same constant quality and clarity, something very exact, eliminating all vagaries, following its own laws, coined by a scientific spirit. All the work seemed to express one formula and yet at the same time something disquieting emerged from them. I did not know how to approach this art. I began to analyse my impressions and arrived at certain rational conclusions. I found that its stability in the unstable times in which we live produced a calming effect. I found a conscious leaning towards a classical formative tendency, in opposition to all the psychopathological romanticism of the surrealists. I found this art very typically English, remembering the strong classical tradition in English architecture and its sense of severe proportions, very typically protestant in reducing the sensual to certain precisely limited strong colour planes. In addition, it showed a relationship to contrapuntal music.

As I have said, I arrived at these conclusions more by a rational than by an intuitive process, which irked me; for art, I thought, should speak primarily through the senses to the mind. My doubts were further strengthened by the remarks of an impressionist painter. 'Nicholson is an architect plunged into painting,' he said. 'The fields are so beautifully green just now, how can he leave it to others to paint them?' I said: Everybody builds the world in which he can live. I do not doubt the sincerity or the taste or the talent of this artist. What is it, then, that makes him work like that? Such

things the artist does, either with pleasure or he is killed by them. I remember having read how Bertrand Russell defended his philosophy of logical analysis, which accepts only an absolute unshakeable objective truth. He said that the aims of this school are less spectacular than those of most philosophers. It refuses to introduce metaphysical muddles into mathematics, and intends to purge its subjects of fallacies and slipshod reasoning. This philosophy contains a kernel of critical self-limitation. In the same way Ben Nicholson consciously renounced, in one period of his development, the representational. Perhaps, I thought, one can learn to see the beauty of this art without approaching it only through the intellect.

W. Kandinsky said once: 'The acute angle of a triangle in contact with a circle is no less effective than the finger of God in contact with the finger of Adam in the painting of Michelangelo.' Here it is indicated that the reason for abstraction from reality is to reach the objective. That artists like Ben Nicholson strive for such a goal I see in the words of Piet Mondrian: 'If objective vision were possible, it would give us a true image of reality. The vision of the new man has liberated itself ...' That is the philosophy behind abstract painting, what is the quality of its style? 'The limitation of the means employed,' says Braque, 'gives the style, produces the new form and stimulates creation. The limitation of the means is often the reason for the charm and power of primary painting.' Here we are on the tracks of Ben Nicholson's reason for using pure geometric forms. What does he say himself? 'Realism,' we read in one of his statements, 'has been abandoned in the search for reality. One would like to spell it with a capital R so that the reality in art may be distinguished from the reality of tangible things. The principal objective of abstract art is precisely this reality. Painting and religious experience are the same thing. It is the question of the perpetual motion of a right idea.' Here we stop short a moment. Religious feeling and abstract painting, do they not belong to a different sphere of sensation? In another of his statements Ben Nicholson quotes a speech of Eddington's published in 1931: 'Not only the laws of Nature, but space and time and the material

universe itself are constructions of the human mind. To an altogether unexpected extent the universe we live in is the creation of our minds. The nature of it is outside scientific investigation. If we are to know anything about that nature it must be through something like religious experience.' Here Ben Nicholson breaks in with: 'As I see it, painting and religious experience are the same thing, and what we are all searching for is the understanding and realization of infinity – an idea which is complete with no beginning, no end, and therefore giving to all things for all time.' In these words the constructive ability of our minds which involve hypothesis for physics and style elements in art, is made the equivalent of the creative faculty and has something absolute in effect corresponding to the 'Idea' in Plato's philosophy, to the *a priori* experience in Kant. It is the same way as that by which Spinoza arrived at his conception of an ethic 'more geometrico'; as Descartes used in his *Discours de la Methode*. Form is the created against the uncreated, is cosmos against chaos; abstract form seems to be the elemental, the unchangeable against the eternally changeable – the *panta rei* of Herakleitos.

I had imagined Ben Nicholson as an academic type, a physicist, rather dogmatic and intolerant, inclined to theorize, isolated and reticent. I was met by an agile man of small stature, with light feet like a dancer or an acrobat, and finely modelled physique, a man of youngish appearance in spite of the slightly greying hair round his characteristic head. His face, with its slight strain of sarcasm round the mouth, resembled Voltaire. Nicholson is witty and inclined to take a word as a starting-point for a humorous sally rather than for a serious discussion. 'Talking is a difficult way of communicating for me,' he said, 'that's why I prefer games. A game creates a personal contact without words.' And so it is. Ben Nicholson is enthralled with ball games. When one meets him on his bicycle wearing a white cap or a blue beret, he is on his way to the golf links, sometimes it may be to the landscape to draw. He loves tennis, and he has himself invented all kinds of ball games. Two rust-brown cats, every muscle tensed, watch the round object as it flies hither and thither. 'Do you love billiards too?' I ask. 'Of course; I spent one

term at the Slade School of Art in London in the year 1911, where I played billiards.' And the aesthetics of a tennis court, a billiard table, a golf links, with its greens and fairways, the small flags and the golf clubs, has very much in common with Ben Nicholson's pictures.

Have I not just said that Ben Nicholson often cycles into the country to draw? An abstract artist? Yes, he likes to draw from nature. The structure of Cornwall, where he has lived since 1939, seems to suit him. 'Look,' he says, and points to one of his bas-reliefs in brown colours, 'isn't this like Cornwall? Abstract painting comes from looking at the sea, the land, the sky, it is visual experience. How could it be anything else? One is what one has seen,' and he smiles his mocking smile. Round his neck is a silk scarf in clear colours. Ben Nicholson never wears a tie. For me he is the man with the coloured silk scarves in the same way as I can only remember Kisling in a blue overall and a red silk handkerchief, Foujita with his fringe and gold ear-rings, Zadkine inseparable from his pipe and huge stick.

His studio. Beneath his windows lies Carbis Bay. On the left the yellow sands and behind it the peninsula of St. Ives, whose silhouette reminds one of Greece. Seagulls wheel in the air, a few Breton boats, with their tobacco-coloured sails, approach the harbour. In the studio stand pictures, stacks of canvases and boards facing the walls; in the middle a working table, beside it a radio and a gramophone. Ben Nicholson likes to work with music. It is the cleanest artist's studio I have ever seen, a few pictures on the walls, some mugs and jugs on the mantelpiece, some books, brushes and tools.

I touch in our conversation on the difficulty of apprehending an abstract painting directly. This leads us to the question of what function a picture really has.

'It is an expression of the painter's philosophy.'

'For the painter ... but for the onlooker?'

'Well. Take Ucello's famous battle painting in the National Gallery. All I see there is the artist's visual experience and his philosophy. He was probably asked to paint a battle, and he used

that theme for his own purpose. It represents for me not a conflict at all, but you will find certain constructive ideas.'

I do not give up. 'What can abstract pictures really communicate to others? It is like Chinese writing which one cannot decipher. Do you think of others when you paint?'

'I do not paint for others. But if you solve a painting for yourself, for some mysterious reason it is a solution for many other people too. For me abstraction is the liberation of colour and form as a means of expression. An abstract painting also leaves the onlooker free. It does not prevent the development of his own poetic ideas. A painting representing sheep on a Scottish moor is indeed a depressing thing to have for breakfast every morning.'

Ben Nicholson is the son of Sir William Nicholson and his wife Mabel Pryde, both important painters of their generation. He grew up in an artistic atmosphere where Whistler, Vermeer, Chardin and Velasquez were admired. At first he wanted to have nothing to do with art. It was with him, as with many other children. They develop by contraries. But when he began to paint, he painted in the way of Vermeer. Soon he recognized there was no step further in that direction.

Ben Nicholson looks out of the window, in his thoughts he turns back through the long years to his beginnings. This artist, one of the most severe in his form and the most style-conscious of contemporary artists, tell us: 'In 1918 I started to paint differently. I came across in London the Vorticists, an English equivalent of cubism. Especially Wyndham Lewis. This movement was dynamic; art cannot grow like that, but it was very important in its time. It certainly helped me to break away. In 1920 I saw in Paris for the first time cubist works, including a particular Picasso, probably painted about 1915. It was an upright picture, and in the centre of it there was a green which was terrific. It made such an impact on me that I remember that impact to this very moment. It was definitely more an instinctive than a deliberate process. Cubism was the real revolution for me. Impressionism and Post-Impressionism hardly touched me at that time. Cubism is the normal growth out of Cézanne. It could not come differently ... About 1923-24 I saw a picture of Miro's. A blue

ground, a white cloud of circular form, and a black electric line which traversed both. In cubism there was yet some link with representation, in this Miro there was none. Cubism was not completely free in the sense of music. There is a third impact which had an influence on my art. This time it was not a painting.

'About 1933-34 I visited Mondrian's studio in Paris for the first time. In this studio, on the second or third floor, he lived for twenty-five years, except during the war, when he was in Holland. He lived there without going outside Paris. Rectangular pieces of board painted with the primary colours, blue, red, yellow, white and neutral grey covered the walls. His room was very high and narrow, a very strange shape; out of the window one saw the railway lines running into and out of the Gare Montparnasse. The quality of Mondrian's thought in his room and the silences in between the things he said, made a deep impression on me. My reaction was instinctive again, subconscious, not intellectual. It was not until one year later that I understood more of his art and the sensation of space he achieved in such a different way from cubism. The modern movement has grown out of Cézanne and Picasso plus Mondrian, whose work has an element which did not exist in theirs.'

The large retrospective exhibition of Ben Nicholson in 1947 illustrated his development and his fight for a personal means of expression. His urge for freedom was decisive, but it never went so far as to become a dogma. He says himself: 'I wanted to be so free that I even would not need to use free colour. I dislike the idea that a picture is something precious, the painter something special. There is an artist in everybody. That was the reason why I welcomed the technique of *collage*. One discovers new things. One does not paint only in one medium, it does away with the precious quality of the easel picture. Art is work and play for me. And work and play are as necessary for me as breathing. Yesterday I began to paint the garden gate. As soon as my hand touches a brush, my imagination begins to work. When I finished I went up to my studio and made a picture. Can you imagine the excitement which a line gives you when you draw it across a surface? It is like walking through the country from St. Ives to Zennor.'

The tide came in, some boats which had hitherto laid still began to move towards the harbour of Hayle. Ben Nicholson followed them with his eyes. 'It is strange,' he said, 'how many people are interested in painting now – many more than before. And so many artists express their pessimism with regard to culture. But perhaps there is no reason for optimism. Who knows?' A smile flitted once more over his face. 'Optimism … Who is an optimist? A man who does not mind what happens as long as it does not happen to himself.'

DENYS VAL BAKER

CORNISH LITERATURE

Cornwall, one of the creative centres of these islands, occupies an unusual position in any regional study of contemporary writing.

More than just another county, it is no longer quite a country of its own. Like Wales, Cornwall has preserved over the centuries many traditions and customs of its own. Unlike Wales it has not succeeded in preserving its language as a living force, either as literature or conversation. This is an important reason why, although one of the six Celtic races represented in the Celtic Congress (Wales, Ireland, Scotland, Brittany and the Isle of Man are the others), Cornwall can hardly be said to have produced a native Cornish literary movement. This becomes obvious if one compares contemporary Cornish writing with the work of such powerful national groups as the Welsh (Rhys Davies, Gwyn Jones, Dylan Thomas, Glyn Jones, T. Rowland Hughes), the Scottish (Hugh MacDiarmaid, Douglas Young, Neil Gunn, Naomi Mitchison, James Bridie), or the Irish (Sean O'Casey, Sean O'Faoilain, Liam O'Flaherty, Frank O'Connor, Patrick Kavanagh). It is true that most of these writers write in English, but equally true that many of them can write and speak their native language, so preserving a link with their countries' ancient culture which nearly every Cornish writer lacks.

On the other hand the creative spirit of Cornwall exists not only among the people, but also within the place. I can hardly explain what I mean more comprehensively, but it is a fact which is at once apparent to any visitor of average sensibilities. Creativeness is invariably stimulated by Cornwall's wonderfully varied character – beautiful coastline, colourful villages and ports, summery weather – but also bleak moors, ugly inland industrial towns, desolate mineheads, relentless winds and sudden storms – and something beyond any of these things, a sense of past, of mystery, of eternity

buried in grey stones and hidden in caves, yet contained in the very atmosphere. In the past this strange quality has attracted to Cornwall many well known writers, among them D. H. Lawrence, Havelock Ellis, Hugh Walpole, W. H. Hudson, Compton Mackenzie, and J. D. Beresford. The same mystery and beauty is as alive as ever to-day, and it is a significant fact that there are more writers and painters living in Cornwall than in any other county of the British Isles.

It is necessary to preface a study of writing in Cornwall to-day with this explanation, otherwise the picture might seem confusing. There are more than one hundred writers at present living in Cornwall, among them many leading novelists, poets and playwrights – but the number who are actually Cornish by birth would hardly exceed a score. Yet the awareness, or feeling of Cornwall, permeates the work of all, from A. L. Rowse to Howard Spring, from R. Morton Nance, Grand Bard of the Cornish Gorsedd, to the Scottish poet, W. S. Graham. So, although there may be only a small national Cornish literary movement, there is a remarkably large field of contemporary writing in the Duchy.

I mentioned earlier that the Cornish language had not been preserved continuously: in fact, it died out completely around 1800. In recent years, however, there has been a revival of interest, led by the researches of the late Henry Jenner, author of the *Handbook of the Cornish Language*. In 1904 Cornwall was accepted as a member of the Celtic Congress. In 1920 the first of a series of old Cornwall societies was formed, encouraging a learning of the Cornish language and a revival of Cornish culture. In 1928 there was held the first Gorsedd of the Bards of Cornwall, a ceremony similar to the Gorsedds of Wales and Brittany. At the Gorsedds, which have now become an annual event, titles are conferred on Cornish men and women in recognition of some manifestation of the Celtic spirit in work done for Cornwall. Cornish-born writers have naturally been prominent among those so recognised.

Most accomplished of to-day's writers in the Cornish language is R. Morton Nance, present Grand Bard of the Gorsedd, editor of *Old Cornwall*, the journal of the Old Cornwall Societies, and author of numerous pamphlets and text-books on the language. Among his

many imaginative works are several plays in Cornish, notable *An Balores* (The Plough) and *Lyver An Pymp Marthus Seleven* (Book of Five Miracles of Seleven), a folklore tale of a Cornish saint. It is Morton Nance who, after years of study of middle-Cornish texts, evolved a unified system of spelling for Cornish which has been of great help in encouraging new students of the language. His work was expanded by 'Caradar' (the late A. S. D. Smith), Welsh bard and schoolmaster, who produced *Lessons in Spoken Cornish*, *Cornish Simplified*, and (with Morton Nance) a complete Cornish translation of St. Mark's Gospel from the Bible. 'Caradar' also produced *Nebes Wherhlow Ber*, a book of Cornish short stories, and at the time of his death in 1951 was planning a series of imaginative works in Cornish. The third of a trio which has helped considerably to re-establish a literature in the Cornish language is Peggy Pollard, author of a well-known English guidebook on Cornwall (illustrated by Sven Berlin). Mrs. Pollard wrote a play in verse, *Bewnans Alysaryn*, a clever adaptation of the old Cornish mystery plays, which won first prize in the literary competition of the Gorsedd in 1940. She has since written three other Cornish plays in verse which it is hoped will be published in the near future. Interest in the Cornish language is increasing steadily, and there are seven books awaiting publication. A young Cornish schoolmaster, Richard Gendall, has started *Anlef*, a small monthly magazine printed entirely in Cornish.

Publications in the Cornish language are, of course, only one facet of contemporary writing in Cornwall. Most Cornish writers prefer to follow the example of 'Q' or that sympathetic 'foreigner', Charles Lee, and write in English, while making use of Cornish dialect or idiom. This is difficult enough: A. L. Rowse, in his fascinating reminiscences, *A Cornish Childhood*, doubts if anyone who was not brought up in a home where Cornish dialect was regularly spoken could be relied to get it absolutely right. Rowse himself was brought up in the village of Tregonissey, near St. Austell, by working-class parents who spoke the dialect, 'unashamed and unspoiled'. A controversial figure among the Cornish, A. L. Rowse is best known to a wider public as a historian and political commentator. In Cornwall he has naturally created most interest

by his Cornish books, *A Cornish Childhood*, *Tudor Cornwall*, *Sir Richard Grenville of the Revenge* and *Poems Chiefly Cornish*. A working-class child who admired the aristocracy, a one-time Labour candidate who has recently out-Toried the Tories in some of his views, an emotional Celt who set out to suppress his emotions in favour of intellectual rationalism – Rowse is made up of many paradoxes. But then so are the Cornish people, and there is no doubt that he understands them well, too well for their liking.

A Cornish Childhood is Rowse at his best, an autobiographical fragment that captures in minute detail pictures of Cornish village life during Rowse's youth, at the beginning of this century, and also during the lifetimes of his parents and grandparents. Somewhere in the book Rowse writes of his admiration for Marcel Proust's *A la Recherche du Temps Perdu*, and there is much the same intensity of observation in this autobiography. The same eye for detail is naturally a feature of Rowse's poems, which have been published in three volumes, *Poems of a Decade, 1931-1941*, *Poems Chiefly Cornish*, and *Poems of Deliverance*. As when he writes:

What is there in a Cornish hedge,
The broken herring-bone pattern of stones,
The gorse, the ragged rick,
The way the little elms are
Sea-bent, sea shorn,
That so affects the heart?

From the same part of Cornwall, St. Austell, comes a young Cornish writer whose first novel, *Wilding Graft*, and an autobiographical volume, *Confession of a Rebel*, recently won generous praise from the critics, including Rowse himself in a broadcast review on the B.B.C. West Regional. He is Jack R. Clemo and he was born and has lived all his life in a remote clay-mining hamlet, St. Stephen, where his father was a kiln worker. Although distantly related to the Cornish novelists, Joseph and Silas K. Hocking, Clemo's work bears little relationship to theirs. *Wilding Graft* is a novel of savage Calvinistic realism, a portrayal of the close-knit life of a Cornish

village from within – and not too kind a portrayal at that. Nevertheless, like the Welsh writers, such as the late Caradoc Evans or Rhys Davies to-day, Clemo gets to the living core of the people. His characters and situations, if melodramatised sometimes, are always alive. In his novels and his poems he is strongly influenced by Thomas Hardy, and it is a good influence. Like Hardy he is a regional writer of national importance. I wish I had more space to deal at length with a number of other Cornish writers whose work makes a special feature of Cornish life and the Cornish dialect. Notable among them are Anne Treneer, poet, short story writer and author of a sensitive autobiography, *Schoolhouse in the Wind*; Rosalie Glyn Grylls, author of the King Penguin *Coast of Cornwall*, and of a new biographical study, *Trelawney*, as well as many shorter studies; and Lady Vyvyan, author of *Cornish Silhouettes*, *Echoes in Cornwall* and *Our Cornwall*, a new volume of essays in which she comes as near as any writer can to explaining something of the magic of Cornwall, concluding on a warning note:

> Cornwall has assuredly its roots in the past. A sense of the past is among our unseen values. A sense of the past is fostered by continuity in everyday life. This sense of continuity, with many other unseen things, is now being buried under the avalanche of a thing that is called progress.

The sense of past, and place, in Cornwall, has also been written about at length by Geoffrey Grigson, whose childhood was spent at Penlynt, in East Cornwall. A man of diverse talents – scholar, authority on flowers, biographer, poet and essayist, as well as editor of a number of miscellanies of past and contemporary writing – Grigson was recently paid the singular honour of being the subject of a middle-page study in the *Times Literary Supplement*. He is a cultured man who remarks pertinently that 'places, sensualities, experiences, are nothing unexamined, unlinked, unvalued, collected only as a bower-bird collects shining oddments.' Any reader of his poems, as in the volume *The Isles of Scilly*, or of his essays on Cornwall, such as 'The Valley of the West Looe', or 'Cornwall and

the Sense of Place', published in the *West Country Magazine*, will appreciate how well he has absorbed and evaluated the Cornish background.

A poet and dramatist of national renown, with strong Cornish links, is Ronald Duncan, who for many years has farmed at Morwenstow, home of that famous earlier Cornish poet, R. S. Hawker. For a writer Duncan is an unusual mixture of imagination and practicality. On the practical side there is Duncan, author of books on farming and regular contributor to the farming papers and farming diarist of the *Evening Standard*. On the other side there is Duncan, the poet and playwright, author of the remarkable masque, *This Way to the Tomb*, and librettist of Benjamin Britten's opera, *The Rape of Lucretia*. Duncan's writing is clear and sharp, almost to the point of abruptness. He is one of the foremost critics of the modern worship of science, the cult of more and more machinery and less and less humanity.

Cornwall seems to include a large number of poets among its native talent. In addition to Rowse and Clemo, Cornish-born poets who will be well known to readers include Ronald Bottrall, Terence Tiller and Charles Causley. The first two of these have outgrown much of their Cornish influence and become what might be termed cosmopolitan poets. Causley, too, by virtue of six years service abroad in the Navy, has developed a much broader attitude to life than might have been the case if he had never left his home town of Launceston. Nevertheless, he is now back in Launceston schoolmastering, believing that in these days a poet needs the practical security of a non-literary job to give the freedom to write poetry in his spare time. Causley is unusual among Cornish writers in exhibiting a real sense of humour. His poems have a liveliness and raciness that make them popular with a wide audience. He may be one of those poets who lead poetry back to public favour.

Among other Cornish-born writers one must mention J. C. Trewin, author of *Up From the Lizard* and dramatic critic of *John o'London's*. As editor of the *West Country Magazine* he has done a great deal to draw attention to the profusion of literary talent in his native county.

Finally there are many non-Cornish poets who have been attracted constantly to Cornwall, ranging from the venerable Walter de La Mare (whose first reaction, according to Bernard Walke, in *Twenty Years at St. Hilary*, was to feel frightened and to want to escape) to younger modern poets such as W. S. Graham, David Wright, George Barker and John Heath-Stubbs. The one most influenced by Cornwall, partly because he lived here for several years, is Graham. Although a Scotsman by birth, he is strongly bound up with the atmosphere of sea and fishermen which is so integral a part of Cornish life.

There is no space even to begin an assessment of the dozens of novelists now living in Cornwall, so I will conclude by listing some of the best of them, leaving it to readers to search out their work and so get a wider insight into Cornwall and its writers. Among those who have lived for a very long period in Cornwall are Ruth and George Manning-Sanders at Sennen Cove, where there was once a colony of writers, including Mary Butts and Naomi Royde-Smith; Frances Bellerby until recently lived at the other end of the county at Callington; Daphne du Maurier at Par, and Angela du Maurier, at Fowey; Howard Spring at Falmouth; Phyllis Bottome at St. Ives; Walter Greenwood at Polperro; Winston Graham at Perranporth and Wallace Nicholls at Newlyn.

PETER LANYON

THE FACE OF PENWITH

The Cornishman is not double-faced but multiple-faced, facets of character which add up to a sort of innocence. He is never still himself except in death, but all the conflicts which lead to a game of hide-and-seek between native and the so-called 'foreigner' are part of a process which constantly surfaces the most diverse and conflicting factors. The Cornishman is fond of private secrets. A solemn intercourse of native with native, often intimate, is mistaken for a gossiping and vicious moralizing. The bush telegraph which puts the G.P.O. to shame is a part of this intimate revelation from native to native. The part of this game which is revealed to the unfortunate 'foreigner' is that part which concerns him alone, the rest is none of his business. Prayer is a strong force, and in the greatest days of revivalist services, in Wesleyan chapels, a poetic resolution was achieved. The loss of such inspiring services is as sad for Cornwall as the closing of the mines.

There is a main force which is centrifugal and centripetal, a giving out and a taking in. In extremes this means a complete trust and desire to give absolutely everything and a converse withdrawal, a returning to a protective native envelope. The eye is prospecting and adventurous, it has also an inward look. Perhaps these qualities are most often found in insular people, and perhaps Cornwall itself has for centuries been almost an island. The intimate contacts of native with native revealed in *Cornish Stories* (understood and enjoyed for their peculiar flavour by natives only) remains. The Cornishman will change according to basic rhythms which are suggested here and will make a good job a 'fitty' job, as he says, not one just fit for purpose but a fitness within a rightness which is determined by his whole history and the nature of his country.

The following sketches offer suggestions towards a revelatory process. They are made from outside by a certain detachment which

is the artist's method, but from within also, in the hope that processes of revelation, extension and creation (latent in familiar objects) may themselves be revealed and shown to have a relativity in time and space. This complication of a familiar and plain scene is made in the interests of an analysis of Cornish character. In the congregation of the Cornish cross, a circular theme, the symbol of this process stands erect, revealed and outward, in the landscape.

LANDSCAPE

From Wicca to Levant the coastline emerges out of carns and bracken and cultivated greenland, revealing on its varied faces a sea history and a land history of men within and without and a commerce of man with the weather. Here, in a small stretch of headland, cove and Atlantic adventure, the most distant histories are near the surface as if the final convulsion of rock upheaval and cold incision, setting in a violent sandwich of strata, had directed the hide-and-seek of Celtic pattern. A motor-boat in some solemn gaiety with insistent cough, searches out the exacted payment of ocean on land; the small rituals of business at the junction of rock and sea wall.

On carns of Zennor, Hannibal and Galva, where giants may have hurled their googlies in mild recreation, an outline of earthwork makes evidence for a primitive brotherhood of man, of the great and small in life and death wherein animal joy and terror found resolution in the protective care of monolith and fort. Hereabouts, perhaps, the sun set westwards, shifting down the monolith to bury the light of primitive fire, and rose again in the hearts of men from the east. The saints were in Cornwall.

From Levant to Wicca, an easterly direction, chimneys are crowned by brick flourish and the towers are lichen-covered, castellated and pinnacled. They rise upward out of the horizontal ground as if the thrust of stone had surfaced to the call of the native, given up its wealth to his endeavour, and been revealed by manufacture as an expression of inner intent. Invention, leading to extension of native culture, made present in time a process of

ancient development. The craft and skill and meaning of the native journey are outward and revealed at the land surface.

VOYAGES OF THE NATIVE

To bring the world within the hand and make immediate the farthest shore, seamen set sail for the mistress of the sea. From storm and shipwreck the homing seaman returns with cargo, unloading on granite quays a wealth of image. What stories he tells, and in his sea soul gives to the land, remain outwardly in his artefacts, are revealed to generations by the face of man and the character of his seaborn gear. This process has been a source of man's struggle to make himself as outward and revealed as this place of granite. Here sea and land answer the deep roots of man and present him with a face.

At Levant Mine, where tin and ocean meet, men fished for food after labour beneath the ocean bed. What is within the granite arms of harbour, sheltered from surface mood and ground sea is concerned with an intimate bobbing, the playful game of boat with mooring, a small outward exchange reflective of deep ocean movements. A happy commerce in granite embrace. But the centre and focus of lighthouse, port and parent are left alone as masts and sails, clumsy with their clawings, move out to their own aggressiveness. Man-engine and steam haulage pass contact to deep levels with man-baited rod and line. Where shifts go down and come up and ships in regular exchange remove themselves and return to parent, the resources of Cornwall are best displayed and landed. In every small and intimate departure or arrival a wholeness of living is revealed, and in commerce of man with granite and Atlantic the transitory is made immediate, each facet related elementally to the next as aspect and image of a whole.

JOURNEY OF THE VISITOR

Running along Hayle estuary and round points to St. Ives terminus a local train brings the man from pavement, office and city statue to

a most complete revelation of history in the earth, to the open face of his country, the ultimate and prized beauty of the flower.

Richard Trevithick made a steam engine, a concoction of homely kettle and manufacture, a concept of extension whereby man's muscled arm is replaced by an idea made solid, of motion and power in simple movements. Steam expansion and piston, valve gear and con rod, cranked for transference to rotary motion; the divider and compass, straight line and circle, all set on the wheels of a horseless cart for the ride up Camborne hill in glory.

The industrial revolution moved inward and outward down and up the line: Par, Lostwithiel, Truro, Redruth, Camborne, Truro, St. Austell and Saltash. From within the drawbridge fell across the Tamar.

To the demands of extension the Cornishman, evolving his time theme, the centrifugal and the centripetal, makes invention, making real the face of his own time, making object and image from within.

JOHN FREDERIC GIBSON

CRABBING DAYS

The sun is high and warm and the bay is patched with wind and calm, deep blue and white. From my window I can see the stout little crabbers coming and going, weaving wake trails, swinging around their pots. The boats seem part of the scene, and one might think that the men are happy to be out there on the edge of the ebb tide; but I am an observer, they are in the midst of routine work. The difference is immense.

The cove from which those boats sail is on the eastern side of the Lizard, a place of many colours. When the sun is out the stunted palms are bright against a blue sky and the cottages gleam white and the pine branches cast shadows. Then it is all warmth and brilliance. The orange fungus on the rocks is vivid; the wild flowers dance above the grasses; the shallow water is ice green. But when the skies are grey the colour is lost and the place is bleak and cold, as barren as the rocks below Cape Wrath. No day is like another, and each morning look from the window reveals a new mood, a fresh face on the land we think we know so well.

Those who live on the edges of the Cornish cliffs might as well be at sea. Their homes are shaken by the winds. The thatches quiver, and security is threatened. Spray drives against the windows, and then the sun comes out and the waters draw back their strength. The place sleeps. The tide rises and falls and the cottages are becalmed under the incurious stars.

This village is a village of the sea. Coming down the steep hill one turns a corner, and there between the thatches is a vivid blue triangle, and, perhaps, a splash of scarlet geraniums. The green tamarisk branches flutter. Down by the beach, near the boats, nets dry in the sun and lobster pots gleam white where the willow is thick with salt. The smell is one of seaweed and brine and tar and hot paintwork.

To go out to the lobster grounds in the first calm of spring is rather like walking over the grasses of a freshly-sown lawn. There is a sense of triumph. At last, after great preparation and long waiting, the hour has struck. Spring is not just a time for cuckoos and lambs and pretty blossoms – it is the dawn of the year, and, more important, the season of economic rebirth.

We gather on the beach at dawn. The half darkness hides detail, but sounds are clear: the rattle of footsteps on the shingle; the striking of a match; the falling of a crutch on to the bottom-boards, virginal boards, that are, as yet, free from fish scales. There are lights in some of the cottages, and late arrivals are silhouettes in their doorways as they look up at the sky before hurrying down to join in the work.

As the light broadens it is possible to see the heaps of pots stacked in the bows of each boat, new pots with new gear, the result of four months' labour in the slate-roofed sheds, the result of journeys to the farms where willow paddocks lie, tended carefully, handed down from father to son and from boat to boat. One generation succeeds the other, and the greatest inheritance is knowledge, knowledge of tide and rock, wreck and spur, sand and wind. The older men know the bottom of the bay as they know their cottage floors; they guide the youth with pride and care.

It is cold. The rocks are still holding the chill of winter, and the air stings the bottom of our lungs. As I wait, a dark figure comes over and bangs a bucket of fresh bait into the boat. 'Right!' growls a voice. 'Off we go!'

Hands come out of the green light, and the boat rocks gently as it slides almost silently towards the water. Then, for the first time for months, the water laps against the keel, and the planking shines in the lustre of daybreak. There is a moment of hesitation, and then we are waterborne, drifting out from the line of foam along the shore. The swell, a reminder of last week's gale, lifts us and drops us. The marine engine stutters into life, zombie-like after its winter's rest, a trifle stiff in the joints.

There is nothing to do for a while but sit and listen to the beat of the engine and feel the growing heat of the rising sun pass

through our skins, to warm our innermost bones. There is time to smoke, time to watch the gannet flying, time to settle comfortably against the transom and dream of outer seas.

On the way out to the lobster grounds, perhaps down below the Lizard Head, perhaps a mile out from Carrig-Luz or west of the tide rip off Black Head, the pots have to be baited, a job which looks easy enough, but that lithe skill of experience is deceptive.

We reach the lobster grounds of our choice, and the engine is throttled back as the pots go over the side. The boat swings in a circle as sixty willow cages splash and sink. We see them in the blue water, swirling downwards, the rope snaking out over the gunwale. And that is all for the first day. The marker bobs on the surface, a little black flag fluttering jauntily. If the weather holds, to-morrow will be the day for reaping the harvest of the sea, dawn to-morrow and dawn on every fine day into mid-December. If a gale blows, the pots will be dragged from the rocks and hurled to deep water or cast up on the beach, smashed and useless. In that case, the work of winter will be undone.

We come gently to the shallow water and run our bows on to the beach. Now the fishermen can wander up to their cottages in search of a late breakfast. For me it is a question of climbing the cliff path and taking a short cut home across the fields in which the small black bullocks stand. As I pass they turn and stare, watching me until I am out of sight behind the tall hedges.

There are nine crabbers on the beach; two men to each boat. These crabbers are about twenty-five feet long, broad-beamed and strongly built. Sails and centre-boards are a thing of the past, but the masts which are stepped about two feet forward of the transom are of some practical use. From them it is possible to haul out the triangular mizzen to steady the boat when hauling nets. Unlike their boats, the fishermen are of all shapes and sizes. They seem to have nothing in common unless it may be strong wrists and a dislike of the taste of crab, and, perhaps, the love of their own village. Some wear blue sweaters and peaked caps, keeping up the old tradition, but there are others who prefer a cloth cap and an old tweed jacket.

As the tides flow later each day, so the boats depart later, and when I go out to haul the nets and lift the pots we are not clear of the beach until well after sunrise. It takes us half an hour to reach the far side of the bay. Far down the coast other boats are coming out from the next village, their sails black against shining water, the beat of their engines drawing the gulls out from the cliffs. There is time to look around. The smoke from our pipes floats up in the sunlight. The wooden gunwale grows warm under my arm.

There is an unfading excitement about hauling up the bottom nets. We find our flag, its cork float straining in the last of the tide. When the engine is cut, the silence is sudden and immense. We clear our throats and then begin to haul on the wet ropes. For a while there is nothing to see but dripping water, the end of the net, a brown mass. And then a skate slithers inboard, blinking its gills at us. After that six crayfish arrive, one after another, their shells yellow and gleaming. By the time the end of the net is aboard we have eleven crayfish and three skate, not a good catch. There are throaty grumbles, wordless, but full of meaning. In no time at all we are motoring swiftly towards the first string of pots.

Hauling pots is, for me, the best part of the morning's work. I lean over the side and watch them as they come up, shadows below the translucent water, barred shapes, and then detailed cones of willow. Sometimes there is a lobster or crab on the top of the pot, and we haul slowly. Young lobsters advertise their presence by a terrific flapping all over the floor of their prison, but the older ones are always dignified in defeat. Crabs are apparently stunned by their misfortune, and move with a purposeless amble around the pot.

The sun rises; our sweaters become unnecessary. To the north the white cottages shine like squares of sky. The coastline appears steep and bleak from our seaward viewpoint. This is spring, stimulating and colourful. For me, it is the first of a number of mornings on the bay. For the fishermen, it is the first of the year and the end of the year. Their life is a cycle. Their life is based on the necessity of going out whenever the wind is elsewhere, and the sooner they are home, the better.

But I found that it was possible to go out on the blue waters of that bay a hundred times and still feel like an explorer. It all depended on the colour of the water, the type of fish to be caught, or the simple fact that each day saw the land colours growing more vivid, more contrasting.

Summer trolling is a lazy, peaceful occupation. Now, when bait is so expensive, the crabbers put out spinners on their way home. Mackerel do as well in the pots as anything else. In the midday heat each man can become absorbed in his own thoughts, lulled to a dream by the siesta hour, the throbbing of the engine, the glare on the water which makes closed eyes seem natural enough. Only the man at the tiller need watch out, and the waters are safe and deep until it reaches the shadows of the cliffs. So each man sits there, worlds apart from the next, one finger alive and alert, awaiting the jerk of a fish on the line. Apart from that finger, bodies relax and minds can wander far and away. There is nothing there that is not immense. The sky is solid, hot and blue; the sea fades away into a haze; the land is a remote façade of brown and green, dwindling to east and west; the boat is small, as are the gulls around, but the boat is forgotten ...

Sometimes we caught over sixty fish in no time at all, and would turn to meet the evening shadows, content, our supper at our feet. We would make for the shore, see the boat high and dry above the spring tide mark, and then wander up the empty road, sleepy in the mellow light of evening.

This kind of thing sounds pleasant enough, but the fishermen are by no means happy. As each year passes prices of willow and rope and bait and paint reach upward, but the amount given for a lobster falls. The hotel industry is not thriving and, in any case, the five shilling meal does not give scope for large helpings of shellfish. The fisherman sees his expenses mounting, boats from two pounds a foot to ten pounds a foot, bundles of willows from ninepence to two shillings, petrol up, tar up, food up, canvas up. It is not any use demanding higher prices for his catch. No merchant would pay more for something that is difficult to sell these days. What, then, is the answer? Some of the men must work on the farms in the winter

months. And that means that there is no one to make the new pots. December to March are profitless to the crabber. He is unable to draw unemployment benefits unless he is prepared to be sent away on a trawler at a moment's notice.

For most Cornish fishing villages there is another problem. House by house, cottage by cottage, the old thatched homes are being bought up by outsiders, and the fishermen and their families are being moved away from the sea to the new council houses. In fifty years time there will be no crabbing as we know it to-day. Between now and then there will be much sadness, much bitterness, in the ineffectual struggle for survival. No great plans and speeches can halt the disintegration of the trade, for such things only hasten the end. Tradition is the strength of the crabbers. New methods of lobster fishing might ensure a catch, but they would black out the dawn lights along the Cornish coast and leave only the husks of villages to which would flow the tide of the city overflow.

R. MORTON NANCE

CORNISH CULTURE

I shall take it that there is a difference between Culture in Cornwall and Cornish Culture. Of the former there is much to be said. With its dramatic and musical life, and the many artists and writers who make Cornwall their home, we may claim to have no ordinary share of cultural amenities here. But it is only to a very small extent that we can connect these with any indigenous tradition of culture, and leaving them aside, I should prefer to search for something like a continuous tradition of culture that is natively Cornish.

We have still with us things visible and invisible to remind us of very ancient cultures in Cornwall. Every common granite field-hedge formed of stones cleared from the land it encloses has in its great 'grounders' and its well-adjusted smaller fragments some suggestion of the pre-Celtic raisers of megaliths or the builders of Celtic hill-forts and British villages, and this is not lost even in the masonry tradition of recent times, with its preference for great masses of stone to form doors and windows rather than using small units. To a Celtic culture, at least, we can trace our choice of long-hilted 'showls' rather than Saxon crutch-handled ones, such a treatment of the soil as 'beat-burning', or the tiny hamlets or isolated farms which spread in Celtic fashion over a Cornish landscape instead of gathering themselves into large villages and leaving houseless tracts between, in the usual Saxon way. Some of our customs, such as that of midsummer bonfires, and old beliefs, as in the curative properties of certain wells, are likely to be pre-Celtic as well as pre-Christian in their origin, giving us here and there some slender thread of continuity which has survived the fabric of a lost culture to which they belonged.

The whole known history of Cornwall accounts far more readily for gaps in tradition than for anything continuous. The Celtic influx caused the non-Aryan language of an older people to vanish

without a trace to be identified, even from the place names of Cornwall, which implies a very thorough break with the past. The effect of a very partial Roman occupation was slight as compared with that, introducing a few Latin words into the Celtic speech, but not ousting this language as it seems to have done in most parts of Britain, and scarcely affecting Cornish place names at all. Neither were these at first affected except over a comparatively small area by the later Saxon invasions.

Some of the Cornish words from Latin are due to church influence rather than to Roman rule, like *pronter* [priest] from *provendarius*. It may be that Christianity came to Cornwall before the Romans left Britain, and has remained here ever since, but we learn from one of the few authentic lives of saints, that of St. Samson of Dol, that even in the seventh century pagan worship of stones was practised, since he interrupted such a ceremony while crossing the Bodmin moors as an overland break in the sea journey from South Wales to Brittany. His cutting of a cross on the worshipped rock rendered it thenceforth proper to pay it such reverence. This was in line with the dedication of venerated wells to saints and the Christianizing of midsummer fires by dedicating them to St. John the Baptist, both of which may be taken also as bridging the gap between pagan and Christian cultures.

The fact that, as for St. Samson, sea passages were shortened by avoiding the Land's End route in going from other Celtic lands to Brittany, had much influence on the religious culture of Cornwall in the Dark Ages. Saints from Wales, Ireland, and Brittany came to know Cornwall and founded cells or small monastic enclosures here, giving their own names to the places, either alone or prefixed with 'Saint' or following such words as *Lan* [enclosure] *eglos* [church], *chapel*, *merther* [martyr], *porth* [landing-place], *bod*, or *bos* [dwelling], and *plu* [parish], the last much commoner while Cornish was still in use. The personalities behind such names had usually become quite forgotten by the time their legends were prepared to be read on their feast days, and, as Canon Doble warned us, in such 'lives' names and sexes were mixed up, birthplaces and family details were invented and miraculous deeds were supplied from stock,

often with grotesque anecdotes to season them, so that the actual history to be learnt from them needs expert sifting from the fiction.

Far many more Cornish place names contain the personal names of men of whose lives we have not even a fictitious account. These are the only memorials of the secular great men, founders of the first Celtic homesteads or hill-forts, whose British names have *car* [fort], *tre* [homestead], *bod* or *bos* [dwelling] as the commonest prefixes before them. It is only to be believed that for some generations at least tales of these great ones would be handed down, but unless they later became mixed up in folklore with giants, as some of the saints certainly did, there has been here another terrible break with tradition, and scarcely one modern inhabitant of a place with such a name as Carveddras, Tregassick, or Tremellick would know that he owes its existence to some ancient Modred, Cadoc, or Maeloc. Still less could a place called now 'Crumplehorn' recognize itself as Tre-Maelhorn, though in Elizabeth's reign it was still at least Tremblehorne.

Such names, especially as Anglicized, are often terrible puzzles to us all, yet they may throw light on the darkest places in our history at least as well as the saint's names, when they find their own Doble to sort them out. The reading of a saint's legend or a miracle-play about him kept the holy man in mind, but can we assume that hero-tales paid similar tribute to the secular great? Whether they were written in verse or handed on orally in prose, there seems no doubt that we can, for the Breton scholar Loth has shown that one of the finest tales of all, that of Tristan and Yseult, was first put into French from a tale told with all the circumstance that accurate topography could give it of actual places in Cornwall, and thus originated here. Whether the tale was one among many, and whether we had Cornish bards to versify such romances, we can only ask, but it seems likely enough that we had here a Celtic culture like those of Wales or Brittany, to which such romances would be a necessity. That they should pass without leaving a trace is less difficult to believe than that all our Celtic folk-songs and music of a much later period should have perished as completely as we know they did. During the earliest Middle Ages Cornwall and

Brittany had what was still a common language and culture, with Cornwall as the parent country, so that other tales of the Arthurian cycle gathered by French authors in Brittany could well have originated here.

It was in west Cornwall and in the fifteenth century and early sixteenth that we had the most evident approach to a native Cornish culture – a reflection, no doubt, of the common European culture, but moulded by its surroundings so as to take a very local turn. This is most obvious in the very Cornish use of granite and oak in our adaptations of contemporary styles in stone and wood-work which are still seen in most of our churches, but even more evident is it in the surviving remnant of manuscripts written in Cornish. All with a religious intention, these allow little scope for originality in their authors, but advantage is taken of opportunities to localize their detail by introducing Cornish place names and to lend life to incidents by expanding the bare story.

The language of them is a later development of the ancient British that was common to Brittany and Cornwall, and, like the contemporary English, had adopted many words from Anglo-French as adornments. The bulk of these writings takes the form of mystery plays for open-air performance in the parish *plen an gwary*, or playing-place, on feast days, and it suggests a high general level of culture that the standing audience were expected to gather the sense of an occasional scrap of English or French as well as their rather refined Cornish. The then Anglicized half of Cornwall had no playing-places and, presumably, no plays like these, and it is probable that west Cornwall owed all these works – passion poem and plays that survive and far more that has vanished – to the good monks of Glasney at Penryn. One good reason for believing this is the introduction into the most important set of these plays of local place names of that district.

Besides place names our mystery plays give us hints of such non-scriptural beings as the mermaid [*morvoren*] and the hobgoblin [*bucca nos*], but it is in the miracle-play *Life of Meryasek* that we get what is most to our purpose – a hint of a continuous tradition from the days of Arthurian tales. The manuscript is mainly in the attractive

handwriting of a priest named Ralph Ton, who signed it as finished by him in 1504,[1] but the first ten pages are in another hand, which may be that of its author, as Thurstan Peter suggests, John Nans, the then parson at Camborne, whose church was dedicated to Meryasek and who had been trained at Glasney. The author has used the Latin Life of the Breton saint Meriadec, who never came to Cornwall, and either joined to it incidents that belong to the Life of another – Cornish – saint of the same name (in Latin Meriadocus) who was associated with Camborne, or else invented all the Cornish part. A point in favour of the latter view is that the play itself admits that there were no relics of the saint at Camborne, an unlikely thing as there had been a local Meriadocus. As in the reputed Lives of some other Cornish saints, a usurping 'tyrant', Teudar, is Meryasek's persecutor in the play. In a scene where this heathen chief, who has strongholds at Lesteader, Teudar's Court, and at Goodern's Roman camp, is about to give battle to the lawful Christian Duke of all Cornwall, unnamed, whose headquarters, like those assigned traditionally to King Arthur, are Castel au Dynas and Tintagel, following the convention usual in mystery or mumming play battles, he begins with big talk and threatens: 'King Alwar, and Pygys, noble King Mark, as well as a king called Casvelyn, are coming to me with assistance'.

That such names, thought of as those of petty kings in Cornwall, should still have been familiar in 1504 seems to imply that semi-historic traditions, such as we have guessed at, did exist, even if unwritten. Again, attached as an interlude to Meryasek, is a play taken from the medieval 'Miracles of the Blessed Mary', and acted in honour of Mary of Camborne, whose chapel preceded Meryasek's church. Much new detail is added to the tale 'The Woman's Son', as usually told, in order to localize it in Cornwall, and amongst other things the son is made to enter the service of a Cornish king, Massen, this time a Christian, who fights a nameless devil-worshipping 'tyrant'. His name suggests a lingering tradition

1 His name, Radulphus Ton, has been misread as 'Hadton' and 'Nad Ton'. Richard Ton, Curate of Crowan, 1537, seems likely to have been related to him.

of Maximus, the Macsen Wledig of Wales, a slender thread of continuity from Romano-British culture.

Such mystery or miracle plays were acted in Cornwall until the Civil War put an end to such pleasures. The latest manuscript of one in existence was transcribed by one William Jordan in 1611, and has full stage directions for an actual performance. This – *The Creation of the World with Noah's Flood* – uses bits of the fifteenth-century Creation play, and 1540 would be a likely date for the rest, apart from some possible re-spelling. By 1611, if we can take Richard Carew's funny story of a volunteer actor in one as typical, performers in such plays were no longer expected to learn their parts (we have a written-out actor's part to show that in the fifteenth century they did), but only to say aloud what the 'ordinary' spoke softly behind them. Carew's gentleman brought the play to a close in bursts of laughter by repeating, instead of the ordinary's words, his curses against the fool who would not say them. Carew, as a Cornishman of the non-Celtic fringe, would have only a slight curiosity about Cornish, but we can forgive this lack when we think of the rest of his wonderful *Survey of Cornwall*, which gives us such a picture of life in the county in Elizabeth's time. If miracle plays were thus crudely acted then, they had much more time to degenerate for lack of help from the clergy before Dr. William Borlase saw the last relics of them in the 'miserable dialogues from Scripture' that in his youth were taken round from house to house with the mumming-play of St. George at Christmas. This tradition of acting, however, gave guise-dance plays in Cornwall an importance that they did not get elsewhere. By 1800 Scripture subjects had given way to local folk-lore, but 'Duffy and the Devil' was a versified play in several acts, as Bottrell and Hunt's extracts show, and another, 'Tom and the Giant Blunderbore', was known though its doggerel lines are lost. Probably there were many more; some improvised, others versified by the best rhymester of the village, schoolmaster or otherwise.

In spite of shattering breaks with tradition during the sixteenth and seventeenth centuries, we find Scawen writing his *Dissertation on the Cornish Tongue* after the Restoration with a very decided wish

to keep intact such links as Cornwall still had with its Celtic past. Still more do we find this wish inspiring Nicholas Boson of Newlyn, who was modestly writing at about the same time 'improving' stories and recording folk-lore in Cornish for his own children, a forerunner of all who have since gathered up the fragments of popular culture in west Cornwall, of whom William Bottrell, 'the Old Celt', is chief. Such men, like the old wandering entertainers of whom Hunt and Bottrell tell us, were surely in the direct line descended from the bards of ancient Cornwall. Most of Boson's work can only be surmised from extracts made by the Welsh antiquary Edward Lhuyd, to whom they were sent, but we have one of his folk-tales, 'John of Chyanhorth', intact, all in Cornish; a fanciful 'Duchess of Cornwall's Progress', in Cornish and English, only part of which remains, showing that the imaginary progress was the pretext for a little survey of the popular antiquities of the Land's End district, and a Cornish essay, *Nebes Geryow adro dhe Gernewek* [A Few Words about Cornish].

It was about this time, too, that John Keigwin was trying to understand the fifteenth-century Cornish manuscripts, and so became the recognized head of a group of local antiquaries and amateurs of the Celtic language that was becoming less and less spoken by the illiterate fisherfolk and country people to whom it had long been relegated. It is to these enthusiasts that we owe most of our knowledge of the latest Cornish, as preserved in the Gwavas and Tonkin MSS., or later printed by Pryce and Davies Gilbert. There was certainly a little centre of native Cornish culture around the shores of Mount's Bay just then, from 1660 to 1730.

As the eighteenth century went on it may be that Dr. William Borlase, with his works on the *Antiquities and Natural History of Cornwall*, turned the thoughts of his neighbours towards speculations about Druids and researches into local history and biology, the latter following up the work done by Ray and Willughby in Cornwall in the previous century, so that popular traditions and linguistic diversions ceased to attract. Borlase compiled a Cornish vocabulary, but recorded no spoken Cornish, and we have no saying of Dolly Pentreath save one from late folk tradition, and should

have had no Cornish from William Bodinar if he had not been able to write a letter in it in 1776. Dr. Pryce printed the collected work of others only; nothing of his own. The break between the Celtic enthusiasts of the beginning of the century and the cultured Cornishmen of its end was thus a wide one.

Coming to the nineteenth century, we reach a period when general culture in Cornwall was expanding greatly along with the scientific, engineering, and mathematical studies that were encouraged by the prosperity of Cornish mining. To this period we owe the beginnings of our Cornish learned societies, and Penzance, Sir Humphry Davy's birthplace, became a little centre of seaside fashion as well as, with its library and societies, one of learning. To mention even the books that were written on all manner of Cornish subjects by local authors during the nineteenth century would fill pages.

Cornish culture, in my restricted sense, was not neglected either. Popular traditions and local dialect, including surviving words of Cornish, were well looked after by Bottrell, Hunt, and Miss M. A. Courtney or Dr. Jago. Davies Gilbert had even printed some Cornish texts for the first (and worst) time in 1826–7, though the new knowledge of Cornish among a few Cornishmen was due rather to the work of non-Cornish scholars: Norris, Williams, and Stokes. With the twentieth century came Henry Jenner's work to arouse interest in the language as well as the ancient history of Cornwall, Charles Henderson's researches into Cornish documents, and Canon Doble's investigations to enlighten us about the Age of the Saints which Canon Taylor had already made more alive for us.

As with all these, Cornwall has usually been fortunate in inspiring friendship and co-operation among its workers, and it was easy to add many others to form a Cornish Gorsedd in 1928 that should foster especially what I have called Cornish Culture, and keep alive in Cornwall whatever is most Cornish and most Celtic. More workers constantly come and give their help, but always there will remain plenty for them to do in gaining, instead of that vague feeling of living in a land haunted by a forgotten past, some sense of belonging to a very long series of cultures none of which is quite as hopelessly lost, perhaps, as we used to think.

READERS' FORUM

Sir,

I like the *Cornish Review* very much, but I could offer one or two critical remarks, although as I am only Cornish by adoption (since I was two years old) may be I am not in a position to do so. In my opinion the *Review* falls short because it seems to aim at admirers of Cornwall rather than the Cornish people. Also, I would like to read more of the real life of the county and less of her artists and aliens, whom I suspect (in some cases) of making a cult of Cornwall and not being part of her at all. I may be very wrong about this, and even unjust, but I feel that the heart of Cornwall beats not in the studios of the 'highbrows' but in the villages and fishing quays and hidden harbours that were the soul of Cornwall when art was confined to Chelsea.

The Cornwall I know and love is not blue door Cornwall, but the tough working world. I am all in favour of encouraging the cultural possibilities of the county – heaven knows it is needed badly enough in St. Austell – but I do feel it should be remembered that there is value in the working world as well as in the artistic.

MARY LOVE
2 Trelawney Road, St. Austell

Sir,

One of your historians might do a service to Saint Ives if he enquired into the origins of 'Fair Mo', and by his researches was able to fix with certainty the date of the festival. The writer is merely a 'visitor' in Saint Ives (last year was only his fifth Fair Mo), but what astounds him is that enquiry among the 'locals', even, does not bring a unanimous answer as to the date on which Fair Mo should be celebrated. Apparently 1949 was the third year in which it has been disputed, and virtually two Fair Mo's have been

celebrated each year by different factions in the town. (Fair Mo 1945 and 1946 seemed to be perfectly clear cut.)

A reason advanced by some of the locals for the uncertainty in the date is that 'The Church' claims one day, and the local inhabitants another. This is perhaps a misunderstanding, for it does not seem logical that the Church should claim any voice in so obviously pagan a feast as Fair Mo, a Pig Fair (peculiar, moreover, to Saint Ives), on which 'in living memory', the writer is told, sucking pigs were slaughtered (sacrificed?) on the mounting steps outside the Sheaf of Wheat.

GUIDO MORRIS
The Latin Press, Saint Ives

Sir,

May I be permitted to say a word in welcome to the *Cornish Review*. It is fitting that this region should have a place for uttering its own voice, for it is a region of character and idiosyncracy. Its people, its scene, its climate, and their interaction, have produced something easily to be distinguished from anything that will be found elsewhere; and this is true, despite the levelling consequences of our day. So long as it remains true there will be a reason for a magazine like this – a magazine which seeks to make known what is peculiarly Cornish in writing, painting, sculpture and all that belongs to a native culture.

The expression that is given to this need not spring out of the heart of the Cornish-born. Mr. Sven Berlin, writing in the first number of 'My World as a Sculptor', says: 'It was Cornwall that helped to release and develop this thing', so that now to work outside Cornwall would alter his vision. And, of course, many who paint in Cornwall, and write of Cornwall, are not Cornish-born. Nevertheless, Cornwall speaks through them; and the thing in this magazine must be that the voice of Cornwall shall speak, through whatever mouth.

This is satisfactorily so in this first copy, and Mr. Denys Val Baker, the editor, may be trusted to keep it so. Of the contents I do not propose to speak, except to say that they are representative and

excellent, setting a standard which, if maintained, should make it almost a duty of Cornish men and women to support the venture.

It is for that support that these few words appeal. At the beginning of this century Sir Arthur Quiller-Couch founded the *Cornish Magazine*. It survived for only four numbers, and that under the editorship of a great and admired Cornishman. It is no use crying shame over that ancient failure. But it would be a pity if it became a habit of Cornish people to see all cultural ventures founder and to leave even their inception to 'foreigners'.

Recently, horticulturists from many parts of the world visited famous Cornish gardens. I was with them for part of the time, and I know they were amazed at what they saw. It was something they couldn't see anywhere else. So it is with the things of the Cornish heart and hand, the Cornish mind and eye. But these things need a platform, and here it is in the *Cornish Review*. The best service which Cornish people can render this cause, which is their own, is to buy the magazine.

HOWARD SPRING
The White Cottage, Falmouth

Sir,
You have no doubt earnestly wished to present a review of Cornish interest, and it is therefore with regret that I have to inform you that to one Cornishman at least all the good and solid Cornish things in your first number are nullified by the blatant conceit of Sven Berlin's article.

I have a concern for the arts as manifestations of the human spirit, and therefore expect that a magazine devoted to Cornish things should reveal the true Cornish spirit in the section devoted to plastic and visual arts. The presentation of Sven Berlin's woolly philosophy and technical absurdities, his disregard for historical and traditional methods of carving which have roots deep in a distant Cornish past, and the devotion of so much space to fantastic goblins, devils and gods in defiance of the humble, simple and workmanlike faith of the Cornishman, cannot recommend your magazine.

I trust that future numbers will do something to correct this orgy of conceit and reveal a recognition of the integrity of the Cornish. As both Cornishman and professional artist, I shall await the time when the *Cornish Review* may find a more stable and constructive artistic policy.

PETER LANYON
The Attic Studio, St. Ives

Sir,

If Sydney Horler★ does not like Cornwall, why does he stay here? And if stay he must, can he not at least have the decency to keep silent about his hosts.

I have just returned home after many years of exile in England. I am amazed by the kindness and goodness that I have met. The Cornish have their faults, like all human beings, and, being a minority, some of them have inevitably developed certain universal traits of minority psychology, clannishness and a keen eye to the naïve chance. I could counter all Mr. Horler's accusations against us by similar accusations against Londoners, but this does not mean that I regard all Londoners as villains. They are often admirable people, in their own place. On the other hand, I would not insult a farmyard by comparing certain aspects of London morals to it.

The sooner Mr. Horler leaves Cornwall, the better will it be for everyone else.

HELENA CHARLES
Higher Ninnis, Redruth

Sir,

As it is improbable that the natives like Mr. Horler any better than he likes them, the remedy is in his own hands. Let him leave Cornwall as rapidly as possible, and not return.

RONALD BOTTRALL
4 Fore Street, Madron

★ Editor's note: his controversial letter is reproduced on page 15 of this anthology.

Sir,

I congratulate you on the second issue of your *Cornish Review*. I should, however, like to say how much I abominate the letters of two of your correspondents, Mr. Peter Lanyon and Mr. Sydney Horler. I can only presume that lavatory walls in Cornwall are so highly glazed that they find it impossible to write on them. I don't think that you need have felt any qualms about telling these two corre-spondents that their ill-mannered observations could have no place in a magazine intended for adults. One can only assume that as Mr. Horler chooses to live in Cornwall he must find himself quite at home amongst 'backward, illiterate and ignorant people', to use Mr. Horler's own words here. I don't know Mr. Lanyon personally, but I rather gather he doesn't like Sven Berlin. There may, or may not, be reason for such dislike, but I should not have thought your magazine was the place for naughty boys to quarrel in.

<div align="right">

ERGO JONES
17b Apsley Road, Clifton, Bristol

</div>

Sir,

Peter Lanyon's letter in your last number is really so rich in misleading assertions that it is hard to know where to have him first. From your point of view, sir, it is perhaps on his assumption that there exists some kind of ideal of Cornishness towards which your contributors should strive on pain of being declared fit only for the outer darkness beyond the Tamar. And what constitutes this ideal? Workmanlike faith. Simplicity. They are still the most spell-binding of clichés; even an Englishman can be relied upon to feel rather a cad for questioning them. Mr. Lanyon evidently knows a propagan-dist's trick or two. But he should read more art history: it would teach him that the artistic life of the obscurest tribes in the remotest places is complicated by the most various cross currents of influence. The Cornish are not so very remote, and are obviously not going to escape the sort of internationalism which has affected Scythians, South Sea Islanders and Eskimos. The majority of good artists working in Cornwall come from outside it. Mr. Lanyon's demand for a Cornish orthodoxy may be sincere, but I don't know

that it is going to be particularly rewarding if it means that we end up with nothing but Mr. Lanyon.

Mr. Lanyon's attack on the *Cornish Review* is one thing: his sniping at Sven Berlin is quite another. Sven Berlin's article displays conceit, says Mr. Lanyon. But conceit is a very dangerous word to bring into this sort of discussion. Perhaps Mr. Lanyon will think it conceit on my part when I publish my conviction that Sven Berlin's work entitles him to consideration as a figure of European importance. Heaven knows that much of his writing is unskilful, but, after all, he is a sculptor and not a writer. The real point is that anyone of his accomplishment deserves to be heard with respect, no matter how awkward his delivery. The tone of provincial sententiousness with which Mr. Lanyon assails him might itself be taken as indicative of conceit; perhaps of even less agreeable qualities besides.

<div style="text-align:right">

BREAN DOUGLAS NEWTON
The Vicarage, Mevagissey

</div>

Sir,

Please do not count on us in future as advertisers in the *Cornish Review*. I am deeply chagrined that any advertisement of ours appears in a publication which opens its columns to such wanton and outrageous insults as are contained in Mr. Horler's article, or Miss Peile's picture 'Wet Sunday in St. Ives', with its covert sneer at the God-fearing characteristics which – to me – are one of the chief prizes of the town.

<div style="text-align:right">

H. W. MARTIN
Managing Director
R. W. Martin (St. Ives) Ltd., 35, 37 and 39 Fore Street, St. Ives

</div>

Sir,

Heartiest congratulations to you for the fine effort you have made in publishing the *Cornish Review*, which undoubtedly is the magazine that Cornish-minded people have felt the need of for many years. At a time like this, when the bookshops are full of 'trash' and unhealthy periodicals, it is appreciated more so. Our

Cornwall, which has lost so much of its culture and traditions, needs people like yourself at the helm in the uphill struggle to preserve those that remain. May you meet with every success.

I would like to add my voice to the already great numbers who have protested at Sidney Horler's outburst against 'us' – the Cornish People. It is, indeed, sad to see such bigoted, ignorant people coming to Celtic Cornwall, enjoying the full benefits of our lovely county, and then coming back with a tirade of abuse and lies against the inhabitants; I liken it to the dog biting the hand that feeds it. We, the Cornish people, welcome the strangers, or 'foreigners', if you like the expression, amongst us; being one of the once great Celtic peoples, we bear no hate against living things, but, as history proves, every generation of Cornishmen have had to bear a cross always made heavier by the Horlers of that generation. It is our individuality that they dislike. Probably they fear a nationalist party in Cornwall. Or is it all 'sham'? Are they really afraid of themselves? Cornwall and the Cornish were civilized and cultured when the Horler type were still barbarian.

E. CYRIL CURNOW
7 *Sea View Terrace, St. Ives*

Sir,

Everyone knows that Cornwall is seething with geniuses who want to be alone. They demonstrate this urge for solitude by massing together, most week-ends, in groups and cliques and gaggles, and emitting conjoint combination against The World. This, of course, means everybody in the world except themselves. The World, they say, misunderstands them. Not, they hasten to add, if anyone is still listening, that they care tuppence about being understood. They spit on Public Opinion. In fact, they despise everyone and everything, themselves excepted, and in particular they despise money.

The attitude of the bogus genius to money is strange in the extreme. When a bearded figure, garbed like a gigolo going to a regatta, tells you that he despises money but, at the same time,

wallows in the beer and cigarettes which other people's money buys, you begin to feel rather puzzled. Can it be, you speculate to yourself, that this palpably pure-souled and martyred Bohemian, who does not object to the mutations of money in liquidated form, has an aesthetic aversion from the sight of money itself, in the shape of coins or notes? No, this is not the case. If you offer him a pound, he does not wince in genteel agony, and shudderingly hand it back to you. He pockets it, in one jet-propelled movement, and then, as they used to say in Western movies, vamooses, muttering something about seeing you later.

The truth is that the bogus genius loves money but hates earning it. After all, if you want to sell a picture nowadays it must have something about it, even if it is only a frame. Many of the pseudo-painters reclining in Cornwall have not enough craftsmanship to frame a picture, and the patience required for such a sordid task is beneath them.

I suppose artists in Cornwall (and by this I mean not only painters but those who follow the arts in any form) may be classified much as follows.

There are professional artists, who live by the proceeds of their work.

There are artists who sell their work fairly well and support themselves, in part, by some other work. These are as much the genuine article as the first group: and, in fact, the temptation to work solely for popularity may be less, much less, if there is some subsidiary source of income, private or earned, to keep a little bread and butter on the plate.

There is also the diminishing tribe of *poseurs*, pretending to be artists, who have enough unearned income to live on, and drape themselves in languid attitudes round chairs in public places. This dying race, it seems to me, does little harm. Indeed, if public merriment is a desirable thing, it does good.

But then there are the strange beings who cannot sell their work, have no private means of support, and refuse to work in any other sphere. This is legitimate, if they do not moan about it. It is a course

that has been followed by many a genius in the past. But your true genius does not go about proclaiming that the world owes him a living. By cold choice he has dedicated himself to his vocation, and, rather than desert it, he faces starvation as an act of free-will.

Not so the pseudo-artist. Unable to produce anything worth selling, blaming the public, and not his work, for this, disdaining any alternative form of trying to support himself, he becomes a parasite on the district he has cursed with his presence. Professing to hate money, he greedily and grossly exults in the comforts other people's money provides.

Most commonly an exhibitionist by nature, the pseudo-artist is the hanger-on who brings creative art into disrepute among the uncreating majority. The theme of his talk is eternally himself: the burden of his plaint is always the chance he never got. And the sight of the success of another fills him with petty, yet splenetic and dangerous, despair.

The pseudo-artist will usually explain to you that he is absorbing the atmosphere of Cornwall. So he is, like a sponge.

ARTHUR CADDICK
Windswept Cottage, Nancledra, Penzance

Sir,

The *Cornish Review* is now clearly established as a leading journal in the West Country and its reputation has reached far and wide, if I may judge from the correspondence I have received in connection with my own contribution to the first number – from as far away as California and India – and also casual remarks from acquaintances who have, as far as I was aware, no knowledge of Cornwall or its own periodical review.

However, I feel I must utter a word of protest against Mr. Ivor Thomas's sweeping generalizations in his article 'County or Country?' Really, sir, to maintain that 'very few Cornishmen have any interest in the revival of a Celtic language' and 'few of them have any interest in the Celtic language of pre-Reformation Cornwall' is grossly inaccurate. I have been preparing a *Handbook of the Cornish Language*, giving its history, literature, short grammar,

and extracts from the remains, for several years, on and off, and when I mention the fact to all sorts of people, I find an immediate display of interest. There is no doubt at all that a very large number of Cornishmen are interested in this work, and also many people who do not know Cornwall itself but are interested in its past as well as its present and future, and feel that a study of the old language would give them a better insight into things in general.

Cornish literature may not be of the highest order in itself, but, as Mr. Morton Nance has pointed out, there can be no doubt that if the language had not been subjected to such strong English influence in the sixteenth century it could very well have produced a literature comparable to that of Middle English. The regular contributions of writers like 'Mordon' to *Old Cornwall* show that by learning this old language we may well discover many a new interest. As Henry Jenner remarked, Cornishmen learn Cornish 'because they are Cornishmen', and 'the reason … is sentimental, and not in the least practical, and if everything sentimental were banished from it, the world would not be as pleasant a place as it is'. It is for this reason that ten thousand men and women, young and old alike, have taken the trouble to learn Cornish and why several hundreds whom I have met all over the world have shown an interest in my *Handbook* – a number hardly to be passed over as 'a few'.

P. A. LANYON-ORGILL
Balliol College, Oxford

Sir,

I would like to support Mary Love's letter in the *Cornish Review*, No. 4. Let us hear something of the real Cornishman, the miner, fisherman and farmer. The men whose forefathers made Cornwall what it is, and whose sons will carry on the work. Approximately one third only of your contributors are Cornish. Please give us a Cornish Review and not a review of the Cornish by a 'passel of arty foreigners'.

F.H. RUHRMUND
5 Trevince Villas, Newlyn, Penzance

Sir,

There may be something in the point of view expressed by Miss Mary Love's letter in the *Cornish Review*, No. 4. But one finds rather puzzling her inverted preciousness and insistence on the specious distinction between the 'real life of the county' and the 'working' world as opposed to the 'artistic'. As I lived in Cornwall until I was twenty and still spend some time each year in the county, I have had some opportunity of seeing various aspects of its life. Where, I wonder, in Cornwall or elsewhere, will one find a harder worker than the artist? If by 'real' world Miss Love means the day-to-day life of the working (as distinct from artistic) inhabitants, is not this recorded in the local papers?

Isn't it mainly a question of function? Unfortunately we cannot all be Cornish by birth, but in a civilised society the artist is as necessary as the farmer or fisherman, and the Cornwall seen through a blue door is at least as real as the Cornwall of 'villages, fishing quays and hidden harbours.' Admittedly the majority of artists living in Cornwall are not Cornish, but it is significant that left to themselves the Cornish evolved no traditional art forms, no characteristic architecture, no handwork comparable to the traditional quilting of Devon, Wales and the Midlands, or the smocking of Wiltshire and Dorset.

It is true that the revival of regionalism at its present stage tends towards the over-emphatic and the self-conscious. But this timely and much needed reaction is a two-way process, focussing back on the region and at the same time going out to a wider world, and the arts – literature, music, painting and sculpture – are the natural media for this communication of the 'spirit of place' to that wider world. In this sense the *Cornish Review* is doing splendid work in fostering the arts, as they have to be fostered in Cornwall or elsewhere if we are to have any more life that that involved in obtaining food and adequate protection from the elements. As William Morris said, we must 'take pains to encourage the beautiful, the useful will encourage itself.'

Surely the real world is the world of values which art celebrates, and the fact that there is such a thing as art in the environment

contributes, as far as anyone participates in it, to the experience of living as distinct from merely existing.

ERMA HARVEY JAMES
Dunshay Cottage, Langton Matravers, nr. Swanage, Dorset

Sir,

May I be permitted to offer some criticism of some 'criticism' of art, which has appeared in your pages?

Mr. David Lewis stands, as it were with bated breath, before the artists of his day; assuming that they have giant proportions he can only speak of their work in terms of overstatement; ever searching for new ways of saying old things, he drifts from pompous speech and the use of most far-fetched metaphor, finally into the grave utterance of nonsense.

In the last number of the *Cornish Review*, Mr. Lewis's note on Peter Lanyon is written in such self-consciously involved language as to be in parts unintelligible. Parentheses abound; in the first paragraph, two sentences holding a third and a fourth in ungainly interposition: it is as if a style had been 'forged' from Caesar, by one who had failed to comprehend the principles of the commentarist's sentence-construction. It is due to the writer to remark that in the fourth line from the end there is probably a misprint, a word omitted; but all Mr. Lewis's longer sentences are so involved, that a verb more or less scarcely adds or subtracts anything in the confusion. He informs us that 'knowing how to use is one of the principal meanings of maturity,' and one perforce must assume his own immaturity.

As to 'criticism,' he informs us that Peter Lanyon is 'sensually apprehensive of white gales on grey granite.' What a boy! Also we are instructed that 'suddenly becoming aware of his own breathing has, thank heaven, come to Lanyon as a shattering revelation.' Were the innocent reader of the above-quoted nonsense to meet Peter Lanyon outside the Saint Ives Town Hall, he would almost certainly observe no psychopathic respiratory consciousness in this good-looking, conventional-seeming and poised young Englishman; nor would he be likely to receive evidence that the artist had apprehended indigenous white gales on the building's grey granite face.

No doubt, the younger contemporary artists are less easy material to write about effectively, than are the accredited giants of art; but it seems a pity that the junior school of 'critics' should be left unhampered to indulge in flights of phantasy, at the expense of an assumedly gullible public, and to the mockery of the striving artists themselves.

GUIDO MORRIS
The Latin Press, Saint Ives

THE LAST COMMENTARY – SUMMER 1952

This is the tenth and final issue of the *Cornish Review*. Born spring, 1949; died summer, 1952. Cause of death, lack of local support – a disease to which have succumbed, in the past, 'Q's' *Cornish Magazine*, the Cornish Shakespearean Festival, the Avon Players Repertory Company of Falmouth, the English Ring Actors Repertory Company of Penzance, and many other cultural ventures. In Cornwall, which teems with great traditions and is probably the home of more artists and writers than any other part of the British Isles, there is none the less insufficient interest and support to justify even the occasional appearance of a literary magazine. Yet the wealth of talent available was so rich that the contents list of each issue invariably included many nationally known writers and painters – names such as A.L. Rowse, Ronald Duncan, Jack Clemo, Anne Treneer, Ben Nicholson, Barbara Hepworth, Peter Lanyon, Bernard Leach, A. K. Hamilton Jenkin, R. Glyn Grylls, Frank Baker, Ronald Bottrall. In this final issue, we have tried to keep up the same standard of quality, to go down with flags flying.

Every possible effort has been made to keep the magazine going, and the editor would like, once again, to thank those who contributed to the Goodwill Fund and the Book Auction. Every issue has run at a loss, and an attempt to remedy this by the publication of the 'Cornish Library' books has only added considerably to these losses. Financially, the whole venture has been a disaster.

And otherwise? Has the *Cornish Review* served a worthwhile purpose? The editor must leave that decision to others. In conclusion, he sends sincere appreciation to the small band of readers and advertisers who gave their regular support to the magazine. If there are any readers with outstanding subscriptions who desire repayment, either in the form of back numbers, a volume of the Cornish Library, or cash – will they please write and send requirements? Thank you.

BIOGRAPHIES

[compiled from various sources, including *The Cornish Review, Artists in Britain since 1945, The Concise Oxford Companion to English Literature* and websites]

Frances Bellerby (1873-1986) was born in Bristol, but moved to Cornwall in the 1930s. Her literary work includes a novel *Hath the Rain a Father* (1947) and books of short stories (including *Come to an End* in 1939), but her preference was for writing poetry, her first volume *Plash Mill* appearing in 1947. *Selected Poems*, drawn from her six volumes and edited by Anne Stevenson, was published in 1997 by Enitharmon Press.

Sven Berlin (1911-99) was a sculptor, painter and writer who led a bohemian, often controversial life in St Ives. His books included the classic biography of artist Alfred Wallis (reprinted by Sansom & Company) and *The Dark Monarch,* a satirical novel about the inhabitants of St Ives which had to be withdrawn in the face of a flood of libel writs. He was a founder member of the Penwith Society in 1949, but disaffection with the modernist movement led him to leave St Ives in the 1950s. He wrote volumes of biography, including *A Coat of Many Colours*, which dealt largely with his life in St Ives.

Arthur Caddick (1911-87) was Yorkshire-born, but more associated with Cornwall. He started writing satirical verse as a young man, with a first success in *Punch*. *Respectable Persons*, a satirical novel, was published by Hutchinson. He was the author of 16 titles in all, some of them slim. He was a colourful figure on the Cornish arts scene, living with his wife in an isolated cottage at

Nancledra and spending much of his time in St Ives pubs. He was one of those who sued Sven Berlin over publication of *The Dark Monarch*, in which he was parodied as 'Eldred Haddock'. His autobiography *Laughter from Land's End* was published by the St Ives Printing and Publishing Company in 2005.

Charles Causley (1917-2003) was born in Launceston and lived most of his life there. A prolific poet, his work is marked by simple diction and rhythm, reflecting an interest in popular songs and ballads. He had a great admiration for the poet John Clare, with innocence a recurring theme of his work, as were religious and seafaring images. His collections include the early *Farewell, Aggie Weston* from 1951. He published stories for children and anthologies of verse. His final volume of collected poems was published in 1992. After John Betjeman's death, British poets voted Causley as their first choice to become the next Poet Laureate, but it was not to be.

Jack Clemo (1913-94) Cornish-born poet, living in St Austell, whose sight and hearing were impaired in childhood, and who by middle age was completely blind and deaf. For years the only outlet for his writing was a local newspaper. He wrote a novel, *Wilding Graft*, in 1948 and a year later, an autobiography *Confession of a Rebel*. His six poetry collections include *A Map of Clay* (1961), *A Different Drummer* (1986) and, his final work, *The Cured Arno* (1995).

David Cox (1914-79) was a painter and teacher born in Falmouth. He was closely associated with the St Ives Society of Artists and the Penwith Society of Arts in Cornwall. He showed at many venues including the RA and RWA and leading London galleries. He later lived in Essex where he ran his own art school for several decades.

John Frederic Gibson, after working in a literary agency in London, settled in Cadgwith on the Lizard, where he wrote his first two novels, *The Bright and the Dark* and *The Heart of the Street*. At the time of writing for the *Review*, he was working on an autobiography.

W S Graham (1918-96) was born in Greenock, Scotland, and moved to Cornwall in 1944. He became deeply influenced by the Cornish atmosphere and people, particularly the sea and the fishermen – an affinity well captured in his memorial poem about Alfred Wallis published in this anthology. He contributed poetry to a wide range of magazines. He was a key member of the St Ives artistic community in the post-war years. Somewhat neglected in his lifetime, Graham's reputation as a major modernist poet has steadily risen since his death. His collections of poetry include *The White Threshold* and *The Night Fishing* (1955). *Aimed at Nobody* was published posthumously in 1993, and *New Collected Poems* followed in 2004.

J P Hodin, doctor of Philosophy at Charles University, Prague, was living in Penzance when he contributed to the magazine. He was a noted art critic of the time, writing several books on contemporary artists.

Mark Holloway claimed 'ancestry in St Neot's churchyard' and lived in West Penwith before the war. He wrote poetry and articles for little reviews, much gathered in anthologies. Wrote books on Dublin and nineteenth-century Utopian communities.

Peter Lanyon (1918-64), born in St Ives, was a painter, largely of abstracts, and printmaker who also notably made constructions, pottery and collage. He was encouraged by Ben Nicholson, Adrian Stokes and Naum Gabo. He exhibited internationally, and his exposure to American abstract painters broadened his horizons. His work is in the Tate and many other public collections. In 1959 he took up gliding to give him a better understanding of the Cornish landscape, bringing a greater feeling of sea and air to his work. He died from injuries in a gliding accident, his death a great blow to Cornish painting.

Bernard Leach (1887-1979), artist, potter and inspirational teacher born in Hong Kong. For years a towering figure in the world of ceramics, with the eminent Japanese potter, Hamada he

founded the Leach Pottery in St Ives in 1920. He exhibited widely throughout the world; many retrospective exhibitions include showings of his pottery at Tate St Ives. His immense influence on fellow potters was celebrated in Marion Whybrow's *The Leach Legacy: St Ives Pottery and its Influence*, published by Sansom & Company in 1996. His own books included *A Potter's Book* (1940) and 20 years later *A Potter in Japan*. His autobiography *Beyond East and West* was published posthumously in 1985.

David Lewis was born in Hampshire and lived some years in South Africa before moving to Cornwall. His books, at the time of this article for the *Review,* included essays on race relations in South Africa, *Beginning,* a collection of poems and *The Sculpture of Lippy Lipschitz*. He later became a curator at the Penwith Society's gallery in St Ives and an eminent art critic and historian. His knowledge of the artists of St Ives is reflected in books such as the Tate's *St Ives 1939-64* and the biography of Terry Frost published in 1994.

Charles Marriott was born in Bristol in 1869, and was for many years art critic of *The Times*. In 1901, success with his first novel led him to retire to Cornwall to write fiction. For a year he lived in a cottage in Lamorna, later occupied by the painter Lamorna Birch. He then lived for eight years in St Ives, before moving to Somerset and London. He wrote notable memoirs, including those in this anthology, of the early Cornish art communities.

E W Martin was born in Devon. He broadcast and wrote about the writers of the region, and his book on Devon, Cornwall and Somerset was published by Phoenix House. At the time of his article in this anthology he was embarking on a projected series of books on English county worthies.

Guido Morris (1910-80) was brought up in a Devon rectory and largely educated by his father; he trained as a naturalist and worked as a laboratory assistant to Dr Solly Zuckerman in the 1930s. He abandoned scientific studies to become a noted typographer and

printer, founding the Latin Press in 1935 at Langford, near Bristol. He moved to St Ives in 1946, befriending in particular Sven Berlin and established his press near the Island. From there he produced elegant, ground-breaking exhibition catalogues and posters. He died in poverty in a high-rise flat in London.

R Morton Nance (1873–1959) was born in Cardiff to Cornish parents. A painter and student of ship history, he is best known for his work in connection with the revival and strengthening of Cornish and Celtic movements. He did more than anyone to revive the Cornish language. He wrote a number of important works, including the *Cornish-English Dictionary* in 1938 and numerous pamphlets and plays. He was President of the Federation of Old Cornwall Societies, editor of the Society's journal *Old Cornwall* and Grand Bard of the Cornish Gorsedd. He is buried at Zennor church.

A L Rowse (1903–97), historian, moderate poet and autobiographer, was born near St Austell. His parents, like many in those days, were virtually illiterate. He wrote on British history and Shakespeare (including *Shakespeare the Man* in 1973). His best-known works include *A Cornish Childhood*, written in his late thirties, *The English Spirit*, in the war years and *An Elizabethan Garland*, 1953. He was a flamboyant figure, openly homosexual.

J W Scobell Armstrong was for ten years a judge on the Plymouth and Cornwall county court circuit, when he became nationally known for his wise, often humorous pronouncements. He worked in military intelligence in the First World War, and later advised the Foreign Office. He wrote a 'text-book' *War and Treaty Legislation*. In later years, he put his abiding interest in Cornish affairs to good effect, making his home the venue for local events. He wrote poetry, and made a study of the work of painter John Opie, many of whose paintings of the Scobells hung in his family home in Nancealverne.

W J Strachan, although not Cornish, attributed his special interest in Cornwall to family connections with the sea, his mother's family coming from Brixham, Devon. The poem in this anthology was one of a series written following a visit to West Penwith, where he also painted oils and watercolours of the Zennor district. His output included a volume of poems, *Moments of Time,* published by Sylvan Press. He had read English at Cambridge under Sir Arthur Quiller-Couch, and when writing for *The Cornish Review* was teaching in Bishop's Stortford.

Ivor Thomas was born in Camborne in 1914 into a mining family. After teaching in London, along with post-graduate research in prehistory, followed by five years' war service he settled at Mullion and became a bard. He was founder of the Cornish Geographical Association. His hobby of 'local history through the eyes of a geographer', led to his writing studies of Cornish geography.

Henry Trevor at the time of his article in *The Review* lived in Penzance, and had made a special study of craft movements, travelling all over Britain visiting craft groups and communities.

H J Willmott became a reporter for an East Anglian newspaper in 1915. After several career moves, including working on *The Countryman,* he settled in Cornwall, working as news editor and feature writer with the *Cornish Guardian.* He collaborated with J C Trewin on a book, *London-Bodmin* in 1949.

Westcliffe Books
A new publishing imprint for Cornwall

The Cornish Review Anthology 1949-52 is the first book in an exciting new publishing enterprise. Westcliffe Books has been set up as an imprint of Redcliffe Press to publish books specifically of Cornish and wider West Country interest. The emphasis will be on the area's cultural and literary life, published alongside more general topics.

The anthology drawing on Denys Val Baker's *Review* will be followed by Alan Kent's groundbreaking study *Theatre of Cornwall*, in which he analyses the turbulent history of theatre and drama in and about Cornwall from antiquity to the present day. This major study can be seen as a companion to his *The Literature of Cornwall: Continuity –Identity – Difference 1000-2000*, published by Redcliffe Press.

Joanna Thomas's *Women of Cornwall*, for publication in 2010, will show how in every field of endeavour women shaped Cornwall's past. Particular individuals have been chosen to emphasise pioneering achievements by women of note, and which have enriched Cornish culture.

The fascinating history of the flora, gardens and plant hunters of the West Country will be told in Jean Vernon's *South West Gardener*, while Ian Sumner's biography of pioneering Victorian photographer John Wheeley Gutch, *In Search of the Picturesque*, has strong Cornwall and Devon interest.

Other early titles include books of aerial photographs of Cornwall and of Devon.

We shall be pleased to hear from anyone with proposals or typescripts of books suitable for the imprint.

For more information, visit our website www.redcliffepress.co.uk

ALSO AVAILABLE

Britain's Art Colony by the Sea
Denys Val Baker

Written from the inside, and 'as it happened', this is an intimate portrait of an artist community in perhaps its most celebrated period, the two decades following the second world war. Traditional painting, epitomised by the glowing canvases of John Park and Charles Simpson, still flourished alongside the innovations of the modernist school led by Ben Nicholson and Barbara Hepworth and which brought international recognition.

The crafts, too, feature in Val Baker's book, from Bernard Leach's pottery on the hill to innumerable smaller studios in St Ives and other locations in west Cornwall, along with locally made furniture, metalwork and textiles.

The book's republication nicely complements the *Cornish Review* anthology and serves as a reminder of those heady days, profiling both the famous and the near-forgotten. Setting them in their historical context, David Wilkinson's introduction shows how St Ives has continued to flourish, to the point at which art is now as vital as mining and fishing were in the past.

ISBN 1 900178 13 3 112pp softback
published by Sansom & Company £9.99

www.sansomandcompany.co.uk
info@sansomandcompany.co.uk

Cornish Art Books

Sansom and Company publish books on British art from 1880 to the present day, with an emphasis on the art and artists of Cornwall, many published in conjunction with Penlee House Gallery & Museum.

The art colonies at Newlyn, Lamorna and St Ives are well covered, with around two dozen books on artists such as Lamorna Birch, Elizabeth Forbes, T C Gotch, Harold Harvey, Charles Simpson and Marianne and Adrian Stokes and, from St Ives, Tom Early, Bryan Pearce and Alfred Wallis. A recent publication has been a wide-ranging survey of arts and crafts copperwork in Newlyn.

The list extends to a major study of Trevor Bell, one of Britain's leading abstract painters, now working out of Cornwall.

We are also especially strong on twentieth-century Modern British art, including Gaudier-Brzeska, Rodrigo Moynihan, Paul Nash, Stanley Spencer, Slade and Euston Road School artists and the artists of the First World War, as well as a number of leading contemporary painters and sculptors.

For details of these and other titles, please visit our websites
www.sansomandcompany.co.uk
www.artdictionaries.com

Sansom & Co Ltd, 81g Pembroke Road, Clifton, Bristol BS8 3EA
T: 0117 9737207
E: info@sansomandcompany.co.uk

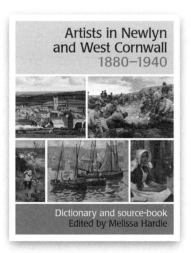

ARTISTS IN NEWLYN AND WEST CORNWALL 1880–1940

A DICTIONARY AND SOURCE BOOK

Editor-in-Chief Dr Melissa Hardie

Drawing on the West Cornwall Art Archive and many other sources, this profusely illustrated book is the most comprehensive survey ever compiled of painters, draughtsmen and women, sculptors and craftspeople working in Newlyn.

The supporting information includes exhibiting records, collections in which the work may be viewed today and bibliographic sources.

The artist profiles are supplemented by essays and a rich variety of contemporaneous source material from the Newlyn colony. Topics covered include photography as art, the artists' schools and classes, with full lists of those artists who attended the Forbes' school, and the Arts and Crafts movement in West Cornwall, including the Newlyn copper industry.

Will become the major source book for Newlyn artists of this period. Interest in the artists of Cornwall currently at a record high.

Approximately 100 colour and more than 150 black & white illustrations
270 x 210 mm | page extent 424 pp | £49.50 | hardback
ISBN 13 9780953260966

Details of this and other new publications are available on our website
www.artdictionaries.com